OHIO
HISTORY

On This Day In
COLUMBUS
OHIO
HISTORY

TOM BETTI & DOREEN UHAS SAUER
FOR COLUMBUS LANDMARKS FOUNDATION

Charleston — London

THE
History
PRESS

Published by The History Press
Charleston, SC 29403
www.historypress.net

Copyright © 2013 by Tom Betti and Doreen Uhas Sauer
All rights reserved

All images appear courtesy of the Columbus Metropolitan Library
Image Collections (CML), Columbus Landmarks Foundation (CLF),
Franklinton Historical Society (FHS) and Dr. Ivan Gilbert (IG).

First published 2013

Manufactured in the United States

ISBN 978.1.60949.668.5

Library of Congress CIP data applied for.

Dedicated to Columbus Landmarks Foundation supporters and the Education Committee members who believe that without a story, a brick is just a brick.

CONTENTS

ACKNOWLEDGEMENTS

This book would not have been possible without the contributions of Columbus Landmarks Foundation's research volunteers and the work of local historians who publish and made their work available: Richard Barrett, David Binkovitz, Leslie Blankenship, Becky Ellis, Ed Lentz, Theresa Carsten, Brenda Dutton, Conrade Hinds, Laurie Hermance-Moore, Ann Seren and Terry Sherburn. Thank you to the Columbus Landmarks Board of Trustees and president Bill Mattes for their encouragement and a special thank you to Tom's parents, Sam and Lena, and sister Gina. Thank you also to the Columbus Metropolitan Library and Joe Gartrell and Darcy Mahan of The History Press.

INTRODUCTION

It seems only fitting to start the first day of an almanac with a reference to a previous almanac—the Columbus Almanac of 1818. William Lusk was the author, and P.H. Olmstead was the printer. Nineteenth-century almanacs generally were composed of calendars, origins of the month's names, a list of roads and distances, the setting and eclipses of the sun and the moon (always helpful on dark roads) and promotional boasts. Lusk wrote of Columbus, "Few towns in the United States are so pleasantly situated for a delightful rural prospect, for fertile neighborhood or health. And, during the whole time of the settlement of this town, the health of the citizens has been almost unparalleled" (yeah, except for that pesky miasma and cholera epidemics). He praised the "care and vigilance

of the keeper" at the Ohio Penitentiary who, despite the responsibility of forty-eight convicts, had not "suffered" one convict to escape. (The first pen was little more than a hole in the ground.) If Lusk were correct and the little town of Columbus had a population of 1,200, that means 4 percent of them were felons.

January 1

Chief Between-the-Logs of the Wyandot tribe died on this date in 1827 from tuberculosis and the effects of a winter trip to plead on behalf of the Christian Native Americans who lived primarily in Upper Sandusky, Ohio. He spoke without interpreters. He was a Christian and a Methodist minister, married to the sister of David Beers, founder of North Columbus. When David was seven years old, he, his mother and his baby sister were taken captive by Indians and separated. Raised by Indians, David's sister was later married to three successive tribal leaders, the last of whom was Chief Between-the Logs. As he was dying, Chief Between-the-Logs pleaded that the Wyandots not be pushed from their land. However, there were less than twenty years remaining before the Wyandots would be removed. Their lands appraised at $125,937.24, but the money was never paid to them. In Columbus, an observer standing on South High Street in the 1840s recorded that he saw a band of Wyandots as they rode into Columbus to take trains from the Union Depot (where the Convention Center is today), heading for St. Louis and the Kansas territories. As the Wyandots were leaving, German families arrived by canal and railroad. Other German immigrants already in Columbus had decided also to move on for new opportunities, boarding trains to go farther west, where they founded the towns of New Columbus and Deshler, Nebraska.

January 2

The P.W. Huntington & Co. bank opened for business in 1866 on this date. It was said on many mornings, Pelatiah Huntington, the founder, picked up small sticks on the way to work to put into the stove to heat his office, but this may be only an illustration of his thrifty nature. Similar stories are told about other banking families, like that of Mr. Zinn, who founded the Great Northern Bank (later a Huntington Bank and now the Ace of Cups bar) in North Columbus. Zinn was said to have acquired a perpetual kink in his neck from looking down to scour the streets for pennies and nickels as he walked to work. Mr. Huntington, the son of a banker and a descendant of a signer of the U.S. Constitution, could have coasted on his family's credentials but chose instead to set out on his own, serving on a whaling ship, the character builders of their day. Huntington came in 1853 when the city was a growing crossroads. He went from messenger to board of directors at the Exchange Bank in thirteen years and was profoundly influenced by a speech he heard on the National Currency Act that emphasized that the stability of a bank should be a reality and not a fiction. Though he was a careful businessman, Huntington "forgot" to renew the charter of the Exchange Bank, and due to this inaction, that bank closed and his own bank opened.

January 3

Columbus's annexation policies did not begin with Mayor M.E. Sensenbrenner, who served from 1954 to 1959 and again from 1964 to 1971. He was credited with tripling the size of the city by extending Columbus's water and sewage services to townships outside city limits. By 1909, on this date, Columbus annexed an additional five square miles to create fifty new voting precincts, becoming Ohio's third-largest city. The motive was to bring in additional tax revenue to pay for existing infrastructure sewer and water expenses within the city. It didn't hurt that it also kept the temperance groups happy. Columbus citizens only had to go south past the city's jurisdiction through Little Germany (German Village) or north to Milo-Grogan (Cleveland Avenue) for a beer on Sunday afternoons.

January 4

A large civic celebration heightened the dedication of Memorial Hall in 1906, making the East Broad Street structure the nation's second-largest auditorium in seating capacity. Built to honor Civil War veterans, it was so long in coming that it also honored Spanish American War veterans. Memorial Hall, for years the quintessential white elephant after the building of Veteran's Memorial on West Broad Street in the 1950s, found new life as the first Center for Science and Industry and, years later, was remodeled and refurbished for Franklin County.

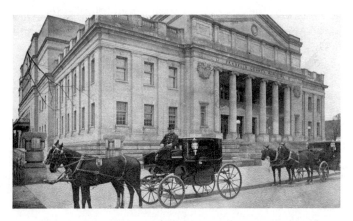

Horse-drawn carriages pull up in front of the newly dedicated Franklin County Memorial Hall. *CLF.*

January 5

The Ohio legislature began to occupy the nearly completed statehouse in 1857, despite fears that the unsupported stairs were free-floating and would collapse. The stairs were connected to the floors but were not attached to a wall and had no supports from underneath. A marching band was hired to test their strength.

January 6

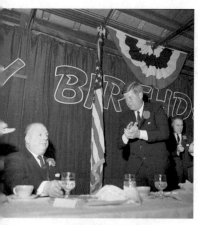

On January 6, 1961, President John F. Kennedy traveled to Columbus and was the keynote speaker at a birthday dinner held for Governor Mike DiSalle at the Buckeye Building on the Ohio Fairgrounds. In his speech, President Kennedy discussed Ohio's recent accomplishments, reviewed the national achievements of 1961 and discussed the opportunities and challenges for his administration in 1962. *CML.*

Classes began over a laundry storefront at East Long and North High Streets for the Columbus Arts School (ancestor to the present Columbus College of Art and Design) in 1879. It was here that one remarkable student, Alice Schille, took art classes. She was a distinguished impressionist painter and watercolorist and the daughter of Peter and Sophia Schille, well-to-do Lutherans and owners of the Schille manufacturing company of mineral waters and soft drinks. She studied art with a number of established teachers in Columbus and later in New York with William Merritt Chase. But her real education came in the form of her extensive travels to Morocco, Dalmatia, Holland, California, Mexico and the Lower East Side of New York. Each trip inspired and created new colors and styles and brought her recognition few could have imagined for a student who painted above a laundry.

January 7

In 1911, an era passed in Columbus with the death of Mrs. Alfred Kelley in Cincinnati. Her home on East Broad Street was the scene of social events and art benefits and was as famous as she was. Her nineteenth-century Greek Revival–style home had been the subject of Ohio history schoolbooks as "The House that Saved Ohio." Her husband offered it on the New York Stock Exchange as collateral for funding the building of Ohio's canals. The Kelley residence on East Broad near Sixth Street became the Cathedral School. By the 1960s—though loved and fought for by Dixie Sayre Miller and other early historic preservationists who tried to save it, but unloved by Ohio Governor Lausche, who would not contribute funding—the house that saved Ohio was not saved by Ohio. It was dismantled to be rebuilt someday. Someday never came. The stone blocks were numbered—some blocks were lost to Alum Creek for flood control—and sent to the Hale Farm in the Western Reserve for storage. Here the numbers washed off, and the blocks were disposed of.

On this day in 1938, famed local artist Leland McClelland profiled Jimmie's Drug Store in a cartoon as one of a series of Columbus hangout profiles for the *Columbus Citizen* newspaper. The people at the corner of Brighton Avenue and North High Street used the drugstore as an important social network before corporate drugstores and Facebook. McClelland worked from a studio on East Broad Street, but mostly, he traveled through the city looking for his subject matter.

January 8

Columbus-born Ashcan School of Art artist George Bellows died unexpectedly at age forty-two in 1925. He attended the first Central High School (East Broad and Sixth Streets). He was an athlete and contemplated a career in baseball. His father, George Sr., was an architect/contractor who was fifty when his son was born. They came from different eras but respected each other's sensibilities—Victorian fussiness and Ashcan realism. George Bellows Sr. created the highly embellished Franklin County Court House that once stood on the southwest corner of South High and East Mound Streets. His son created *Stag at Sharkey's*, a famous depiction of prize fighting that was almost banned when Bellows brought it to a Columbus exhibition. A properly aged reproduction of it is in the appropriately named Ringside Café in Pearl Alley downtown.

Central High School, located at East Broad and Sixth Streets, was one of the nation's first high schools, built in the early 1860s. *CLF.*

January 9

The lines were drawn! In 1909, Westerville was selected by the Anti-Saloon League as its national headquarters. Seven miles to the south in Columbus, the Germans in the Sixth Ward, the Italians in Milo-Grogan and the Irish on Irish Broadway took another sip of beer and waited.

Although Westerville was home to the Anti-Saloon League, the Woman's Christian Temperance Union kept watch on alcohol consumption in Columbus from this location on East Broad Street. *CLF.*

January 10

It was an era of trusts and trustbusting—odd terms to use since men of wealth and power rarely trusted each other. Columbus was a convention town in 1900, and hotels were big business. On this day, it was announced that the Neil House Hotel, the Chittenden Hotel and the Great Southern Hotel were being consolidated into the Columbus Hotel Company. Despite $300,000 cash on the table and some big names like brewer Nicholas Schlee, the deal did not go well. The partners in the trust stood to lose a great deal of money if the deal fell through, and it was rumored that the Great Southern was already leaking money and might foreclose. As the country song says, "Sometimes you hold them, and sometimes you fold them." Despite the Columbus Hotel Company's insistence that if the Great Southern did join in, it would still be a first-class hotel and able to charge its standard room rate of $2.50 to $5.00 a day, the Great Southern decided to "hold them" at the behind-the-scenes insistence of Ralph Lazarus, a Great Southern Hotel trustee, who politely repeated, "No deal." The others lost their appetite for the fight. According to the other hotels, they had only been trying to save the Great Southern and now did not care to be in the position of "begging to be sold a dead horse." They waited for the demise of the hotel to pick it up at a cheaper price. One hundred years later, the Neil House and the Chittenden Hotel have disappeared, but the "dead horse" continues to exist.

January 11

A fine hotel, a beautiful woman—where were the detective story writers at a time like this? In 1917, the body of Mona Byron Simon was found in a luxurious room of the Deshler Hotel at Broad and North High Streets with bullets through her heart. It was only months since the hotel had opened, and a sensational murder was not desired publicity. Her body was removed quietly at midnight through a back entrance, and the coroner, duly informed, "had forgotten to tell the newspapers." Through the years, despondent suicides occasionally plunged from the hotel's windows, and in 1940, in an odd version of strip poker, a gunman accosted four card-playing friends in a room, ordered them to disrobe and stuffed their discarded clothing and cash from the table into a bag. (Wasn't that an episode on *Seinfeld* where George…?)

In 1946, tired of painting imitation seams up their legs with eyebrow pencil because of World War II shortages, Columbus ladies responded to the cries of someone yelling, "Nylons!" on Broad and High Streets. The long line to buy the coveted stockings at Neumode Hosiery started at 7:00 a.m., snaking two blocks north and one west. Passersby swarmed for a place in line, and a police officer acted as usher. A cab driver and a sailor joined the line to buy for their wives. By 10:30 a.m., all the stockings were gone.

January 12

James Thurber, a writer for the *Columbus Dispatch* (whose life did not yet include writing for the *New Yorker* or trading quips with Dorothy Parker at the Algonquin), was inside the old city hall (sometimes called a monstrosity of Victorian architecture by those who hated bric-a-brac or did not appreciate the building's peculiarities that allowed a basketball court over the city library) when the building caught fire and burned to the ground. It was the most spectacular fire in Columbus in 1921. The Ohio Theater replaced the old city hall. Thurber, almost forgetting to file the story in the excitement of the fire, eventually headed to New York.

January 13

After three years of negotiation, the last piece of land was purchased for the new city hall complex. On the same day and year, the new Griswold YWCA building on South Fourth Street was dedicated in 1926. The Columbus Young Women's Christian Association was organized in 1886 as part of the Women's Education and Industrial Union, serving as a boardinghouse for young, single workingwomen and operating a kindergarten and nursery for working mothers.

January 14

In 1946, there was no stopping to shop for nylons (see January 11) as the last of the German prisoners of war who were housed in Columbus left the Columbus Army Service Forces Depot on East Broad (generally known as the Defense Construction Supply Center or DCSC). The 179 prisoners were sent to the base camp at Camp Perry for the first leg of their long trip back to Germany. The camp opened January 22, 1945. Some ex-prisoners posed for photographs, and many just seemed relieved it was over.

January 15

Charles Godfrey Smith, arrested under the name William Smith, was in city prison on the charge of following and insulting women on the street in 1900. Smith chased Miss Schneider along North Park Street when he was arrested; he was identified as being "the terror of ladies residing between the railroads and First Street." A strenuous effort had been made to capture him, both by the police department and "by gentlemen residing in the infested district." Smith lived with his wife on Spruce Street, held a job as a machinist and admitted he had a mania for seizing women and squeezing or kissing them. Though traps had been set for him, Smith was able to evade capture until Officer Howard, pretending to be a woman, finally caught the perpetrator. A fine was issued.

January 16

Several hundred children marched in order from their burning school in 1911 when the overheated furnace started a blaze at St. Mary's School on Mohawk Street near Sycamore Street. The firemen extinguished the fire in the basement but had to return (and the children left the building a second time in the same orderly fashion) before the fire was completely out. Father Specht, in charge of the school and the church, was so pleased with the work of the firemen that he donated ten dollars to the Firemen's Benevolent Association.

January 17

Luther Donaldson was finally elected to something at city hall in 1870—then located on the second floor of the old Central Market on South Fourth Street between East Main and East Town Streets. After forty-eight ballots, Donaldson became president of Columbus City Council. Previously, Donaldson had lost his bid to become mayor of Columbus to George Meeker, who was constantly bedeviled with the controversial Sunday saloon closing laws; directed the groundbreaking of the Victorian City Hall "monstrosity," whose fire was covered by rookie reporter James Thurber; and fought over annexations. (See January 12.)

January 18

In a quiet neighborhood of homes north of Columbus with the interesting street names of Lincoln, Chase and Stanton (very Civil War–ish), a murder occurred in 1911. Alice Griffis, wife of the Chaseland pottery plant watchman, was found brutally beaten to death under mysterious circumstances. Though the deathblow had apparently been delivered to her outside the house, the attack had started inside. The murderer had entered the home by breaking windows. Mrs. Griffis was reading the evening paper. Upstairs on the dresser was a loaded revolver, kept for defense in a remote place. She should have had plenty of warning, but the revolver was still there, unused. Mr. Griffis found his wife's body in the yard, and the case remained a mystery. Columbus annexed Chaseland (1,030 acres) from Sharon and Clinton Townships in 1955.

January 19

The State Convention of the Colored Citizens of Ohio, made up of representatives of twenty Ohio counties, ended after meeting for four days in 1851 in Columbus at the Second Baptist Church. Among the Franklin County delegates were James Poindexter, reverend of Second Baptist; John T. Ward, whose moving and transfer business is the oldest black-owned business in the country; and David Jenkins, editor of *Palladium of Liberty* and tireless proponent for education. They debated the points of the new Fugitive Slave Law and passed resolutions and petitions, including petitions to open education to all children in Ohio and one petition to Queen Victoria of England, asking that she never consent to have any part of Canada affixed to the United States. Canada, of course, was a welcome refuge for those on the Underground Railroad and the United States' Fugitive Slave Law offered no protection in the North.

The Columbus Turkish Bath Company opened at 190 East State Street in 1904, offering electric massage and plunge baths—hopefully not at the same time.

January 20

Local activity in Columbus ground to a halt in 1978 after more than ten inches of snow fell on the city in a two-day period of blizzards across Ohio. Schools closed for weeks; buses actually picked up passengers without correct change; Columbus residents stripped grocery stores of the only things they knew to buy in an emergency: bread and milk; and people coped with cold homes by piling on the clothes or staying in bed. By September, the only reminder of the snow was the baby boom.

January 21

It was not the infamous Triangle Shirtwaist Factory Fire in New York—but it could have been. In 1913, three young female factory workers saved themselves from incineration by leaping from the third-story roof of the Burdell Sweat Pad Company at 176 West Broad Street. The factory was built on pilings at the west end of the Broad Street Bridge and extended over the river. Ten girls climbed down the front fire escape, but the three were trapped on the roof and leaped fifty feet into the muddy Scioto River, where they were rescued by firemen.

January 22

The *Columbus Dispatch* in 1911 supported the idea of increased annexation of the city limits and, in doing so, recognized that the growth of the city would increase the power of the newspaper to influence the public agenda.

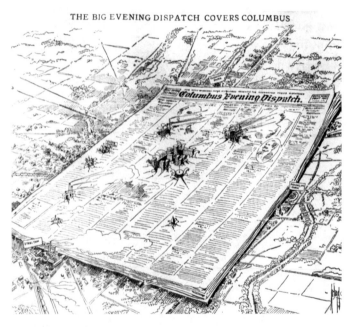

The *Columbus Dispatch* exerted enormous influence over central Ohio. *CML.*

January 23

The old Dunbar Theater at 1289 Mt. Vernon Avenue was transformed into a treasure chest of beauty by a master craftsman in 1933. The upper floors of the building, under the peaked eaves, were an exhibition chapel with plans for the first floor to become offices and glass-cutting rooms. Ludwig von Gerichten, founder of the von Gerichten Art Glass studios, was a well-known stained-glass artist, with employees in Columbus, New York and Munich, Germany. For many years, he operated one of the largest stained-glass businesses in the United States, and Von Gerichten stained glass was well known and highly prized. Von Gerichten sometimes played both sides of the business. He frequently lobbied the American government to shut down the importation of German-manufactured stained glass, saying that it ruined the American stained-glass industry, which could not make the product better or cheaper. At the same time, he ran his own German workshops that supplied his American customers. (See April 14.)

January 24

In 1931, the new Ohio Bell (remember them?) telephone directory showed no taverns or saloons in Columbus (of course, it was Prohibition). However, over 250 confectioners and 90 bakeries, many in homes, had sprouted up across the city. The number of bakers and candy makers outnumbered attorneys. Large quantities of sugar needed for candy and pastries could also be used in the fermentation process and might not draw suspicion if Mother sold brownies from the front window while, from the back door, Father sold alcohol (or, as they called it in the German community during Prohibition, "vinegar").

January 25

In 1890, the United Mine Workers Union was founded in Columbus on the site of the old city hall (now the Ohio Theater) on East State Street. The merger between the National Progressive Union and the Knights of Labor District Trades Assembly 135 came after years of feuding among miners. The headquarters of the United Mine Workers of America was at North High and Chestnut Streets until 1898. The United Mine workers focused on better wages and an eight-hour workday but, especially, safer working conditions in the coal mines across the country.

January 26

In 1926, four men died from "black damp," a toxic gas while working on the American Insurance Union Citadel (now the LeVeque Tower). Working in caissons to secure the deep foundation needed for the skyscraper, the men were overcome by the toxic gas despite the attempts of a worker known as "Big Bill" to save them. He repeatedly descended in a bucket to bring them to the surface. The caisson construction for the AIU (LeVeque) was so deep that "sand hogs" who had worked on the Holland Tunnel in New York were called in, and an on-site hospital and chamber was erected where men suffering "the bends" (as if they were deep-sea divers) could be treated.

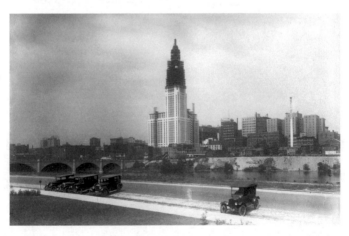

A 1926 photo from across the river of the Columbus skyline featuring the AIU Citadel under construction. *CML.*

January 27

In 1840, a significant number of immigrants arrived in Columbus from Montgomeryshire, Wales. They formed their own Congregational church in a small frame building, eventually building a substantial church across the street at 55 East Blake Avenue. Though Welsh had immigrated into the city for two decades, this latest immigration was a direct result of deteriorating economic conditions in Wales and fiery Welsh preachers who denounced ruthless landlords and encouraged immigration to Columbus.

January 28

More than $150,000 was pledged by city council to make the Columbus Zoo "one of the finest in the nation" in 1951. The master plan was voted on after members of council and civic leaders took a tour of the twenty-one-acre site by O'Shaunessy Dam. Included in the plan was money for a new giraffe house, new reptile house, modern children's zoo, miniature train and new power plant. Many improvements would be in place for the zoo's silver anniversary in 1958. The zoo was so popular that its gate receipts in 1950 were almost $90,000.

January 29

The case of *Columbus, Springfield & Cincinnati Railroad Company v. the City of Columbus* opened over the appropriation of another portion of the old North Graveyard for railroad right of way in 1871. The Old North Graveyard, the city's northern border between North High and Park Streets, was established in 1813. The land had been donated by the proprietors of Columbus for the purpose of establishing a burial place for the citizens of Columbus, placing it under the oversight of the continuously cash-poor city that did not have money for maintenance either. Residents petitioned city council to prohibit further burials, stating, "The decomposition of the dead affected the water in the neighborhood" (well, yeah). The North Graveyard, already diminished by the railroads, was needed for more tracks. After viewing the property, the jurors decided that the value of one hundred feet was $14,625. The Railroad Company proposed to begin preparations "at once" for the removal of graves and subsequent laying of track across the graveyard property. They must have begun "at once" because…well, a Columbus Landmarks Foundation tour can point out where they missed more than a few bodies in the Short North.

January 30

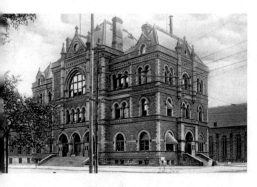

An 1887 photo of the post office on the southeast corner of East State Street and South Third Street. *CML.*

President William Taft rededicated the newly expanded federal building, the Historic United States Courthouse and Post Office, at East State and South Third Street (now Bricker and Eckler), in 1912. Despite a severe bronchial infection and coughing fits, President Taft also revealed in Columbus that he favored the creation of a world court to settle disputes among nations. The 1912 building was a remarkable extension of the 1887 building and a conversion to a High Victorian Gothic style. The idea for the federal building had begun as early as 1858, but the growth of Columbus from 1860 to 1890 saw an increase in the population of the city five-fold to a total of almost eighty-nine thousand residents. In the middle of construction, the architect was able to convince Congress to appropriate an additional $60,000, adding a third story to the 1887 building. The 1912 building had doubled its size again.

January 31

Dr. Samuel B. Hartman, once the richest man in Columbus, died on this day in 1918. He built a fortune from a "cure all" tonic named Pe-Ru-Na, claiming he received the formula in a dream from an Indian. Pe-Ru-Na was the most successful-selling patent medicine in the world in 1887, though sales began to fall after the Pure Food and Drug Act of 1906 forced the good doctor to disclose his product contained 27–30 percent alcohol. His downtown holdings included a factory, an office building and an acoustically perfect theater, two hotels, a surgical hospital and his palace on East Town Street, once a modest home but clad in marble as his wealth grew. He owned the Hartman Farms south of Columbus, where he kept racehorses and dairy cows. For all he owned, nothing remains but the Hartman Hotel on South Fourth Street, now condos, unless one counts the many pieces of marble—once part of his home—that now decorate the yards of the east side.

The main administration building of the Pe-Ru-Na Company at Rich and Third Streets. It was demolished in the early 1970s. *CLF.*

February 1

The real reason for the existence of the city of Columbus, of course, is because it is Ohio's capital. A new statehouse had been in the works since 1837 to replace the old one at the corner of State and High Streets. The work on the new statehouse would stop and start in fits of appropriations, and a generation of citizens in Columbus grew up looking at a tall and ugly board fence built to keep the construction workers—inmates of the Ohio Penitentiary—from escaping. And then a miracle of sorts: on February 1, 1852, just as the legislature thought it needed only a small fireproof building for records, the old statehouse burned to the ground. It provided some impetus—finally, and the House and Senate convened in rented halls until part of the uncompleted statehouse was occupied in 1857 (and finally finished in 1861).

February 2

In 1958, Ohio State University's Armory and Gymnasium was destroyed by an intense fire that filled North High Street and the campus with dense smoke. The castle-like armory had been the logical conclusion to an OSU problem. In the 1890s, student groups had formed their own athletic associations and constantly overspent. Rather than someday be embarrassed by scandal, the university founded an athletic association and built the armory. Students had a space for physical training, and (what the university wanted) there could be a place for military training, as was expected in a land grant institution. The firm of Yost & Packard designed the building. The site of the armory stood empty for more than twenty-five years after the fire (but is now Wexner Center for the Arts).

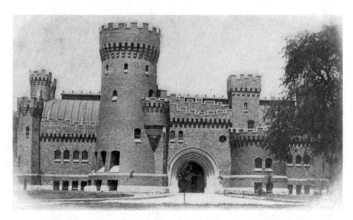

The OSU Armory and Gymnasium was the architectural inspiration for today's Wexner Center for the Arts. *CML.*

February 3

A soldier who was stationed in Franklinton during the War of 1812 recorded that, in 1813, it took a full day to cross from Franklinton into Columbus (of course, without a bridge across the Scioto River, small boats had to be used). By February 4, he had marched to Worthington, and by February 5, he was in Delaware—slow going. The headquarters of the American forces in the Northwest was located in Franklinton under the command of William Henry Harrison. The anonymous soldier and comrades were on the move to Fort Meigs to defend northwestern Ohio from British troops. Lucas Sullivant, founder of Franklinton and godfather of Columbus, was authorized on this date two years later in 1815 to build a bridge over the Scioto River to connect Franklinton to Columbus.

February 4

Famous English suffragette Sylvia Pankhurst came to the city to speak in favor of women's suffrage in 1911 at Memorial Hall on East Broad Street. Many well-known and educated women of the city believed voting was intended to be one vote per family—and as the moral compass of each family, unsullied by the dirt of the political arena, the woman would be looked to by her husband for her moral guidance. After seeking her view, the man would vote his wife's advice. Mrs. John Battelle—who ran her family just as forcefully as she set the course for the Battelle Memorial Institute to honor her husband and her son; who worked for three years to help physically rebuild France's cathedrals; who established the Girl Scout movement in Columbus from St. Stephen's Episcopal Church; who funded Columbus sculptor Mary Cook in her creation of six hundred life masks for reconstruction of disfigured American soldiers' faces, beginning the idea of reconstructive plastic surgery; who walked the picket line in Chicago for women's right to vote and strong-armed presidential candidate Warren G. Harding—Mrs. B was not buying into that nor kidding herself that a husband would listen to the opinion of his wife. She supported suffrage.

February 5

Though there were officially no Hungarians in Columbus in 1852, Columbus citizens went wild when Louis Kossuth—patriot of Hungary, the George Washington of the Hungarian people and symbol of democracy—visited the city to raise money for his cause. Speaking from the front of the Neil House (remember, you were warned that this spot was historic), in the statehouse and in city hall, Kossuth was everywhere in his short visit—with the exception of Kossuth Street (later named for him and his visit). He was led by a procession that included the governor and legislators and was "followed by mechanical associations, benevolent societies, with a delegation of the city butchers on horseback." He couldn't address many. By the time he reached Columbus, he was simply exhausted but thanked the workingmen of the city for their support. Impressionable young men with a flair for the dramatic quickly took up wearing Kossuth hats—black hats with feathers—to show their support for his revolutionary ideas and, perhaps, because nothing says romantic like a Hungarian feather hat.

February 6

In 1907, one of Columbus's best-known citizens was dying of pneumonia. Reverend James Poindexter, born in Richmond, Virginia, came to Columbus at age nineteen and was a barber and a pastor at the Second Baptist Church for fifty-five years. He was well known to the public and to politicians of his day, serving as a member of the Columbus school board and as a city councilman; a trustee for the state school for the blind (his granddaughters Della and Nettie taught there); a trustee of Wilberforce University; and an advocate for African American interests to President Hayes, President McKinley and Governor Dennison. He was perhaps the only African American who, by 1907, had served on a petit jury in Ohio. His abhorrence of slavery and desire for social justice was well known. Poindexter Village, one of the first housing projects in the United States, was dedicated to his memory in 1940. President Franklin D. Roosevelt came to Columbus to do the honors.

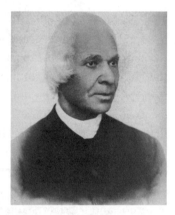

James Preston Poindexter came to Columbus in 1838 and was pastor of Second Baptist Church from 1862 to 1898. He was the first African American on the Columbus City Council in 1880 and served on the Columbus Board of Education from 1884 to 1893. Poindexter was nominated for the state legislature on October 30, 1873. *CML.*

February 7

C.S. Ewen, cited for restless operation, was sentenced to one day in jail for driving thirty-six miles per hour on Indianola Avenue in 1924. Many of the streets north of Ohio State University had been laid out on either side of Indianola in the previous decade, and the North Columbus Businessmen's Association and the Northwood and Oakland neighborhoods were civic-minded and powerful vigilante organizations that made Mayor James Thomas's life challenging. Thomas, interestingly, ran on the issues of traffic and the negligence of the auto industry to put money back into roads and streets.

February 8

In 1931, Ohio State University's classes of 1927, 1929 and 1930 announced plans to convert Mirror Lake's old spring into an artistic rock garden. The spring once supplied artesian water, and many came to fill their containers. It was considered a major factor in the board of trustees' decision to locate the future site of the college at William Neil's farm. However, in the 1890s, the city of Columbus accidentally punctured the source of the water, and the natural spring went dry. The lake was supplied with a small fountain to keep the water constantly moving.

The change of Mirror Lake at OSU made front-page headlines. *CML.*

February 9

What stories are behind the most modest facades? In 1931, three days before the celebration of Lincoln's birthday in a home at 513 South Champion Avenue, Mrs. Mary (Pinkerton) Thompson, age seventy-three, revealed that as a child, she had lived in President Lincoln's White House in 1864. Her mother was cousin to Lincoln, and her father was a confidential war messenger to the White House. When the family's home burned down, "Cousin Abe" invited the family to move into the White House. She had the run of the house, even going into Lincoln's cabinet meetings. He would scoop her up into his lap, where she napped while he conducted business. In the garden, she walked with Lincoln, but he was too tall for her to hold his hand, so General Grant held her hand instead. Only two weeks later, it was revealed that Columbus had another famous descendant, Mrs. Paul G. Miller of 65 East Lakeview Avenue, who was the maternal granddaughter of Mary Washington, niece of President George Washington.

February 10

The borough of Columbus was incorporated in 1816. Ask yourself if this matters since the passage of Columbus into "borough status" is not an event to be celebrated, and the city already focused on more events than Lucas Sullivant could shake a stick at for the bicentennial in 2012.

February 11

In 1934, Valentine's Day was only a few days away and the Dutch Candy and Ice Cream Company at 1920 North High was advertising its boxes of assorted chocolate, hard and chewies and all creams. One-pound boxes ranged from forty-five cents to one dollar. The Walter Scott family was successful, employing thirty workers in a candy factory just north of their Dutch Chocolate Company and south of their ice cream factory. The Dutch Chocolate Company was a build-out in front of a house. The company's branding was still evident decades later through a distinctive Dutch roof and blue and white Delft tiles on either side of the façade. The College Girl, a popular clothing store, retained the cheerful tiles, and the building still exists, though greatly modified.

February 12

In 1972, Columbus folk artist, barber, teller of Biblical tales carved in wood and mentor to the next generation of artists Elijah Pierce received national and worldwide attention when New York City's Museum of Modern Art featured his wood carvings. His barbershop was dismantled and a Columbus State University parking garage on East Long was built. A statue of Pierce marks the spot where the barbershop stood.

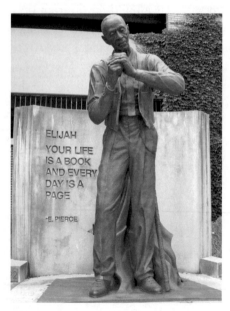

The Elijah Pierce monument is located on East Long Street on the campus of Columbus State University. *CML.*

February 13

Abraham Lincoln was at the Ohio Statehouse on his way to his inauguration in 1861 when he was officially notified that the Electoral College confirmed him as the sixteenth president of the United States. Boarding a train on his way to Washington for the inauguration, Lincoln's chance encounter with an assassination attempt would change a Columbus newspaper reporter's life forever. William Coggeshall was at the right place at the right time to intervene when a bomb was tossed toward the Lincoln party as they changed trains in Pennsylvania. Newspaper reporter and Lincoln admirer Coggeshall intended to travel with the Lincoln party only to Pittsburgh and then return to Columbus. But when he threw the device out an open train window, Coggeshall was invited by Lincoln to accompany him to Washington. His admiration for Lincoln led to Coggeshall's most unusual act of honor. Before he even told his wife and while waiting for more than a year to come up with a way to honor Lincoln, Coggeshall named his yet-unnamed youngest daughter (called "Baby" until then) for what he considered Lincoln's greatest achievement—known as Prockie, her full name was Emancipation Proclamation Coggeshall.

February 14

Columbus was announced as the location for the new state capital of Ohio in 1812, with the deal reportedly made after a night of drinking. The Ohio legislature accepted the proposal from the Starling-Johnston-McLaughlin-Kerr syndicate to establish the capital in exchange for its laying out lots, the donation of ten acres for a public square, donation of ten acres for a penitentiary and for the construction of the statehouse, state offices, the penitentiary and other buildings. The statehouse grounds were laid out as one large square, Virginia style, as opposed to four smaller squares as is common in New England towns (and Worthington). The old town of Franklinton (1797) on the west side of the Scioto continued to thrive for a number of years while the east side of the river was laid out on the high bank once known as Wolf's Ridge. Howling wolves (and not to be confused with Columbus family names) frightened early Franklinton settlers who preferred to take their chances with floods.

In 1848, on the same day but thirty-six years later, and having absolutely nothing to do with the founding of Columbus but perhaps more to do with looking good for Valentine's Day, a city ordinance was passed forbidding daylight bathing in the Scioto River between Mound Street on the south and the Ohio Penitentiary on the north.

February 15

In 1934, Big Bear grocery opened the nation's first grocery self-serve supermarket in a former roller skating rink on West Lane Avenue (now the site of the Riverwatch Tower). The elliptical structure, prior to being a roller skating rink, had been the Crystal Slipper Nightclub and was also once used as a stable for polo ponies. For a short time, Big Bear kept a live bear in a cage outside the door to attract shoppers and children, but the real show was always inside. Because it had been a former roller skating rink with a slightly banked floor, the dance of the shopping carts was a major attraction. Left unattended, even for a moment, hundreds of shopping carts turned into demolition derby cars, especially on busy Saturday mornings.

February 16

In 1931, one of Columbus's most distinctive buildings was about to be born at 40 South Third Street, immediately south of the Columbus Dispatch Building. The nine-story American Education Press building, home of *My Weekly Reader*, also housed the University Club. Designed by Richards, McCarty & Bulford architects, the building's façade was distinctive because it announced itself as a publishing house with forty cast-metal spandrels, each containing a punctuation mark or a letter of the alphabet.

February 17

Citizens and luminaries gathered at Union Station in 1919 to welcome native son and flying ace Eddie Rickenbacker from the war. The city began to envision a grand gesture to honor America's most famous aviator, announcing that it would acquire his boyhood home at 1334 East Livingston Avenue and turn it into a memorial aviation museum.

However, Rickenbacker, who did not live in Columbus after the war, left the future of the house to his sister, Mrs. Pflaum, a widow who decided the six-room house was not appropriate for a museum, believing her brother had made his own memorial in his accomplishments. She declined the offer.

A new neighborhood theater opened on February 17, 1938—the Indianola (also called Marzetti's Studio 35 and now Studio 35), at 3055 Indianola Avenue.

Famed World War I flying ace Eddie Rickenbacker was also a talented race car driver. *CML.*

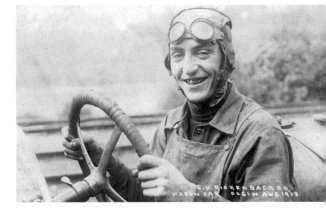

February 18

Phillip's Original Coney Island was established in 1912; eight days later in the same year, Farrow's Harley-Davidson Motorcycle dealership was founded. Two iconic businesses in Franklinton and Columbus on West Broad Street—now that was a way to celebrate a city's centennial. The Farrow dealership is the oldest Harley-Davidson dealership in the United States.

February 19

Columbus was officially chosen as the seat of government by the Ohio Legislature in 1812. Leave it to the government to be five days behind the announcement. Come on, folks, they already said they were going to accept the proposal. (See February 14.)

February 20

Capital Lodge #167 of the Knights of St. Crispin organized to protect the interests of boot makers and shoemakers in Columbus in 1866, and by 1873, it had a membership of fifty. With the onset of economic depressions that followed the Civil War, like other early labor unions, it faded out of existence. The Arbeiter Verein managed to keep 143 members. The Arbeiter Verein (Workers' Association) admitted all classes of laborers and kept its meetings (like other labor groups) secret. Each member paid five-dollar dues annually, and if he became disabled, he received five dollars weekly. The union's motto was "United we are victorious, separated we must surrender; union makes strength, science is power, as labor is the origin of all wealth." (Not exactly short enough for a coffee mug or a t-shirt.) On the southeast corner of East Rich and South High Streets, the Mechanics Beneficial Society joined together with the city's mechanics, manufacturers and artisans. By 1841, the society built Mechanics Hall at the intersection, maintained a library and held weekly public lectures, and it was a frequent gathering spot for other groups.

The children of Columbus mourned the loss of their "friend in the big stone house" in 1931 when William H. Fish, owner of the Fish Stone Company and builder of Goodale Park's Fish Gate (northwest corner of the park), died at age eighty. Fish conducted yearly playground activities at Goodale Park where children could compete for prizes (described as "numerous and costly") personally presented by him to each child.

February 21

In 1812, the name Columbus was chosen for the new capital on the east bank of the Scioto River. (See February 14 and February 19.) Popular history credits Joseph Foos with suggesting the name, perhaps because he was—in addition to a dozen other jobs he held—the boatman who ferried people across from Franklinton to the new Columbus side, and he might have had a special regard for a fellow sailor. Fortunately, he did not identify with Greek mythology's most famous boatman and label the east bank "Hades."

Former president Theodore Roosevelt visited Columbus in 1912, addressing the Ohio Constitutional Convention and giving his famous Charter of Democracy speech. Roosevelt was preparing to launch his bid to retake the White House from his successor, William Howard Taft from Ohio.

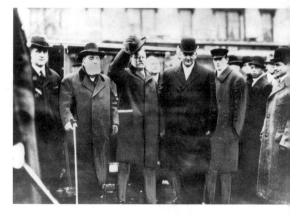

Former president Teddy Roosevelt arrives at Union Station in 1912. To the left of Roosevelt is Reverend Washington Gladden (with cane). *CML*.

February 22

The fate of Ohio as a presidential swing state was sealed in a Columbus tavern when the Whig Party chose General William Henry Harrison as its presidential candidate during the party's convention in a Columbus tavern in 1839. Excited supporters also came up with the first catchy election tag—"Tippecanoe and Tyler Too." The ale must have been flowing.

Miss Jane Hammond, principal of Twenty-Third Street School, appeared before Judge Black in juvenile court in 1908, stating that forty students in the school had been gambling. She had known for some time that students were not reading when they were quiet, and her investigation revealed a well-developed numbers system. The children saved their pennies until they accumulated a sufficient sum to play a combination of numbers they selected. A special session of the court was called to talk with the children. Numbers running was a time-honored, though illegal, way of making money, especially in poorer neighborhoods—though this might have been the first time that children were the organizers and not the runners. Today the numbers game is called the Ohio Lottery.

February 23

Watching a downtown parade and celebrating George Washington's birthday across from the statehouse, Albert C. Osborn, a local newspaper editor, was shot to death by rival newspaper owner William J. Elliott in 1891. Actually, his brother P.J. Elliott had pulled the trigger that killed Osborn, but William was seen as the mastermind of the planned killing. P.J. received twenty years but was paroled in 1896. William Elliott won the lottery, so to speak. He was pardoned in 1899 with the so-called Fourth of July pardon by the warden (not to be confused with the Thanksgiving pardon that was also an annual gift of the warden). Elliott and his wife left the city immediately, bound for Los Angeles, where he hoped to get back into the newspaper business.

February 24

Nationally known publication the *American City* placed the Columbus Civic Center on the cover of its 1938 February magazine. In the article, James Skaates of the Columbus Chamber of Commerce concluded by writing, "Columbus isn't through building yet! Prominent Masons occasionally discuss the thoughts of a new Masonic Temple. When the time arrives for these plans to mature, considerable pressure undoubtedly will gather behind the suggestion: 'Why not make them a part of Columbus's beautiful civic center?'" They must have resisted the pressure.

February 25

At Central High School (now COSI), events on February 25, 1971, led to a major United States Supreme Court decision: *Goss v. Lopez* (1975). From January through March 1971, there was wide unrest in many American high schools, including the Columbus City School's high schools and junior high schools, on the Vietnam War and/or Civil Rights issues. Ten students at Marion-Franklin High School were suspended for ten days each for disobedient conduct following an assembly. As per district policy, an expulsion from school required a hearing; a suspension did not. A few weeks before, civil rights protests by African American students began when Central High School administration cancelled a student-organized Black History Week assembly when it did not agree with the students' choice of speakers. The next day, there were widespread demonstrations at many schools. Two Columbus students, Dwight Lopez and Betty Crome, respectively from Central High School and McGuffey Junior High (Columbus Alternative High School is now in the building), were suspended after a disturbance at Central High's cafeteria. Lopez maintained that he was a bystander. Betty Crome was at Central and was suspended from McGuffey by authorities though it is not clear how anyone knew she was there. Neither had a hearing. On the basis of a violation to the Fourteenth Amendment to the U.S. Constitution, the Supreme Court ruled in favor of the students. The Due Process Clause forbade arbitrary deprivation of liberty. The case is a landmark in students' rights.

February 26

In 1850, railroad service began in Columbus when the first train to run on the Columbus and Xenia Railroad departed from Xenia. With the National Road and the feeder canal from Lockborne, Ohio (that entered Columbus at the Scioto River near the present-day Waterford and Miranova Towers), Columbus was poised to become a crossroads city, attracting new monies, immigrants, entrepreneurs and goods.

February 27

While Columbus was planning for a comprehensive and adequate traffic regulation system that included traffic lights on main arteries, the Columbus & Southern Ohio Electric Company was quietly making plans. Though the company denied it in public and even to city officials, in private, the streetcar company hinted that riders on North Fourth and Summit Streets and Indianola and Chittenden Avenues would be riding in buses and not streetcars by the end of 1938. The president of city council objected to having any issues aired in open meetings, but the fact that the Columbus & Southern Ohio Electric Company was removing wooden block paving from the Fourth Street viaduct in the summer was also a logical first step in removing streetcar tracks.

February 28

On February 28, 1930, Dr. Snook calmly went to his death in the electric chair at the Ohio Penitentiary for the murder of Theora Hix. Mrs. Snook stood by her husband throughout the trial and through subsequent appeals to the governor to spare the electric chair even though most of Columbus had condemned him within the first few days of the murder. She and her husband walked out of the cell arm in arm to the small red brick Death House in the southeast corner of the prison yard. A heavily veiled Mrs. Snook left at 6:47 p.m., and the hearse from Schoedinger Funeral Home came into the yard to receive the body. (See June 14 and July 24.)

Tuskegee Airmen Robert Peoples, Preston Pugh, Williams Brooks and Malcolm McCoy came to the Martin Luther King Library in 2002 to share their experiences. McCoy recalled that white German prisoners-of-war faced less harassment than black airmen. Black newspapers like the *Chicago Defender* pressured President Franklin D. Roosevelt to order the Army Air Corps to train an all–African American flying unit at the Tuskegee Institute. The 99th, 100th, 301st and 302nd were formed from 1941 to 1944. A number of the Tuskegee Airmen lived in Columbus because of the proximity of Lockbourne Air Force Base.

February 29

Samuel P. Bush, described as a "prominent Columbus capitalist," urged a concerted taxpayer effort to demand an investigation into the Ohio Senate to look into charges of maladministration and graft in various state departments in 1938. Mr. Bush was the former president of the Buckeye Steel Casting Company on Parsons Avenue, with an office at 141 North Front. He was also the grandfather and great-grandfather of two United States presidents: George Herbert Walker and George W. Bush.

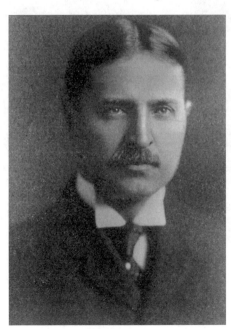

Samuel P. Bush oversaw the phenomenal growth of Buckeye Steel Castings on Parsons Avenue during World War I. *CML.*

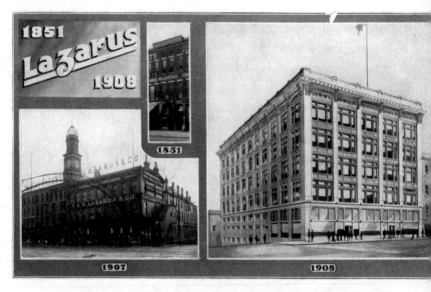

A 1908 postcard featuring the Lazarus Department Store, 145 South High Street. *CLF.*

In 1930, Jane Thurston, daughter of the famous Columbus "king of magic" magician, Howard Thurston, married her new husband for the third time. Jane eloped with Harry Harris, devastating her parents. Their first marriage was under assumed names, the second used correct names and the third was in a Catholic church. Three times was not a charm: they divorced in 1932. When Thurston died four years later and his body came home to Columbus, to Jane's surprise, she learned she was adopted. Thurston left her only $500, explaining that she had caused him much mental anguish and financial difficulty. For years, friends or family gathered at the Green Lawn mausoleum on the anniversary of his death to wait for a sign from beyond the grave. None ever came. Jane died in Florida in 1994. (See April 13.)

In 1931, the F.&R. Lazarus Company celebrated its eightieth anniversary at South High Street. By 1895, the store required its own electric plant, and on the day it opened, children were released from school to inspect the plant. In 1909, the business moved across Town Street to the northwest corner of the intersection; in 1926, the building expanded along South Front Street on the site of a former house of ill repute (the source of much amusement for Fred Lazarus). South Front Street was much lower than South High, and two "basements" were created. This allowed shoppers on the escalators at South Front Street to smile when they saw the sign "Up to Basement."

March 2

Grand-opening specials abounded in 1929 as Montgomery Ward & Company opened its first local store at East Main and South Third Streets. While Columbus boasted a number of Sears & Roebuck homes that could be ordered by catalog, Columbus also had Montgomery Ward homes, ordered by catalog as well. Columbus children loved the store, not because they shopped there, but because generations of them called it "Monkey Wards."

March 3

There was little support for unionization at Buckeye Steel until an organizing drive started on this date in 1941. Weekly meetings were held at the Croatian Hall on Reeb Avenue and at the Little Italy, a South side nightclub. Visitations were made to workers' homes, and the Steel Workers of Columbus was able to receive a majority vote for unionization in 1942. Unlike efforts to unionize at Timken Roller Bearing Company (the headquarters of which were in Canton), labor leaders remarked that where Timken tried every means of unfair labor practice, Buckeye Steel did not. Buckeye was an old Columbus family business with many ties to the city and to its workers. While Buckeye did not want workers to unionize, they were "more realistic."

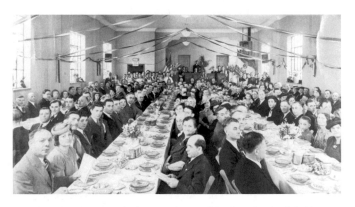

The dedication luncheon for the new home of the Croatian Hall, held March 31, 1940. *CML.*

March 4

Singer and actress Judy Garland sang on the stage of Indianola Junior High, the nation's first junior high, at 420 East Nineteenth Avenue, in 1938. She had been invited to receive the honor of "Sweetheart of Sigma Chi" from the nearby fraternity and accepted the invitation of the Indianola students to give a small concert.

March 5

The city's oldest charity (continuing to this day) was founded in 1838, following a cholera outbreak. The Female Benevolent Society was established to "alleviate the distress of the poor and afflicted of their own sex." Thirty-three years later (1871) on almost the same date, the society adopted a new constitution at the First Presbyterian Church and emphasized: "to seek the poor in the city of Columbus, and provide them relief, aid, instruction, or employment, as may be deemed best." And seek they did as the ladies of the Female Benevolent Society, all upper-class women of the finest Columbus families, made home visits and personal meetings a key element of the charity's operation.

March 6

In 1920, the new name of the hospital operated by Drs. Method and Tribbett was announced—the Alpha Hospital (now a gallery on East Long Street). The committee met at the YMCA, and after "careful review of the names suggested by the several competitors for the prize," Mrs. Charles Chavis's suggestion was selected. The name was most appropriate—with "alpha" meaning "first," the hospital was the first African American hospital in Columbus. Though African American physicians could work in other hospitals, they were not permitted to work on an equal basis with white doctors.

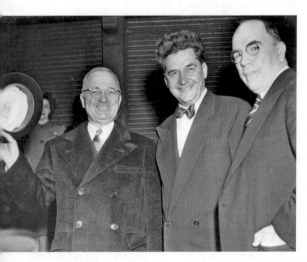

President Truman traveled to Columbus with special guest Sir Winston Churchill on March 6, 1946, to speak at the conference of the Federal Council of the Church of Christ in America. Pictured with Truman are Governor Frank Lausche and Bishop Oxnam. *CML.*

March 7

Capital University received its charter approval from the State of Ohio in 1850. The university was established as a Lutheran theological school, and Lincoln Goodale gave real estate for the establishment of the school near Goodale Park. Capital University later moved east into the present-day suburb of Bexley in the late nineteenth century.

March 8

In 1977, United States District Judge Robert Duncan issued his ruling that Columbus schools had indeed violated federal law in its creation of separate schools for white and black students. Though Columbus schools were desegregated ninety-two years before the ruling of *Brown v. Board of Education* by allowing families to send their children to the nearest school, there was a glaring exception—the creation of Champion School in 1909 to draw off African American students from surrounding east side schools. When seen in a larger context, these years before World War I were tumultuous with regard to race relations both nationally and locally. Fear and ignorance were fueling a deep divide in tolerance. President Woodrow Wilson, and even OSU President William Oxley Thompson, believed the two races could not and would never be able to live together. Columbus embarked on a relatively peaceful desegregation plan that produced court-ordered busing.

March 9

Update on Columbus financials in 1937 on this date: first, the Broad Street Presbyterian church purchased the Edward Orton Homestead at 788 East Broad Street and spent approximately $146,000 on improvements in the church and adjacent property. Secondly, the H.C. Godman Company announced a 10 percent increase in piecework and hourly wage increases for its 300 employees. Third, the Jeffrey Manufacturing Company announced an increase of five cents per hour on the base pay to its 2,300 workers. And last, the Timken Roller Bearing Company announced an increase in the wages of the 600 employees in the Columbus plant, which amounted to a $300,000 increase in the payroll. Where was the Depression in Columbus?

March 10

They were gone—a little more than a month after the announcement of their coming demise was made by the Ohio State Saving Association in 1926. The nineteenth-century two- and three-story homes that sat at the southwest corner of Gay and Third Streets were demolished to make room for Ohio Savings, which advertised "Own Your Own Home" as it tore down homes. However, ninety years later, Gay Street east of Third Street has been revitalized with the blocks of newly built urban town houses in the same scale, profile and building materials as the ones that came down in 1926.

March 11

In 1926, a fire, starting in the attic of the Central Presbyterian Church on South Third Street, threatened to destroy the entire property. Smoke blanketed downtown. The fire in a defective chimney was put out but not before fears arose that the historic church would be lost. The church had the tallest church tower in the nineteenth century, and early fire companies used to hang their hoses to dry from it. And it was from this church that the Reverend Lyman Beecher—father of Harriet Beecher Stowe, author of *Uncle Tom's Cabin*; and father of the Reverend Henry Beecher, the more "free-love," or at least freely philandering, minister of Brooklyn, New York—pleaded with the Presbyterian Congregation to stay Presbyterian. The church members listened, and only a few became Congregationalists.

Players Theater, the oldest community theater in Columbus, originally housed on Franklin Avenue in two houses joined together by 100,000 bricks from the demolition of the old Central High School, moved to the Vern Rife Center in 1989. There was no word as to whether the ghost of the Players Theater, a former longtime volunteer, also moved to the new space.

March 12

Legendary Ohio State football coach Woody Hayes died in 1987. Former United States president Richard Nixon arrived in Columbus to give the eulogy. Nixon and Hayes were friends, and according to Hayes's grandson, Phil, vice-president of the Columbus Education Association, even as a young child on a ride in Air Force One with his family, Phil was coached to never say the word, "Watergate."

March 13

In 1939, one of Columbus's best-known amusement parks was placed on auction. The Indianola pool and pavilion at North Fourth Street and Nineteenth Avenue opened in 1904. It boasted the largest swimming pool in Ohio—and it was—fed by three artesian wells. The park, like Olentangy and Minerva, was established on the ends of a streetcar line to lure more riders into taking the streetcar. The pavilion was used for dances, bowling and even diving horses. The pool was where many women in Columbus learned to swim, though the owner finally resorted to paying them one dollar if they would do so. Women were reluctant to show their figures in bathing attire, but the bribe of money (and the ingenuity of the owner who also added a covered walkway from the bathhouse to the pool) brought in many new customers. The pavilion continues to exist, having been a grocery store, a thrift store and now a completely renovated church. The pool remains but is under the parking lot.

March 14

Ray Lichtenstein, the famous pop artist who helped make everyone famous for fifteen minutes, lived on Iuka Avenue when he was a student at Ohio State. In 1984, his sculpture *Brushstrokes in Flight* arrived in the city to be placed at Port Columbus airport. Originally an outdoor site was selected for the sculpture; however, it was determined that inside (where it is today) might be better because it would be less subject to the elements and to touch-up by city workers. Though everyone at the city saw the Lichtenstein piece as a work of art, there was debate as to whether it would need to be maintained by the artist or could be cared for by the city as if it were a bike rack.

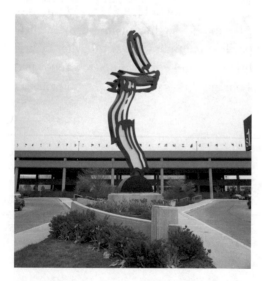

Brushstrokes in Flight was originally outside of Port Columbus terminal but was moved inside for easier maintenance. *CML.*

March 15

In 1933, the little house on West Twelfth Avenue belonging to Ohio State University's Home Economics Department was in hot water, so to speak. All seniors in home economics were required to live in the Home Management House for a period of five weeks, during which they put into practice all facets of management theories and during which time the students would buy, cook and eat meals together. However, in the spring of 1932, one African American student, Doris Weaver, was told she could substitute another course for this last requirement or she could move into a well-furnished modern apartment of "similar" quality and quantity of furnishings as the little house and, under the direction of a supervisor, perform her necessary tasks and entertain her friends (as was done in the Home Management House). Ohio State University president George Rightmire and the OSU Board of Trustees said, "It has never been the policy of Ohio State University to require students of different races or nationalities to reside together as part of a single family...it is not within the power...to compel the people of one nationality or race to room with or live in such intimate relation...against their desires." Doris Weaver demanded her right to take the senior course. Her writ was denied; six judges of the Ohio Supreme Court concurred and dismissed the petition. Shut out of a power structure that did not wish to share its power, Doris Weaver took the substitute course in order to graduate on time.

March 16

In 1895, the Chittenden Hotel at the corner of West Spring and North High Streets reopened after a fire ravaged most of the building, causing $1 million in damages. But fires were not the only threat; by the end the twentieth century, downtown theaters across the country were threatened as vaudeville died and television changed the habits of people who once frequented movie theaters.

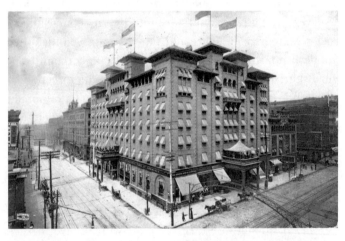

The third Chittenden Hotel was one of the largest and handsomest hotels in Ohio. Like the proverbial Phoenix, it arose in a more beautiful and perfect form from the ashes of its former self after the first two buildings were destroyed by fires. It was an eight-story building, with a series of Spanish turrets, and it presented a very striking architectural appearance. The hotel contained over three hundred guest rooms. The site is now the home of the William Green Building. The hotel was demolished in 1973. *CLF.*

March 17

Of course, it is St. Patrick's Day, and in 1899, the Irish community had been preparing for this "proper celebration" since March 4 (if not before). The members of the Ancient Order of the Hibernians gathered at 8:00 a.m. in full regalia. The band and various divisions formed the parade and marched to St. Patrick's church on Naghten Street, where solemn high mass was celebrated and a eulogy on the life and works of St. Patrick was delivered. The Friendly Sons of St. Patrick held its charter open; in addition to the 70 registered members, another 150 joined to be able to attend the evening banquet at the Great Southern Hotel, a German-Irish enterprise. An elegant dinner consisting of Blue Points oysters, green turtle soup, diamondback terrapin à la Maryland, filet of beef, broiled spring chicken on toast au cream, lettuce and tomato salad, emerald ice cream, fancy cakes, Roquefort cheese, fruits, coffee, XXX Hennessey brandy, St. Patrick's punch and cigars—and then the serious eating and drinking began.

March 18

There were certainly no secrets in Columbus in 1859—boastfulness in the city caused newspapers to report on every aspect of progress they could unearth. Though it was only 1859, "progress" was already measured in how many "old" houses were torn down. Columbus citizens were delighted with the sounds of the hammer, the axe and the plane—it meant money coming into the city (jobs, jobs, jobs—sounds like 2013)—and, of course, there was self-fulfilling prophecy. A city that promoted itself as prosperous was prosperous. Reported in three months, January to March 1859: William Neil built two large, three-story stores on High Street; the old Gwynne building on High Street and Sugar Alley was coming down for the new Johnson Block; Hoster & Son added a large addition to its building at its brewery on Front Street; Mr. Erlenbush added a large extension to "Brewery Corner" at High and South Public Lane (Livingston); and Dr. Goodale was building two dwellings on East Town Street…only a few of the more than twenty construction projects recorded.

March 19

With the opening of the new Franklin County jail at the southeast corner of Front and Mound Streets in 1978, Sheriff Harry Berkheimer and others were nostalgic for the old jail on Fulton Street between South High and South Third Streets. The walls of the old jail had crumbled, and prisoners sometimes pushed their way through the walls and shinnied down the downspouts. Former sheriff Stacy Hall recalled being on the phone when he saw a prisoner pass his second-floor window on the way to the street below.

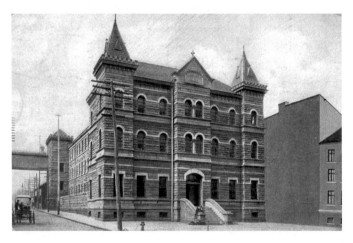

The original Franklin County Jail (pictured about 1908) was located between South High and South Third Streets. *CML.*

March 20

In 1863, Robert Neil's woods (on Harbor Road, now Cleveland Avenue) were transferred to the federal government for the building of an arsenal in the Civil War. Known by a variety of names—the arsenal was renamed Fort Hayes in the 1920s to honor President Rutherford B. Hayes—it was used for the training of soldiers in every American war from the Civil War through Desert Storm, eventually becoming Fort Hayes Metropolitan Education Center. The most prominent building was the Shot Tower, originally designed to make "shot" by dropping molten lead from the five-story tower into pools of water below but never used for that purpose. Where Civil War soldiers slept in the Shot Tower, marched indoors or, at one time, guarded munitions and repaired small arms, students practiced art. Classrooms and eating spaces were reshaped from where officers' formal dress balls were held, where the first OSU basketball game occurred (when they played the soldiers), where band concerts were given and where World War I recruits learned French before departure overseas.

March 21

Columbus lost its only burlesque house in 1932 when fire destroyed the Lyceum Theater. However, Columbus would have others in the next decades, and Larry Flynt would also be arriving in Columbus to start his *Hustler* magazine empire on West Gay Street (along with a sort-of-known-but-pretend-it-didn't-exist-illegal Hustler Club in the basement). The offices for the magazine were located in the former Kaiserhof Hotel that opened just before World War I on West Gay; the building remains today and is under renovation for a next life.

March 22

In 1923, the fine old Neil House was coming down. President Warren G. Harding called it "the real capitol of Ohio." When the third (and sadly, final) Neil House emerged after 1923, it was the source of more stories. In the 1930s, a Cleveland journalist noted that the "new" Neil House and its neighboring buildings were the location of "about one thousand speakeasies and beer flats and approximately four thousand bootleggers—and that is a conservative estimate if bell-boys, taxi drivers, and colored hip-pocket vendors are included. Hotel attendants specialize in quick service and provide fairly good liquor, too."

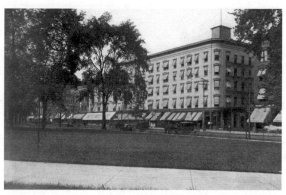

The second Neil House was William McKinley's residence when he served as Ohio governor. *CML.*

March 23

Popular *Columbus Dispatch* columnist the late Tom Fennessy on March 23, 1976, captured one downtown street whose length could be walked in twenty minutes. "State Street… That Great Street." Nothing changed, and yet everything changed since it was written. He wrote, "You could…be born in Grant Hospital, live your days in one of several apartments that are along the street and, in the end, have your choice of Woodyard or Schoedinger for an undertaker…anchored in the city and the imagination by Andrew Carnegie's marble library building at the east end and at the west by the state government's tribute to art deco architecture, the State Departments Building." Fennessy noted it was a street where go-go girls plied their trade at the Beach Comber, one could buy an altar cloth or a pornographic magazine and it was still possible to get a room at the Norwich Hotel. A person could tell the school board how it was making a mess of "our institutions of lower learning" or eat at the Garden, the Courtyard, a Burger King or Presuitti's Spaghetti Express. But the State and Fourth Grill was "that most democratic of all Columbus watering spots with a clientele that includes drifters and dentists and diverse stations between." Now it is a parking lot.

March 24

In 1888, city council passed a law forbidding the obstruction of city streets by railroad trains. This was a particularly serious problem on North High Street (near the present Convention Center); imagine crossing in front of an oncoming train with a horse and carriage. The problem could be solved if one segment of the traffic either went above or below the other. Experimenting with horse, carriage and streetcar traffic going into a tunnel under the railroad tracks proved nasty. A healthy horse can leave twenty to twenty-five pounds of manure behind in one day. Eventually, the idea was reversed, and a viaduct structure was built on North High (and later for Summit and North Fourth Streets and Cleveland Avenue) for vehicular traffic above and railroad traffic below (giving Columbus a much-needed change in topography from its usual flatness).

March 25

At 9:00 a.m. in 1913, Columbus's greatest disaster began when frozen ground and unprecedented rain combined. Earthen levees broke, sending thirty feet of water into Franklinton and west side neighborhoods. Houses were knocked off foundations, and ninety-three lives were lost. The river flooded eleven times before 1913. Yet no one was prepared for this one-hundred-year flood. The east side of Columbus was never in danger, though many residents did panic when someone at the Neil House yelled, "The dam's busted!" James Thurber's short story, "The Day the Dam Broke," was written twenty years after the tragedy. He estimated it would have taken a rise of ninety-five feet of water to flood High Street on the east side. In his imagined story the people fleeing the rumored flood on the east side grew more frantic when someone yelled, "Go east!" The crowd included housewives, dogs, cats, his own mother carrying eggs and bread, office workers, children on skates and a driver who made it as far as Reynoldsburg. According to Thurber biographer Harrison Kinney, the Thurber story was so popular with General William Hode, commanding general of the Fourth Armored Division, that he required his staff to read the story to more fully understand what had happened in the Battle of the Bulge when there were rumors of huge German penetrations where American positions were overrun.

March 26

Ohio State University students, mostly GI students and their families, lived wherever they could find accommodations in 1949—and at River Road Village (near Union Cemetery at Olentangy River Road and Dodridge Avenue), they also formed their own church in a recreation hall. Nonsectarian and nondenominational, the students organized readings each Sunday and hosted different speakers. The Sunday program included the minister of King Avenue Methodist Church, a professor of education from OSU, the African American associate secretary of the OSU YMCA, a member of the Ohio CIO and a speaker from the American Friends Service Committee. Started by a husband and wife (Mormon and Church of England, respectively) with the help of Reverend Milton McLean (hired by OSU as an advisor to religious studies) and the minister of North Congregational Church, the "church" was so popular that other groups donated equipment and florists donated altar flowers. Students solved what to do with more than two hundred children when Protestant families babysat Catholic children during Mass, and Catholic families reciprocated an hour later.

March 27

Jerry Finney, a free African American man and a cook in many Columbus public houses, was kidnapped in 1846. Slave catchers produced documents saying he belonged to Mrs. Bathsheba Long of Frankfort, Kentucky, though he did not know his accusers and had been a resident of Columbus for almost fourteen years. In Kentucky, he was found guilty of being an escaped slave and turned over to Mrs. Long. Citizens in Columbus raised money to buy the freedom of the free man. Finney was returned to his family but with tuberculosis.

Columbus's first skyscraper, the Wyandotte Building, was built in 1898, at 21 West Broad Street. *CLF.*

Secretly, Columbus periodically suffers from "Cleveland Envy," but on this day in 1898, Columbus could be smug. Not only did the city's first skyscraper, the Wyandotte, open, but Columbus had also snagged the famous architect Daniel Burnham, who designed Cleveland's Society for Savings Bank, to do the job. And, to make smugness even "smuggier," Burnham also designed Columbus's third Union Station.

March 28

In 1872, the city's "new" city hall opened amid a large civic outpouring at 31 East State Street. The large Victorian building later burned in 1921, and the Ohio Theater was built on the site. (See January 21.)

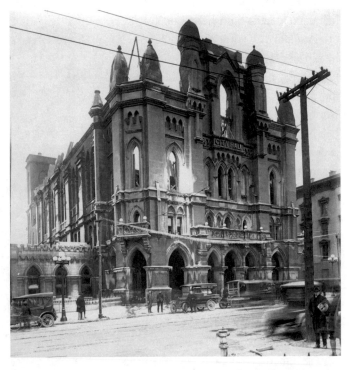

The original Columbus City Hall building (as seen after the fire that destroyed it on January 12, 1921) opened on March 28, 1872, and was located at 31 East State Street. *CML*.

March 29

Volume 1, number 1 of *The Columbus Jewish Chronicle: A Voice for Columbus Jewry*, published March 29, 1918, was an impressive publication of articles and advertisements. The articles dealt with world affairs, Zionism, discussions on anti-Semitism in Russia—and thoughts about kosher butter. An ad in the paper pointed out, "'Purity' Nut Margarine... is a food product that not only answers every requirement of the strictest Jewish Dietary Laws, but is economical as well. Where butter is costing anywhere from 50 to 60 cents a pound, every Jewish housewife will hail with delight the opportunity of using this wonderful product at a saving of almost 25 cents a pound." The Capital City Dairy Company in Columbus, the maker of Purity Nut Margarine, started in 1883 and was the largest manufacturer of margarine (or butterine) in the United States. The building at 525 West First Avenue was enormous and situated close enough to the Olentangy River to be environmentally suspect. When it was demolished in 2004 to make room for the upscale Harrison West urban neighborhood, many older Columbus residents remembered their school field trips to view the workings of butterine. Like a trip through a fun house, students clung to each other and to posts, machines and anything stable in an effort to stay upright on the slick margarine-coated floors.

March 30

In 1859, a courthouse fire caused many records of deeds, land transfers, wills and personal dealings to be lost. The pressure by the public for a new courthouse gained strength.

March 31

After taking a serious look at itself, the Ohio AFL-CIO was astonished at some of the findings of a poll and employed high school students to help solve the problems in 1967. On March 31, 1967, the Ohio AFL-CIO developed a new political strategy, "The Spirit of '67," to develop a computerized list of members. The only problem was it was 1967—not only were computers big as a bathtub and floppy disks came in pizza-box size, but how and who was going to do all the data processing and entry on lists and lists of participating unions? Thirty-four girls from Columbus's Bishop Ready High School worked after school every day from 3:30 p.m. until 7:00 p.m. and on Saturdays from 9:00 a.m. to 5:00 p.m. (Did the girls also receive minimum wage?) The Bishop Ready girls computerized information on 70 percent of the state's union membership by the following January—and the shocking results showed six out of every ten union members were not registered to vote. With John Gilligan's campaign for governor beginning, eighty-five thousand new voters were registered as a result of the data processing, and Gilligan won.

April 1

Old Clintonville disappeared a little more on North High Street near Orchard Lane in 1927 when an old residence and storehouse were demolished to build a new business block. The storehouse was the only business of its kind north of Goodale Street, and longtime resident Elmer Pegg, a pioneer of Clintonville himself, estimated that the building had been there since 1825. And he would have known since it belonged to his family. The brick had been made on site from clay taken from a nearby stream bank. The store had been operated by Mr. Beckley, who also ran the post office. Neighbors volunteered to carry the mail back and forth to Worthington, Dublin, Clintonville, North Columbus and Columbus. The demolition of the building completed previous alterations that had sheared off parts of the façade as High Street was widened. The hitching posts and rail were removed as well. The last business that used the structure was Katherine Corbett's dry goods and notion store.

April 2

In 1849, a crowd of men gathered at Broad and High. They were preparing to head to California to prospect after news of the Gold Rush reached Columbus. Patrick Egan left with them, but he returned home without the fabled riches, sailing out of California to the Isthmus of Panama, crossing it by pack mule train and coming north from the Gulf of Mexico to Columbus. On the way, he helped Ellen Ewing Sherman and her children, wife of future Civil War general William Tecumseh Sherman, to her home in Lancaster. Egan started a livery business in Columbus but soon found his calling: "Funerals on Short Notice. Terms: Cash."

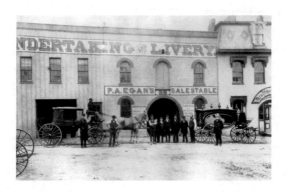

An early photo of the P.A. Egan Undertaking and Livery, located on West Naghten Street. *CML*.

April 3

Ever wondered what is hanging off the back of your house? "Fresh air sleeping apartments" were becoming very popular in 1909. Five hundred houses, many on the East side, had added them, much to the delight of Dr. Probst, the secretary of the state board of health. Sleeping porches were used to ward off tuberculosis, invigorate appetite and overcome "disease germs." Frank Packard, noted Columbus architect, commented, "Not only...tuberculosis but other diseases equally as deadly" would be cured through sleeping porch use. One advocate added, "Virtually the only difference extreme weather makes is in the amount of covering one wears. We greatly resemble Eskimos when we are ready for retiring in zero weather...last winter I slept under a buffalo robe. Now it is entirely too heavy."

April 4

The Columbus Metropolitan Library on Grant Street was dedicated in 1907, made possible by a gift of $200,000 from Pittsburgh-based industrialist Andrew Carnegie. Columbus was one of the last Carnegie-funded libraries, and it is popularly believed that Carnegie was moved to fund one more library after meeting John Pugh, Columbus librarian and Welshman, after they pored over maps of Columbus and its growing population changes. Carnegie agreed to fund a brick library, and though Pugh delightedly reported back to city officials, they asked him to return to Carnegie and ask for a marble library. Instead of labeling Columbus as ingrates, Carnegie was said to be pleased with the request as it showed the importance of learning in the city. The library's site was on a former swamp, known as Frog Heaven, for all the noise of the courting frogs in spring; in 1907, it was a popular courting spot for young (human) lovers.

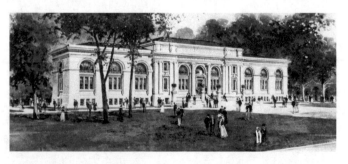

The Carnegie Library became a popular strolling spot for Columbus residents. *CML.*

April 5

New York City's popular and flamboyant mayor Jimmie Walker arrived in Columbus to help dedicate the new expansion of the Deshler-Wallick Hotel in 1927. Walker, never known for turning down a drink, vowed he would have a sip of champagne in every room of the hotel. After toasting hundreds of rooms, Walker sadly could not make good on his promise.

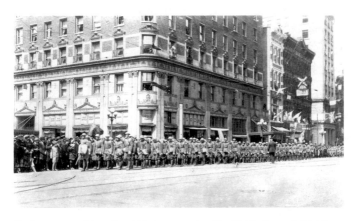

On the corner of Broad and High, a parade of the Thirty-Seventh Division with the newly completed Deshler-Wallick in the background as seen in World War I. *CML.*

April 6

The current Sullivant Hall at OSU was built as the first Ohio Historical Society museum at Fifteenth and North High Streets. A jewel in the building was the memorial bronzes dedicated on April 6, 1926, as Ohio's official memorial to those who served in World War I. In addition to the bronze memorial panels, the statue of *The Victorious Soldier* was unveiled, the work of Bruce Wilder Saville, former member of the Department of Fine Arts at Ohio State and instructor in sculpture at Columbus Art School. When the Ohio Historical Society museum moved in 1970, it also relocated *The Victorious Soldier*—the famous doughboy statue in front of the building was said to wink at virgin coeds (but had never been known to wink in the fifty years he was on duty). Saville employed a returning veteran, architecture student Harold Sands, to help with the castings of *The Victorious Soldier* and memorials. Sands's own World War I helmet was used in the production of the casting of *The Victorious Soldier*.

April 7

It's spring! It's spring! Oh, break out the jump ropes, the chalk and the roller skates! What, you say, no roller skates? In 1908, on order of Chief O'Connor of the Columbus Police Department, children were forbidden to use roller skates on the street. (Oh, man!) This applied especially to the children on Bryden Road and East Broad Street, whose skating was annoying pedestrians. (Wait a minute, weren't the pedestrians on the sidewalks and the kids in the street?) Police were ordered to stop the children.

April 8

In 1926, Sears, Roebuck, and Co., located at 78 South Third Street, widely advertised that Columbus citizens had a chance to save $500 to $2,000 on a complete home with easy payments of $15 to $75 dollars a month. Customers had their choice of three models of bungalows ranging from $962 to $2,395. Prices were amazing, but there was one catch—the customers had to put the house together themselves or contract to have it done. The houses came directly from the Sears, Roebuck, and Co. factory and included lumber, nails and other hardware. It did not come with brick, cement or plaster. Built-ins and upgrades were available, and, oh yes, the ad read, "If you can build the house yourself, you may need a lot." Yes, don't forget to buy the land for the house.

April 9

In 1961, workmen began the demolition of the old Schumacher mansion at 740 East Broad amid reports that it would become the site of a large motel. Art collector, businessman and partner of Samuel Hartman (of Pe-Ru-Na medicine fame), Schumacher, a Danish immigrant who settled in Waco, Texas, had an extraordinary life. His home was filled with artwork that formed the first major collection of the Gallery of Fine Arts (later the Columbus Art Museum). His marriage to Hartman's daughter was not as lucky and ended in divorce. He was credited with being the brains behind an advertising gimmick still used today—the testimonial. For hundreds of children, he is also Santa Claus. (See December 30.)

Fredrick Schumacher's mansion was one of the most spectacular mansions of East Broad Street. *CML.*

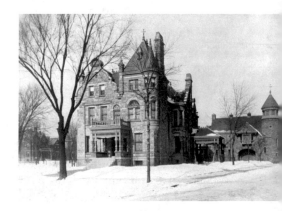

April 10

In 1949, the face of East Broad Street was one week away from abruptly losing a part of the nineteenth century with the removal of two of Columbus's century-old recognizable buildings—both part of the homestead next to St. Joseph's Cathedral on East Broad Street. Known to most people as the home of four Catholic bishops, the buildings were part of the city's change post–World War II. The lots on which they stood were part of the Deshler family's legacy. On one lot, a Deshler generation built a home in the 1840s. Even after the completion of the cathedral, the Deshler children played in an empty lot next to the cathedral and remembered bringing water for circus elephants from a brook that ran behind Memorial Hall (old COSI) and the present Midland Mutual building. Bishop Hartley acquired the lot and houses in 1885, and the clergy moved from across East Broad, where Bishop Sylvester Rosecrans had purchased a home from prominent merchant Joseph Gundersheimer. Deshler descendants often visited Bishop Hartley's residence to admire the exquisite woodwork of the family home. As the new diocesan headquarters was being built in 1949 and the old Deshler home was removed, the diocese temporarily relocated to the home of the other owner, William Sullivant, whose childhood house, the Sullivant mansion at 65 South Sandusky, was the rectory of the Convent of the Good Shepherd—that would be lost with the construction of the Sandusky Street interchange twenty years later.

April 11

On Sandusky Street, one of the last of the log buildings of Franklinton, a fort built for the settlers' refuge against possible attacks by neighboring Native Americans, was dismantled. The cabin was of cherry and walnut, and not a nail was used in its construction. Arrowheads were found between logs, and the logs were carefully saved and numbered. Taken down on this date in 1911, 115 years after it was built, it was hoped the cabin would be reconstructed for a summer home at Buckeye Lake.

April 12

Columbus is often credited with having a "recession-proof" economy, one fueled by the diversity of many institutions of higher learning and small manufacturing, pharmaceuticals and insurance companies. One of the latter was the Farm Bureau Mutual Automobile Insurance Company (now Nationwide Insurance), which was issued a license to operate in 1926 and issued its first policy two days later.

April 13

Columbus native and internationally known magician Howard Thurston died at age sixty-six in 1936. He was interred at a private mausoleum, Green Lawn Abbey at Greenlawn and Harmon Avenues. Though there seem to be several variations on the story of how and why Thurston's family and friends tried to contact him after his death, there is no mystery as to Thurston's accomplishments, popularity and generosity (aside from how he treated his daughter in his will). He is credited with perfecting the tricks of sawing a woman in half and levitating a woman in space. His last performance in Columbus was in 1934, and children were always invited to attend for free. Whether one believes, as his friend Claude Nobel did, that it was possible to meet with Thurston again, it is possible to see him again in a different setting than the Green Lawn mausoleum. In his youth (really as a child), Thurston hustled to help his bankrupt family—as bell hop, railway newspaper seller between Columbus and Pittsburgh, racetrack horse exerciser, tramp worker and (after going to an "evangelist school") sideshow magician. The family originally lived at 207 East Livingston Avenue, and after Thurston returned from England, Denmark and Russia, having made it big, he put his family into a nearly new (built circa 1890s), ornate and spacious apartment (that still stands) on the corner of West State Street and May Avenue in the Franklinton neighborhood. Supposedly, they occupied the tower corner apartment of nine rooms, and Thurston stayed here when he played Columbus. (See March 1.)

April 14

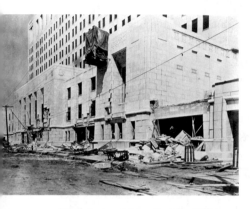

While under construction, the Ohio Departments of State Building on Front Street was damaged by a gas explosion on April 14, 1932. *CML.*

In 1909, many of the most prominent African American men in the country (and presumably their wives) came to Columbus for a banquet at the Dunbar Theater (see January 23) on Mt. Vernon Avenue. Ralph Tyler, auditor of the treasurer for the navy, gave a golden wedding celebration for his parents, Mr. and Mrs. James Tyler, of 1107 Highland Avenue. The guest list included Booker T. Washington of Tuskegee Institute; former Louisiana governor P.B.S. Pinchback; federal judges; and all the original "Taft men," African American politicians who supported President Taft.

Believed at the time to be the work of anarchists, the 1932 explosion that killed seven workers at the Ohio Departments of State Building under construction on Front Street was from a gas leak. The explosion was so forceful the gigantic brass doors on the west side of the building were propelled over the Scioto River and landed on the steps of Central High School (now COSI).

April 15

As if August Wagner's opening of the Gambrinus Brewing Company on the South Side in 1907 was not enough to welcome visitors to the city, an electric "Columbus Welcomes You" sign nearly fifty feet tall—and the first sign to be viewed by visitors arriving in Columbus through Union Station—was created in 1911. The municipal light plant provided the electricity, and the Convention and Publicity Bureau took the credit. Of course, it was not the only improvement in the city. In 1910, the north side of the viaduct had been renovated by removing unsightly freight platforms and dumping grounds in favor of a row of ornate store buildings. Wagner is said to have been the inspiration for the King Gambrinus statue that can still be seen on South Front Street though the brewery is gone.

Electric sign opposite Union Station on High Street greeted Columbus visitors. *CLF.*

April 16

On the site of the old city hall on East State Street, Columbus City Council adopted a resolution granting women the right to vote in municipal elections in 1917. (See June 16.)

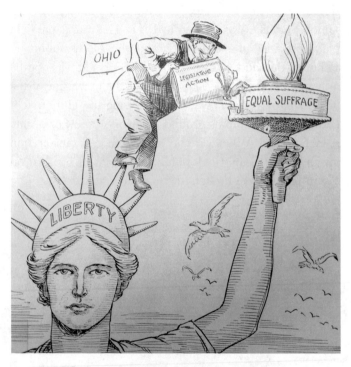

Columbus Evening Dispatch cartoonist Billy Ireland frequently used the issue of women's suffrage, as seen in this cartoon from February 16, 1917. *CML.*

April 17

Jimmy Lloyd Eblin, a thirty-five-year-old worker, was injured during the demolition of the Deshler Hotel at Broad and High in 1970. A bulldozer plunged through a scaffold. The loss of the Deshler Hotel was a turning point in the public's perception on the future of downtown, and it was certainly a break with the past. The northwest corner of Broad and High Streets had been in the Deshler family since the early 1800s. In the walls of the Deshler Hotel, a time capsule with John Deshler's impressions of Columbus in the early twentieth century was found. In it, he spoke of being able to fish in the current of a spring (now Spring Street) when he was a boy. After many years as a vacant lot, One Columbus was built on the site of the former Deshler home and then Deshler Hotel. Within its walls, on the Broad Street side near the entrance to the building, a facsimile of John's letter to the future is imbedded.

April 18

Union Station was not the city's only railroad station. In 1896, orchestra music entertained visitors at 379 West Broad at the newly opened Toledo and Ohio Railroad Station. Designed by noted architect Frank Packard, the railroad station is a Victorian, Shinto-Gothic, pagoda-themed piece of architectural eye candy. Having withstood the 1913 flood (with a water mark inside to show how high the flood waters were) and a variety of uses, the building was restored (and is now occupied) by the Columbus Firefighters Union.

The Toledo and Ohio Railroad Station still remains as one of the most distinctive buildings in Columbus. *CML.*

April 19

On this day in 1918, German textbooks were symbolically burned at Broad and High in protest of the foreign policy actions of Kaiser Wilhelm I. The German language ceased to be used in Columbus public and parochial schools. Fourteen thousand students who were studying the language stopped learning their German grammar and verb declensions. Since the late nineteenth century, four schools in Columbus had taught all subjects exclusively in German, and the Ohio legislature published all Ohio proceedings in both English and German versions. German lobbies in Cincinnati and Columbus had forced the legislature to ensure the German language would remain alive in law proceedings and learning. The book burning was political theater—like renaming frankfurters as hot dogs or sauerkraut as liberty cabbage. Supposed anti-German backlash often was done with the full participation of the younger German American generation, which was thoroughly Americanized by popular culture. Most of Columbus had German roots. City council did its own political theater, changing some street and place names (Washington Park for Schiller Park; Whittier Street for Schiller Street—thereby trading in one poet's name for another), but most of city council was also German American. By the 1920s, Schiller Park resumed its original name by city council ordinance, and the schools were teaching the German language as an elective.

April 20

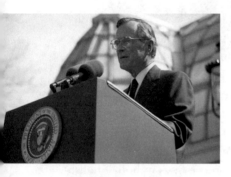

President George H.W. Bush opened Ameriflora '92, an international horticultural exhibition, on the grounds of Franklin Park. Prior to arriving, Air Force One purposely flew over the large crowd before landing at Port Columbus. *CML.*

President George H.W. Bush opened Ameriflora, a $95 million dollar floral-themed exhibition in Franklin Park on East Broad Street in 1992. It was the largest celebration in the United States in conjunction with the 500th anniversary of Christopher Columbus's 1492 voyage to the New World. Mayor Dana "Buck" Rinehart had been the major proponent for the city's hosting since Columbus, Ohio, was the largest city in the United States named for the explorer. The 500th celebration of 1492 was less appealing to the Native American organizations, which protested both the event and the replica of the *Santa Maria* in the Scioto River.

April 21

In 1930, a tragic fire at the Ohio Penitentiary took the lives of 320 prisoners. The fire broke out in New Hall, constructed in 1877. Large and barn-like, the walls were stone, but the roof was wood. After dinner, prisoners in New Hall yelled, "Fire!" but the warden and guards, assuming it was a mattress fire, ordered windows to be broken for ventilation. The fire flared in wooden construction forms coated in petroleum. Though the fire trucks arrived and the warden ordered the cells to be opened, confusion delayed freeing the men who now, in panic, tried to wet themselves down with the meager amounts of water available. Men cried to be shot. Narcissa Gaeta, a prisoner, carried 50 men from the burning cellblocks. Of 262 prisoners in two cellblocks, only 13 survived. A makeshift morgue was set up in the Horticulture Building at the State Fairgrounds. The cause of the fire pointed to three prisoners. Saving up kerosene from the construction site and igniting it with a candle, they planned to escape in the commotion but were back in their cells when the fire started. They were convicted of second-degree murder and sentenced to life in jail. One man hanged himself after being accused, a second man later jumped to his death from an upper-level cell and the third tried to commit suicide several times but was unsuccessful.

April 22

Goodale Park was converted into Camp Jackson, a Civil War training camp for Union volunteers, in 1861. Mr. Goodale, who had dedicated the land to be used as a park, was most likely not amused. Two months later, Camp Chase was opened four miles west of the statehouse. (See June 20 and July 14.)

Civil War soldiers muster out at Camp Jackson in 1861. *CML*.

April 23

With the extension of the city limits to Oakland Park Avenue, Columbus newspapers advertised, "Spring is Here! Now is the time to make your selection of building lots for your home or for investment in beautiful Kenmore Park." Among the amenities for Kenmore, on North Cleveland Avenue in the Linden district (formerly an independent village), were city streetcar lines, stores, boulevard streets and "effective restrictions." Kenmore Park was a "restricted home community," using the code words of the day to signal that only white homeowners were permitted in 1926.

April 24

It would be four exciting days of announcements for the city. On the first day, workmen for the city parks began planting trees along East Broad Street in 1924 as part of the city's beautification plan. East Broad Street had been designed to carry the traffic in the center of the street but also had carriage lanes on either side to accommodate access to the mansions. The street's design had been inspired by William Deshler, who saw beautiful tree-lined streets and carriage lanes on his trip to Havana, Cuba.

April 25

The 1920s were a time of transition for Columbus, and in addition to municipal tree plantings on East Broad Street, the city's service department gave notice that it would be purchasing eight motorized trucks in 1924 for refuse collection. They would replace eighteen horses that died in the city's horse barn as a result of distemper.

April 26

On the third day, the Central Ohio Oil Company in 1924 opened its 20th gas station in Columbus to make it more convenient for local merchants to obtain Peerless high-test gasoline and motor lubricants. By 1931, there were 349 gas stations (under a variety of companies) providing gas for the automobiles of ninety-nine automobile dealers (not counting used car dealers) and 209 automobile service and equipment dealers to replace the parts lost or malfunctioning from the cars sold by the ninety-nine dealers. Already, the front yards of former mansions sported used car lots, and downtown buildings came down for a tiny little filling station.

April 27

And last, in 1924, the Columbus YWCA extended an invitation to every girl in the city to attend its thirty-six-acre Camp Wildwood, located nine miles east of Columbus on Westerville Pike. Since its inception in 1886, the YWCA worked to empower women and eliminate racism. It has housed young women when needed since 1886, provided for emancipated teens not ready to go out into the world alone, housed relocated Japanese women in 1945, signed charters and petitions to support anti-racism, supported the ERA amendment in Ohio and, in 1929 (with a gift from Mary Griswold), was able to establish the YWCA on its present site (that formerly had a tiny little filling station on it).

April 28

It was a hangover day in 1827, one day after the construction started on the feeder canal linking Columbus to the Ohio and Erie Canal. Hundreds of Irish laborers, convicts from the Ohio Penitentiary, the mayor and 999 of his good friends dug an eleven-mile-long, forty-foot-wide, four-foot-deep ditch from Main and Scioto Streets to the canal town of Lockbourne. Well, that day the dignitaries actually just turned over a few ceremonial spades of dirt. The project would take four years to complete, with the first canal boat arriving in Columbus in 1831.

April 29

In 1865, the Lincoln funeral train came into Union Station. Lincoln's casket and another small casket were on board. Willie Lincoln, who died in 1862 at age eleven, was going home to Springfield too. The train had left Cleveland at midnight and arrived at 7:30 a.m. Through the night, people lit fires along the way. Honorary pallbearers accompanied the hearse to the statehouse, where it was placed in the Rotunda. One of the pallbearers was Fernando Cortes Kelton, a wealthy dry goods merchant whose son Oscar had been killed in the war.

Mr. Deshler and Mr. Thurman entered into an agreement with the City of Columbus to purchase the land of the old Stewart's Grove and plan the city's first public park in 1867. When it was in private hands, the land had been used by the German community for celebrations, picnics and target shooting. Part of the land around the park was the so-called Shooting Lots where target practice was held.

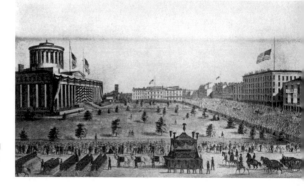

A lithograph of President Lincoln's funeral cortege passing the Ohio Statehouse in 1865. *CML.*

April 30

Columbus was historically not a union town because of an abundance of free labor from the prisoners at the Ohio State Penitentiary. Employers looked for such cheap labor. In only one of many examples, a new glove and mitten factory owned by the A.T. Hallock Company opened in 1899 "outside" the prison. The operation employed sixty women (and children), and with the "other necessary labor" from the factory it owned inside the prison, it produced ten thousand pairs of gloves per day. The leather and linings were cut out and fitted together in the penitentiary, and the sewing was done by women and children outside the plant. Within a few years, however, Hallock's practices were challenged, not by labor unions, but by another company that wanted a similar "sweetheart" deal for its industry. Prison labor was a political plum within the prerogative of the governor.

In this early postcard, a guard stands watch over the west wall of the Ohio Penitentiary. Many businesses that used convict labor sprang up outside the walls of the prison. *CLF.*

May 1

Columbus was included on the first and only American tour of Italian tenor Enrico Caruso in 1908. Unlike Isadora Duncan, who appeared in Columbus the following year (see October 29), he loved Memorial Hall and the reception he received in Columbus. By 1908, a sizeable Italian community had settled in Columbus to work in the marble quarries and/or truck farm in the outskirts of the city. Many were from the same towns in Sicily, met him at Union Station and, with great honor, escorted him to Memorial Hall, where four thousand fans waited. Caruso's death in 1921 was marked by many Columbus merchants and businessmen, who displayed his draped picture in their store windows.

May 2

In 1978, an exclusive downtown club for the "young set" opened in a 126-year-old brick home at 473 East Rich Street. Twenty-six-year-old Donald Dick was hoping to create a private club for "young professionals." (Note that the term was used then, and those young professionals are now in their youngish seventies.) He was inspired by a trip to New York and visits to Maxwell Plum's and 21 Club, and the target audience for his venture would be "young people who don't like the stuffy atmospheres of the other clubs." Not a stranger to business, he was part owner of the Beck Tavern, and his father owned Dick's Fish Market at 254 South Fourth Street. He named his business 473 Rich Street.

May 3

It was the best of times and the worst of times—actually just the worst of times. There was a severe economic downtown in 1899 and smallpox in the Badlands. The "well-fed and tenderly nurtured hobos at Haig's mission held an indignation meeting and resolved…that they turn themselves loose upon the unsuspecting public." Over one hundred men had been exposed to smallpox and were held in quarantine in the mission at Third Street north of Long Street. Additional smallpox cases were in the cheap sleeping rooms next to a saloon owned by a man named Dowling. The men had been treated well at the mission, but they were restless and planned to escape. Public health officials and police were ready. When the mission door flew open, police outside readied their shotguns. The men rushed back inside, preferring quarantine to shotguns. It was decided the men in Dowling's saloon should be moved into the mission too. While the "tenderly-nurtured hobos" (as the newspaper described them) were ordered to bed, the transfer of the new men from the saloon began. "They did not propose to leave a place where there was a barrel of whiskey for a place where the hottest drink to be had was coffee." The police started to batter down the door until the saloonkeeper relented and opened it with a key. There were no further reported cases of smallpox.

May 4

In 1970, only hours after the Kent State shootings in which four students were killed in demonstrations, one thousand student protesters (the so-called hippies with long hair, armbands and "colorful costumes") invaded the OSU's Army ROTC awards ceremony on the intramural playing fields north of King Avenue at 5:00 p.m. Sitting in the field between the decorated rows, the protestors faced Ohio National Guard troops armed with rifles and bayonets at 5:15 p.m. Then a demonstrator took a bullhorn, persuading the one thousand anti-war protestors not to disrupt. The reviewing stand of officers, American Legionnaires and Daughters of the American Revolution waited. When the military band began a stirring march, the demonstrators danced between the ROTC rows and marched behind the ranks of cadets.

May 5

The new Mills buffet restaurant opened at 77 South High, complete with a soda fountain, an oyster bar and a charcoal grill in 1926. The interior was decorated with murals depicting Ohio history, appropriate for being across from the statehouse, and with wholesome and modestly priced food. It was popular for decades. James Thurber, as an accomplished and widely recognized New York author in his hometown, took his mother and brother there for lunch on a hot and humid summer day in the 1940s at her request. Having walked blocks from her residence at the Southern Hotel, she was probably not in a mood to wait in a long line (but she was also the theatrical heart and wit of the family). Just inside the door, she collapsed. Patrons rose from their tables to assist the fragile elderly woman while her sons hovered over her, unaware of her plan. She opened one eye and whispered, "Quick, grab a table."

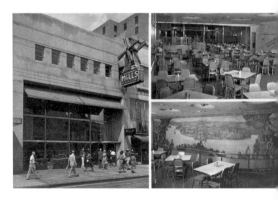

Mills Restaurant, at 77 South High Street, was a very popular eatery for decades. *CLF.*

May 6

When Columbus reached a population of more than seven hundred, a local government could begin. Nine councilmen, elected directly by the voters, were to elect the mayor, recorder and treasurer. The mayor served as ex-officio president of the council. The first election took place in a tavern, the Columbus Inn, in 1831.

May 7

The courts in Columbus were intent in breaking up the rabble that hung around the canal known as "the Bowery" in 1897. The police arrested John Stout for being drunk and breaking eight panes of glass at Mary Powell's house. He was fined five dollars. A raid on Mary Powell's house ended with her being charged a "common character." John Long was charged with loitering with the woman; Charles Taylor was charged with breaking into the house of Samuel Bogardus, stealing a suit of clothes from him. He was fined fifty dollars. Six other men were charged with loitering, and one was placed in city prison on the charge of riding a bike without a light. Ollie Sidener, alias Jack the Ripper, alias Mary Smith, was charged with being a common character. Poundmaster John Landes arrested John Bachler on the charge of interfering in the performance of his duties. The officer stated that he was placing some cattle in a pound when they were taken away from him. During the trial, when Bachler was asked if he had any cows, he promptly replied, "No…but I have got a wife." That case was postponed until the next day. By 1901, the Old Bowery passed into oblivion, a victim of do-gooders and missionaries and demolition of the infamous Morehead Saloon. Gone were the "head bangings" (the thrashings the drunks gave each other), the murders and the Bowery dance that drew the sightseers (at no small risk to themselves).

May 8

It is tantalizing to think what ending the writer O'Henry might have given this story since he too penned short stories in Columbus when he was a guest of the state (in the Ohio Penitentiary). When Amelia Earhart visited Columbus in November 1928 to participate in the opening of the Community Fund Drive, a story of her flight across the Atlantic Ocean was appearing serially in a monthly magazine. Earhart wrote one installment while in Columbus and put it in an envelope with twenty cents postage, intending to mail it to the editor, but she lost it on the way to the post office. Nothing was learned of the manuscript until 1929 when Zemora Bradley, of 330 Wyandotte Avenue, informed newspapers she had it but didn't know what it was. She found the envelope when she took over a foreclosed house that had been a rooming house. Written in pencil on the back of the envelope were personal notes. One was from the landlady of the rooming house to a roomer who had found the missing manuscript and had left it in his room. The note read, "Your rent is due November 24, two weeks in advance." The reply was, "Wednesday is my payday. Will you please be so kind and wait until then?" The rent was not paid, and the landlady took over his personal belongings. The Earhart manuscript was among them.

May 9

Eight arrests were made on Sunday, May 9, 1910, for a violation of the Sunday closing law and one for violating the "screen" ordinance. In one case, the chief of police, learning that the saloon of Mrs. Lehner, south of the Hocking Valley tracks on South High Street, was open, sent nine detectives to raid the place. When they arrived, the bartender, John Webber, thinking they were customers, asked what they would have. The police placed Webber and Mrs. Lehner under arrest and took them to the city prison. In another case, two officers investigated John Marcino, "saloonist" at Third and Chestnut Street, found the place was closed, but as the screens were not properly arranged (screens to hide the open door of a saloon from passersby) they arrested him for violating the screen ordinance. It was a typical May Sunday afternoon in Columbus. By Monday morning, the city had collected $100 in fines.

May 10

A huge dust storm was spotted moving into the Midwest in 1934. The storm winds whipped up a formless, light-brown fog that spread over an area 1,500 miles long, 900 miles across and 2 miles high, covering almost one-third of the country. By the next day, an estimated twelve million tons of soil fell on Chicago, and dust darkened the skies over Columbus and Cleveland. By May 12, the dust hung like a shadow over the entire eastern seaboard. The Great Dust Bowl had arrived.

May 11

The first meeting of the Ohio Agricultural and Mechanical College was held in the office of Governor Rutherford B. Hayes in 1870. The stage was set for a future Ohio State with the establishment of the Land Grant Act, signed by President Abraham Lincoln on July 2, 1862. Presumably, the meeting did not discuss football since there was no official team until 1890. After looking at many sites for the location of the new college, the trustees finalized their decision to buy William Neil's 331 acres for $117,508, based (supposedly) on the sweet artesian spring waters of Mirror Lake. After tasting the water, one German trustee exclaimed, "It's hard to get a Dutchman away from a spring like that." Columbus residents came from miles to bring water home, but unfortunately, in 1891 while installing a sewer trunk line through the campus, the city struck the source of the spring, and in a day or two, it was dry—remaining so for over one hundred years. (See February 8.)

May 12

In 1968, a familiar Columbus landmark was doomed. The old Franklin Brewery building at 625 Cleveland Avenue was coming down as part of the $9 million dollar expansion of the Moores & Ross Dietetic and Ross Laboratories operation (now Abbott Labs). For over forty years, the Franklin Brewery building played a role in Ross Labs. Started in 1903 when brothers-in-law Henry C. Moore and Stanley M. Ross joined to form the Moores & Ross Milk Company, Ross was a small direct-to-consumer dairy based at 429 East Long Street, but Moore's dairy farm was originally in Briggsdale. The name became Moores & Ross Milk & Ice Cream Company and introduced changes in milk handling (first to use bottles instead of pails), processing and delivery (like the "stand and drive" truck). When it produced a milk-based infant formula, the picture on the label was Richard M. Ross as a baby, and in World War II, the company supplied both the army and the navy with a palatable dry milk product, though enlisted men might have preferred what the old Franklin Brewery had produced. The family name "Ross" is associated with generous bequests to Columbus Museum of Art and the Ross Gallery in Delaware.

May 13

Under the jurisdiction of Columbus City Council, the Hare Orphanage on Tuller Street north of Lane Avenue provided shelter and care for children who did not have parents (the building is still there). Hannah Neil, wife of the "stage coach king" and Neil House owner William, also took in orphans or children whose parents could not care for them in a former mansion on East Main (also still there). Hannah Neil recorded an incident in which a recently widowed man brought his five children and the family cow to her. He could not take care of the very young children while trying to work, but he had brought his only asset, the cow, to help feed them. In 1859, twenty-eight children lived at the Hare Orphanage, ranging in age from infants to teenagers.

May 14

Heyl School students used recess time to work their large open garden in a lot opposite the school in 1917. Growing fresh vegetables in World War I was as much a patriotic act as the victory gardens in World War II. School gardens remained popular through the 1920s and 1930s. In 1929, seven hundred students in Columbus schools who maintained school gardens throughout the summer were given more than $1,000 in cash prizes through the generosity of the H.C. Godman Shoe Company.

May 15

Following a tradition of many years, several children of the Ohio Avenue Day Nursery, 162 North Ohio Avenue, made their annual pilgrimage to the Columbus Urban League for a May Day celebration in 1952. The children, dressed in proper starched white summer clothing with bows and shiny shoes, presented flowers to Nimrod Allen, executive secretary of the Urban League at its headquarters.

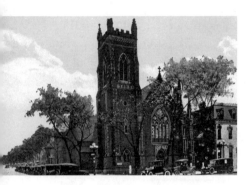

Trinity Episcopal Church on the corner of East Broad and Third Streets was the site of Columbus's most famous wedding. *CML.*

Prince Ernst Manderup Alexander zu Lynar of Prussia and May Amelia Parsons in 1871 were married at Trinity Episcopal Church in possibly the only royal wedding ever performed in Columbus. With the wedding on a Tuesday at noon, even schoolgirls passing by came to watch (or eye the Imperial German legation with the prince). The couple met in Paris at the court of the French emperor Louis Napoleon while May was on a tour of Europe. May's father, George McClelland Parsons, was a millionaire and state legislator. The prince was an attaché to the Kaiser Wilhelm, who bestowed a title on May as a wedding gift to the couple. George Parsons insisted the wedding be performed in Columbus, and the prince took time while here to dedicate an oak tree in Schiller Park, the Peace Oak, marking the end of the Franco-Prussian War. The family made international headlines again after World War I. (See December 18.)

May 17

Death stalked the clouds above the Linden community in 1927. Two pursuit planes collided, killing the occupant of one plane and sending the other to parachute from his burning plane. One plane crashed into the rear of 2762 Beulah Road, landing between the house and the garage. The airmen were part of a "mimic aerial warfare," practicing responses if their army depot was attacked. The crash was witnessed by hundreds of spectators throughout the city.

May 18

Johnny Jones, popular columnist for the *Columbus Dispatch*, reported in 1958 that Dale Cornell and his wife, Alice, were marking a tragedy. They lived on the original 1812 land of her ancestor, William Armstrong, who was operating a gristmill when a son came running to tell him Indians were attacking the cabin in Blacklick. The mother tried to escape up the chimney, the children ran to the attic and one son escaped from a hole in the roof. The mother and younger children were killed; two boys and a girl were taken captive. Armstrong spent years searching for the children, but when he found his two sons, they refused to leave their Indian parents and had to be taken by force. The girl was never found. Armstrong remarried; the two boys eventually left home. Years later, a letter and a large wooden carved marker with a log cabin arrived. The two boys sent the marker to remember the tragedy, but nothing further was known. In 1958, the marker was dedicated.

However, in the 1850s, a similar story was recorded in Martin's *History of Franklin County*. Jeremiah Armstrong, a Columbus city council member, told his childhood account. It is essentially the same story, with the murder of small children, the death of the mother who tried to escape through the chimney, a relative going through the roof and the capture of three children. However, the timeline of events, the location of the incident and the endings are completely different.

May 19

In the Village of Minerva Park, east of Westerville Road and between Morse and Dublin Granville Roads, the Columbus Railway Company created the Minerva Amusement Park in 1895, named for the wife of the president of the railway, Minerva Shepard. The park opened on May 15 or 19 (accounts differ, and May 15 may have been "a soft opening") and was 150 acres of wooded land with a lake and buildings that supported various athletic events and dancing. Swan boats crossed the lake and real animals— monkeys, bears and deer—formed a small zoo. The casino was built to hold 2,500 people, larger than any downtown venue, for vaudeville and musical performances. But the park's success was short-lived: accessible largely only by railway, the trip from downtown Columbus took about forty minutes and other amusement parks were closer. When the park closed, Charles Johnson, developer, laid out lots and built homes for "Columbus's most beautiful suburb" in 1926. Johnson often worked in partnerships, and together Johnson and Pavey built many of the "suburbs," each described as THE most beautiful—Berwick, Indianola Heights, Driving Park, Hilltop and elsewhere. However, because many of the park's trees were left and the lake was officially acquired in 1954, it may well be that this is the most beautiful suburb Johnson created.

May 20

In 1959, there was criticism about how state legislators spent their free time. The entertainments were rumored to be "too ugly to repeat," and it was already known that in this pre-Watergate-anything-goes era, lobbyists routinely provided free food and unlimited drink for legislators and played poker (and lost purposely). A sting operation by Columbus police vice squad arrested a prostitute who claimed to specialize in state legislators, patriotically giving special rates of thirty dollars instead of fifty. No wonder, decades earlier, Florence Harding accompanied her husband, Warren, to Columbus, and even though they lived together at the Great Southern (Westin) Hotel when the legislature was in session, and she accompanied him to the legislature and social events, Warren still managed to cut out of smoke-filled poker games for unmentionable dalliances with Columbus's demimonde women. Not publicized then and certainly not well publicized even today were the antics of Wisconsin senator Joe McCarthy, who came to town (prior to his fame routing out Communists, he was an influential head of postwar housing funding) with lists of what he wanted when he stayed at the Deshler Hotel: liquor, poker buddies and prostitutes.

May 21

In an 1897 version of a soap opera, Peter Hayden II, whose family fortunes had been established by his grandfather industrialist Peter Hayden, and his father, William Hayden, filed for divorce from his wife, Mary Ayers Hayden, and for custody of their only child, Hamilton. The grounds were his wife's adultery. The scandal of the rich and famous was sensational because Mary freely admitted she had committed adultery with Raymond Jones on May 3, 1897, at the Hayden residence on Lexington Avenue. (An admission, how refreshing.) The name Hayden was well known in Columbus. Grandfather Peter and son William owned a company town, Haydenville in southern Ohio, and the Hayden family was involved in iron, saddle hardware, banking, home building and loans and the manufacture of cement blocks and cement mixers. What may be unusual was not that the young mother took up with a lover but that after the divorce, Raymond Jones was listed as living at his mother's house at 813 Park Street with a twenty-two-year-old sister, a thirty-one-year-old brother, a twenty-four-year-old "daughter" named Mary (oh, sure) and a six-year-old boarder named Hamilton Hayden. Three years later, Raymond, who still lived on Park Street, was ordered to turn his "stepson" over to Peter Hayden, but he defied the court and said the boy had disappeared. There was no recorded marriage of Mary Ayers Hayden and Raymond Jones, and Mary disappeared. In a twist worthy of *Madame Bovary* or *Anna Karenina* (rather soap opera–like but with great costumes), Raymond committed suicide. Mary apparently had no regrets.

May 22

In 1933, a planning committee of the city announced there were slums near the new Civic Center (had they never seen them before?) in an area bounded by Town Street, High Street, Fulton Street and Canal Street. The area, in addition to six others, was being surveyed to "justify the construction of modern housing structures." The city engineer said it was worse than "Flytown"—341 of 476 dwellings did not have bathrooms, 500 families shared 296 outdoor toilets and 167 households used their backyards for rubbish heaps.

May 23

Green Lawn Cemetery, two miles south of Broad and High Streets, was created by an act of the Ohio legislature in 1848. The first purchase of land was made, and on this date in 1849, a "public Pic Nic" was held on the ground, one in which the picnickers were expected to work to help clear off ground in preparation for the design. Lots and avenues were laid out in July by Howard Daniels, an engineer and landscape architect, following the principles of the Cemetery Beautiful movement. Irregularity or variety was one of the objectives of the movement, in keeping with the most natural-looking landscape, "strip(ping) the place of half its gloom," a not-so-veiled reference to the Old North Graveyard, and creating a restful place of contemplation for the living to visit. By January 1858, there had been 1,079 burials, of which 247 were removals from other burying grounds.

May 24

At West Dodridge and North High Streets, a new Turkey Hill convenience store was built in the last few years. Ironically named, the store sits exactly on the site of the David Beers 1804 log cabin (moved to another location in the early 1900s) where, from his yard, he routinely hunted bears and once trapped twenty-four wild turkeys in a single day.

An early picture of the Beers cabin in its original location on North High Street before being moved. *CML.*

May 25

Modern Columbus was on display in 1954 (just one year before Elvis would arrive in Columbus!). The new electrical living exposition of Lincoln Village, just ten minutes from the new Westinghouse Plant and Ternstedt Division of General Motors, opened. The growth of the west side was fueled by affordable homes and ready jobs for working families, though the Columbus Home Builders Association warned of a threat to the peak summer building construction season because of a shortage of FHA inspectors. Over seven hundred applications for building plans per month were being turned in.

May 26

Paupers in Columbus were moved to a new location on Poor House Lane in 1840. Nine years earlier, the Ohio legislature had authorized the establishment of poor houses, and Franklin County purchased a farm near the Whetstone River, three miles north of the city from Robert King. The much-respected Dr. William Awl occupied part of the building, and the superintendent worked the farm for a salary. However, it was decided the location (near the present-day intersection of King Avenue and Olentangy River Road) had to be changed, "it being too far from Columbus, from whence more than three-fourths of the paupers were sent, and it was both inconvenient and expensive, conveying sick and infirm persons to it; and sometimes in seasons of high water, it was inaccessible, there being no bridge." (Shouldn't that have been obvious?) Five acres was purchased on the South side, a new building erected and the paupers were moved in 1840. One of the inmates, Mary Sours, ninety-three years of age, made the trip and lived another eight years before "she sank with old age. Til like a clock, worn out with eating time, the weary wheels of life at length stood still." By 1850, the term "poor house" was replaced by "county infirmary," and six more acres were added (including the Beck Street School site). The poor were expected to tend the potato fields. To give some perspective, in 1856, 160 paupers had been admitted, and the majority were women and children.

May 27

The only former living president of the United States in 1919, William Howard Taft, visited Columbus to promote the League to Enforce Peace. The organization was established in 1915 to promote the formation of an international body for world peace by citizens who were concerned about the outbreak of war in Europe. The former president arrived at Union Station to participate in a meeting at Memorial Hall. A dinner was held in his honor at the Deshler Hotel later that evening, and twenty women of the Franklin County Suffrage Organization attended. Suffrage leader Dr. Anna Hall and Harvard University president Abbot Lawrence Lowell joined Taft for the meeting that followed dinner.

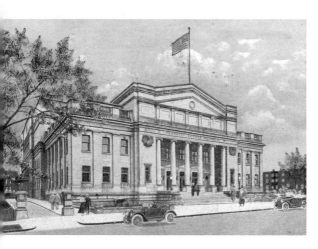

An early view of Memorial Hall on East Broad Street. COSI was located here from 1964 until 1999 when it moved to the former Central High School. *CML.*

May 28

Rock band Pink Floyd ruled Ohio Stadium in 1988 as more than sixty-four thousand fans attended the concert. The number of people overwhelmed the organizers as long lines wrapped the stadium and beyond. The concert began before one thousand ticketholders could even get into the stadium, still waiting to be searched by security at the gate for alcohol, drugs and tape recorders. Despite dealing with the challenges of sixty-four thousand people and many who waited hours for admittance, Ohio State University police were pleasantly surprised that there were no serious incidents. Magically, twenty minutes after the show ended, the stadium was empty, with the exception of workers cleaning up. Oh, if only the football games could be so orderly.

May 29

Columbus was the site of a rare moment in campaign history in 1980 as both candidates for president of the United States ended up in the same place, at the same time, on the same day. Incumbent Jimmy Carter and former California governor Ronald Reagan held dueling rallies. President Jimmy Carter spoke at Nationwide Plaza to thousands, thanking Ohioans for helping nominate him in 1976 and hoping they would help to reelect him. At the Ohio Statehouse, Ronald Reagan told an equally large crowd that he should be elected, citing Carter's failures with inflation, unemployment and defense policy.

May 30

A new plant, Steward and Silver Company, 525 East Hudson Street, created a new building product, celocrete blocks, in 1942. The company produced seven thousand blocks in an eight-hour day. Celocrete, a strong but lightweight building block produced from the slag of steel furnaces, had good insulating properties and was fire resistant. The block could be painted or stuccoed, was resistant to rodents and vermin and was bulletproof (what an odd claim!). Two noted buildings made of celocrete in 1942 were the offices and warehouse of the Livingstone Seed Company on Kinnear Road and the modernistic Al Haft "hotel" on East Main. Haft was a noted boxing and wrestling promoter who held court in the present-day Elevator Bar and in the Short North at Haft's Half Acre.

May 31

In 1859, the following incident happened on this date in a Columbus courtroom: a German came to a Columbus judge to take his final oath of naturalization. His honor asked the usual questions—if he was attached to the government of the United States, and would he make a good citizen. The witness hemmed and hawed and scratched his head, not understanding the questions…he hesitatingly replied that he didn't know, he supposed he would, and added, his face brightening up, "I'm pretty sure of it. I voted last October." His honor's bland smile changed into something very like a frown, and he suggested that the man's voting before he was naturalized was a poor way to show his qualifications to become a good citizen. The witness was a little taken aback at this but found the courage to reply: "Well, your honor ought not to complain. I voted for you."

June 1

Standard Oil of Ohio opened its first drive-in gas station in Ohio in 1912 at Oak and Young Street. The first automobiles in Columbus were owned by the wealthy, who babied their new toys, housing them for the winter in heated structures or storing them on upper floors of their own garages with the help of hydraulic lifts.

Families sometimes let a teenage son take the wheel—with unexpected results. In one incident, a young driver zipped down East Broad Street, dodging streetcars and horses, making quick left- and right-hand turns, and eventually losing control of the auto into a new plate glass window of the Lazarus Department store. He was not seriously hurt, but the auto was. Since autos were new and accidents even newer, the crowd that gathered did not disperse nor did Lazarus have the auto immediately removed. Instead, the store put a sign on the vehicle that read, "Everything new comes to Lazarus first."

In 1926, the new Crittenton Home at 1166 East Main Street opened, having been established in 1904 on East Broad Street. The Florence Crittenton Association was founded by Charles Crittenton, a wealthy New Yorker, in memory of his daughter, Florence, who died of scarlet fever at age four. Crittenton traveled the country by railroad car, stopping at any town or city to give $500 seed money to start a home for "fallen girls or unwed mothers."

June 2

In 1918 during World War I, work began on what would become the nation's largest federal supply depot, the Defense Construction Supply Center (DCSC). During World War II, it housed German prisoners of war. (See January 14.) After World War II, it was a second-tier Soviet nuclear target in the Cold War.

In a 1955 banquet at the now-gone Neil House, across from the statehouse, the Columbus Bar Association honored forty-seven members who had actively served for more than fifty years. The room was filled with luminaries, like Carrington T. Marshall, former Ohio chief justice and a presiding judge at the Nuremberg war crime trials. Many poked fun at their own profession. One speaker talked about a lawyer who came to court with a "snoot full" of alcohol in the morning and twice as much in the afternoon. Unabashed, he looked at the judge and said, "Your honor, if you think you're sober enough to continue now, I'm ready." Ohio native Clarence Darrow came to Columbus to take his bar exam but had little money for lodging. He figured he could drink and talk law through the night at the Neil House bar. However, when a bar companion and Darrow had too much to stay awake, Darrow accepted the invitation to sleep on the floor of his room. In the morning, Darrow's host was gone; Darrow arrived for his exam only to find his drinking companion was the examiner. He passed Darrow without even asking one question.

June 3

Red Bird Stadium, later Cooper Stadium, was dedicated on West Mound in 1932 to house the St. Louis top minor league team. The popularity of baseball was ensured for generations by a collaborative effort of the city, the school system and communities like the Hilltop—all working to support athletics in the lives of Columbus children. (See August 11.)

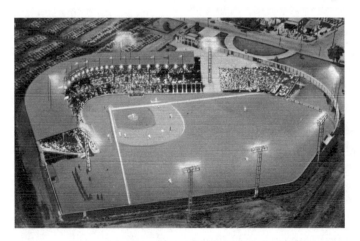

Since completion in 1932, the ballpark on 1155 West Mound Street has been home to the Red Birds, the Jets and the Columbus Clippers. *CML*

June 4

Demolition began in 1988 on the short-lived but captivating Christopher Inn on East Broad near the Memorial Hall. The hotel was Columbus's first and only circular glass high-rise in the 1960s, designed by Karlsburger and Sons, specifically by architect Leon Ransom. When the hotel was in the process of being dismantled, the exterior walls came down first and it appeared to be the residence of the futuristic cartoon character George Jetson, who could have flown right into his sky-high home.

The Christopher Inn was a unique addition to the Columbus skyline. It opened on July 29, 1963. *CLF.*

June 5

Columbus hosted the 1852 North American Saengerbund song festival. While this might sound quaint (and also old-fashioned), all German communities had fiercely (ok, how "fierce" could a singing society have been...let's make that "highly regarded") competitive singing contests. Columbus would have drawn singing groups from all over North America—as far west as the Great Plains, Chicago and Milwaukee; as far south as St. Louis; and as far east as New York. Columbus had large singing societies of its own— Germania, the Maennerchor, the Leidenkrantz and the Swiss Club. To host such an event, facilities needed to be enlarged to hold the competitions—in addition to brewing more beer and stuffing more sausages.

June 6

Prior to World War I, Columbus was a huge convention city with numerous downtown hotels and 125 daily trains coming to and departing the city. Columbus was, after all, situated within a radius of five hundred miles and seventy-five million potential customers. An event in 1914 was aimed at the traveling salesmen to help sell the city. Booths showcasing products, specifically home products, available from local businesses ringed the north side of East Broad Street. The United Commercial Travelers (UCT) organization, based in Columbus, organized the event, which included a vaudeville show, a smoker and a buffet lunch offered to the "knights of the grip," a slang term for traveling salesmen who carried their wares in their luggage. The events were held at Rankin Hall (now the Diamond Exchange building on West Gay Street). Traveling salesmen, by 1914, had acquired a dubious reputation and were often, according to UCT, an underappreciated lot. They would feel more appreciated after being treated royally with assorted sandwiches, doughnuts, coffee, homemade buttermilk and Columbus-made "stogies."

June 7

Columbus became the home to the American Rose Society with the dedication of the Park of Roses in 1953 by then state auditor James Rhodes, who, when he was mayor, helped to make the vision of the park become reality. The Park of Roses was separate from Whetstone Park, which had been purchased by the city in 1944 from the E.A. Fuller heirs.

A foldout brochure detailing the history, location and description of the Park of Roses, located inside Whetstone Park. *CML.*

June 8

On June 8, 1893, royalty visited Columbus when the Duke of Veragua, Spain, and his family visited the largest city in the United States to be named after their distinguished ancestor. Mayor Karb offered a gold key to the city that unlocked a richly decorated box holding an American flag and a photo of the duke inside, and Governor McKinley extended his hospitality. In a most unusual welcome, the duke and his family were received into the homes of three of Columbus's most well-to-do families—the Chittendens, the Waites and the Joyces—all on the same day. (See April 20.)

June 9

With the come-and-go of the Civil War already doubling the size of the state capital, Columbus was no longer a city that was easily crossed by foot in a stroll. In 1863, the Columbus Street Railroad Company placed the first horse-drawn streetcar into operation.

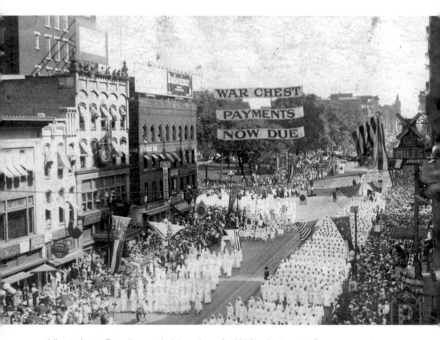

Liberty Loan Parade was held on June 9, 1918, with twenty-five thousand marchers, some carrying large flags. A total of $749.43 was collected from the spectators for the war effort. *CML*.

June 10

Nationally recognized political cartoonist Billy Ireland began his first "Passing Show" cartoon, the first-ever full-page cartoon that reported on the events of the city each week with a gentle sense of humor but much civic pride, in 1908 for the *Columbus Evening Dispatch*. Ireland drew over eight hundred cartoons, worked exclusively for the *Dispatch* and mentored cartoonist Dudley Fisher. Today, the Billy Ireland Cartoon Library at Ohio State recognizes the cartoon, especially the editorial cartoon, as an important component of media and journalism, and the library, while collecting extensively, also focuses on Milton Caniff, creator of "Steve Canyon" and "Terry and the Pirates." Caniff was also mentored by Billy Ireland, and when Caniff lost his job in the Depression and was considering acting, Ireland wrote him, "Stick to your ink pots, kid; actors don't eat regularly."

June 11

The Foreign Grocery Company on 1926 Parsons Avenue, owned by William Trautman and his son Edward and brothers John Gaal and Alex Gaal, was one of the largest retail businesses in Columbus. The *Columbus Evening Dispatch* reported that, for the curiosity seeker in 1917 Columbus, this was the place to meet "foreign" people and hear foreign languages—thousands of Hungarians, Croatians, Slavs (Poles and Russians) and "Hetzgovinans and other races." Alex Gaal knew seven languages, some clerks knew four or more and everyone knew at least two, not counting English. It was noted that when "housewives of 10 races, whose husbands are working in the mills, want to gossip, they don't do it over the back fence, they go to the grocery store." The business, started in 1906 by William Trautman, a wax-mustached genius with an ear for languages, was conceived to be just a small niche business, but it outgrew two earlier locations, doing $250,000 a year. Trautman was well known enough that he was asked by the Swedish consul in Cleveland to take personal responsibility for the Austro-Hungarians stranded and living in Sweden (the Hapsburg Empire having failed in World War I). Often, postal letters addressed to foreign-sounding names with no address found their way to the Foreign Grocery, which tracked down the recipient. Clerks ate at the store, having their own cook, and sold paprika for cooking or steamship tickets for a return visit home.

June 12

One of Columbus's oldest businesses, Columbus Coal and Limestone, was established in 1888. Coal first came to Columbus from Nelsonville in 1829, and it influenced the economic growth of the city. The Hocking Coal and Iron Company was the largest company in town and, in 1887, employed three thousand of the ten thousand men at work in the mines in Southern Ohio. There were more than fifty coal dealers in Columbus in the 1880s, and 4.5 million tons of coal was shipped through Columbus on an average year. About 90 percent of it was destined for other locations, and Columbus grew rich on the trade.

June 13

Columbus was overly excited (Columbus is always overly excited when something new comes) in 1901. The interurban cars had come to Columbus, and the first line (painted royal blue) linked Grove City to Columbus. While there were no special activities planned to open the line, the board of trade anticipated "fresh and dew-covered" farmers' produce. Passengers could ride to amusement parks or connect to other cities. Families could go to the country to escape summer's heat; country folk would come to town for shopping and big doings. A new interurban depot on West Gay Street was planned, but only one problem remained. The gauge of one company's track was five feet, two inches, while the gauge of another's track was five and a half inches less. Details, details, details. It had to work out—Columbus already proclaimed itself "The Great Interurban Center!"

June 14

Columbus's most well-publicized murder and "trial of the century" began with the discovery of a coed's body by the New York Central Rifle Range near the quarries on McKinley Avenue by two boys walking through the area in 1929. (Notice how we are cleverly, or annoyingly, telling this story in serial excerpts.) Her roommates identified the body as Theora Hix, who had said she was going out on a date. The next day, the soon-to-be-confessed murderer, Dr. Snook, arrived at their "love nest" at 24 West Hubbard to cancel the lease that he and "his wife" had taken. Within twenty-four hours, police focused on Snook.

June 15

Demolition began on the city's oldest market, Central Market, and first city hall in 1966 on South Fourth Street. The building had survived more than a century of wind, rain, squawking chickens, hordes of large families buying larger sacks of potatoes and political storms in its upstairs city hall. It was a timbered structure that, for many, had outlived its usefulness and for others was more confirmation that the city was shedding its history in favor of federal funds for urban renewal. The market was 150 years old. For six generations, this site had served the city folk and the country folk. Central Market created the commercial growth between Fulton and Town Streets with banks, farmers' hotels, small restaurants and Jewish shops filled with dishes, kitchenware and shoes. Could the Holiday Inn already being built behind it do that?

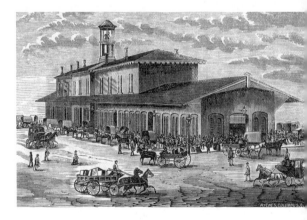

An early drawing of Central Market, the site of the first Columbus City Hall. *CML.*

June 16

Always ready to jump on a bandwagon, Ohio ratified the Nineteenth Amendment to the United States Constitution extending the right of suffrage to women in 1919 at the Ohio Statehouse. Previously, the state had turned away petitions to extend suffrage and ignored the largest march (of its time) to the statehouse when over five thousand women demanded the right to vote. (See April 16.)

June 17

President Harry Truman made a twenty-nine-minute stopover in Columbus in 1948. Viewed as the underdog to his opponent, Governor Thomas Dewey in New York, Truman won later that year, crediting his short whistle-stops from the back of his train as the way he connected to voters and solidified their confidence in him.

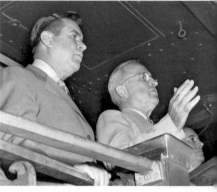

President Truman (pictured with Republican mayor James Rhodes) made a twenty-nine-minute campaign stop in 1948. *CML.*

In 1953, an investigation was underway by the Committee on Un-American Activities in hearing room 2 of the State Office Building on South Front Street. The committee called witnesses, many of whom were associated with Ohio State University, to find out the extent to which the Kremlin had reached into Columbus. A professor of journalism, who lived at 82 West Dominion Boulevard; a secretary in the Romance Language Department; and her husband, who worked in theoretical nuclear physics and lived at 59 West Ninth Avenue, were questioned. The accused denied being Communists but were "outed" by the statements of an undercover FBI agent. The committee had done its job. Yes, Columbus had Communists.

June 18

The first sale of public lots took place in Columbus in 1812. Two of the first twelve lots were sold to Germans who generally arrived in the city to enter into a trade or retail business. Christian Heyl, one of the earliest German settlers, opened a bakery with his sister and eventually used his entrepreneurial skills to create a combination bakery, tavern and hostelry, where some of the earliest meetings of Lutherans and even city council meetings were held.

June 19

Let's be honest. This date has been picked to relate a charming story that happened in 1934. The Maramor Restaurant at 137 East Broad was well known outside Columbus for its fine food and the famous diners, especially theater people who played the Palace or worked with Kenley Players. The restaurant was started by Mary Love (Maramor, get it?), who once managed the Lazarus tearoom. Her husband, Malcolm McGuckin, ran the candy shop and had his own devotees. Using fresh foods and careful preparation, dishes were praised by none other than Duncan Hines in 1947, who acknowledged that it was one of his favorite eating spots. Sometime in 1934, famous art patron and writer Gertrude Stein and her equally famous companion Alice B. Toklas, a talented cook herself, ate at the Maramor. They toured America for seven months (June 19 seemed like a perfect touring car date). Alice wrote, "In Columbus, Ohio, there was a small restaurant that served meals that would have been my pride if they had come to our table from our kitchen. The cooks were women and the owner was a woman and it was managed by women. The cooking was beyond compare, neither fluffy nor emasculated, as women's cooking can be, but succulent and savoury." (And this from a woman who supposedly knew her brownies.) The Maramor closed in 1969, and the building was razed in 1972.

June 20

Camp Chase, four miles west of the statehouse, was established in 1861 to house and supply the growing numbers of volunteering Union soldiers from Ohio. Its later story as a Confederate prisoner-of-war camp, the largest of the North, is well known, including the loss of thousands from disease and lack of sanitation. In July 1865, the prison portion of the camp was sold for little more than $3,000. By 1866, all government property was removed, leaving only vacant buildings. In 1872, members of a Quaker community purchased 460 acres. A neglected cemetery was discovered in 1893 by William Knauss, a Union veteran, who had befriended a Confederate veteran. The two agreed to mutually assist the comrades of the other. Knauss met the challenge of the neglected cemetery with a good heart, his son-in-law and a few friends who no longer "waved the bloody shirt." The dedication of a refurbished cemetery was marked by the unveiling of an arched monument in 1902 with one word on it—"Americans." Knauss turned his work over to the United Daughters of the Confederacy who arrived each year on the first Sunday in June nearest to the birthday of Jefferson Davis (June 3) to mark Confederate Memorial Day. For a man whose mission was to mark an important piece of Columbus history, Knauss's own house on East Fifteenth Avenue and North Fourth Street has escaped all notice that it was the home of an amazing man.

June 21

A large boulder in Martin Park marks the approximate spot where General William Henry Harrison stood in 1813. The War of 1812 was still in progress, but around him stood Tarhe, the Crane, the principal chief of the Wyandots and other chiefs who pledged their re-attachment to the Americans in their fight against the British. The only record of that meeting was published in a weekly paper, *Freeman's Chronicle*, published June 25, 1813, by James Gardiner in Franklinton. Martin Park is near 800 West Broad Street. (See June 28.)

June 22

A year after Stonewall Union of Columbus was founded, the city held its first gay pride parade in 1982 with over one thousand people participating in the march up North High Street. The parade marked the thirteenth anniversary of the police raid on the Stonewall Union in New York City's Greenwich Village. Many point to the raid as the beginning of the gay rights movement.

June 23

Sunburned, tired and dusty, "the second section" army, composed of over a hundred men, tramped into Columbus to march to the statehouse, pleading for relief measures to be taken up by the Ohio legislature in 1933.

June 24

Labor representatives from Ohio met at the Union Hall at 20 East Mound Street in 1884 to found the Ohio State Trades and Labor Assembly. Inspired by the success of the national and politically oriented Knights of Labor, the dominant union organization in the 1880s, the assembly's mission was to establish the eight-hour day in state contracts, abolish convict labor at the Ohio Penitentiary and restrict child labor.

June 25

It was announced on this date that a new type of hotel at 487 South High Street was to open in 30 days. The year was 1922, and nothing could better illustrate the impact of the automobile on the changing city. The old landmark home of the Hosters was purchased by a new developer in town who had "vision." The three-story structure with a frontage of 171 feet on South High Street and extending to Wall Street would be remodeled into forty sleeping rooms to accommodate the auto tourist. Another building would contain an additional twenty guest rooms, a restaurant and business rooms. All the buildings would be connected with space for fifty automobiles close by so that guests could conveniently park near their rooms. Thus the Park Hotel, or a sort of cobbled-together hotel/motel, was born. By the 1950s, it had deteriorated into little more than a rooming house for those who had fallen on hard times.

June 26

In a previously unpublished account (it will soon be obvious why it was unpublished), a child pasted a school writing assignment into a scrapbook in 1959. In 1959, the worst flood since 1913 hit the west side. The first-person account, titled "What I Done in the Flud," from "Jackie," a child who experienced the flood, is as follows: "My grandmother was fluded out. My Anut was to. My grandmatner's car was filed all the way up to the top of the car and I meed abut to the top. My Anut lost every thing but the house and the beds. My Father, Mother, and I went and help them clean it out. It was a hard job to, all that mud and water was so messie. The Sohio River was in a miss to, boats were up in trees, close were to. One house we seen had one wal standing. Those homes were very pretty once apond a time but now the look a ton of water struck it did very hard. The Sohio River has when we sall hunk of ice flowing down streem." (Poignancy makes up for spelling.)

June 27

A cholera epidemic overwhelmed the city in 1849, taking 316 lives and causing the city to quickly form a board of health. One of the first burials in Green Lawn Cemetery was for Dr. Benjamin F. Gard, the physician who helped so many during this time but also became a victim of the epidemic.

June 28

In 1900, two small boys, descendants of old and famous Columbus families, drew aside a flag that unveiled a memorial tablet in the middle of a Franklinton's Martin Avenue. James Milton Wilcox, great-great-grandson of Lucas Sullivant, founder of Franklinton and Columbus, and Allen G. Thurman, great-grandson of Senator Allen G. Thurman, helped mark the spot where General William Henry Harrison had made his famous peace treaty with Native American tribes. Franklinton residents, living on the edge of the Ohio frontier during the War of 1812, considered the second American Revolution, breathed much easier when Native Americans pledged not to side with the British. Milton Wilcox's great-grandfather, as a boy of the same age, would have been one of Sullivant's three sons who witnessed the original treaty signing on the farm of his father. (See June 21.)

June 29

The city's spacious new Union Station, designed by Chicago architect Daniel Burnham, opened to railway traffic in 1897. It was the third and most remembered Union Station and lasted until 1977, when it was torn down by the Battelle Foundation to make way for a hotel. The demolition began in the late evening hours on a weekend and played out to a shocked community who saw it on the 11:00 p.m. news. Citizens formed the Columbus Landmarks Foundation as a result. One arch remains in the Arena District.

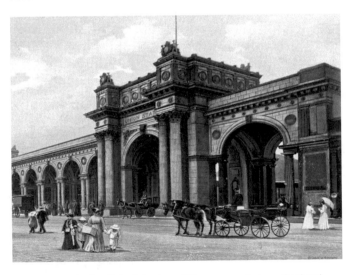

At the height of rail traffic in Columbus, 126 passenger trains arrived and departed daily. *CLF.*

June 30

Steel workers Local 2173 started a walk-out at Timken Roller Bearing (now a vacant expanse of land at East Fifth and Cleveland Avenues) in 1941 in response to the company's laying off five women, supposedly for being "careless " inspectors. However, the real reason was that they were members of a yet-unrecognized union. Only 110 workers of the 2,400 employed were members of the steel workers union. Timken management agreed to return the women to their posts when the workers in the parent company in Canton threatened to slow down production in support of the women.

The first war bond for July 1942 was sold in front of the Woolworth store, at 105 South High Street, to the vice-president of City National Bank & Trust Company. The store sold $500 worth of bonds in two hours. Less than a block north, at the Deshler-Wallick Hotel, petroleum industry leaders were making plans to go door-to-door to urge people to donate hoarded scrap and old tires. The Ohio Highway Patrol in Columbus estimated there were four thousand tons of scrap rubber in salvage yards. Columbus housewives were already saving bacon grease and cooking fats. Two pounds of it provided enough to make five anti-tank shells.

One housewife was giving up more than bacon grease. Mrs. Alice Boutwell, of 194 West Lane Avenue, living with her daughters Amaryllis and Anna Jean, had six sons in the armed forces—Wayne, Dwight, Wade, Kent, Claire and John—the most of any family in Columbus. She spent three nights a week writing letters.

July 2

The Huntington Bank Building under construction showing the "old" bank building on the left being combined with a new addition on the right. Eventually a new facade would cover everything, making it indistinguishable where the "old" building ends and the "new" building begins. *CML.*

Columbus was amazed in 1926 to get a new bank building—a significant structure—but not lose the old building. The new Huntington Bank was emerging from the old one, and comparing what the building looked like at the halfway stage, any observer could note the challenges. No sense losing banking business with a demolition and a rebuild when the new building could be constructed and expanded over the old. Synder & Babbit were the architects. The new façade was formed from huge blocks of solid Bedford limestone trimmed with green terra cotta. Tiffany & Company in New York was responsible for the decorative bronze applied to either side of the main entrance and installed all the solid bronze fixtures in the loggia of the building, a four-story structure extending the entire length of the frontage of the new building.

July 3

When the Ohio State Fair opened in 1899 in Franklin Park, the Board of Agriculture zealously guarded against anything that would bring the exhibition into disrepute. All sideshows, hammer-pounders, ring games and the like were prohibited, and it was also noted that someone should pull the crop of tall weeds so the many visitors would not have a bad impression of the city.

July 4

The Schiller monument was dedicated in Schiller Park in 1891. Frederick Schiller, one of the most beloved German poets of the nineteenth century, was the Germans' gift to the holiday because the Fourth of July was a time to come together, regardless of different faiths, and to celebrate a thanksgiving for being in a new country.

In 1907, there were officially no citywide celebrations of the Fourth of July holiday. Germans aside, the Fourth was a time for family or neighborhood celebrations. The interurban cars were full, taking families to Buckeye Lake and to Glenmary Park (Worthington). Driving Park held matinee horse racing. The north side was celebrating at the corner of Neil and Third Avenues, where the Declaration of Independence was read. No work was done by the inmates of the Columbus workhouse, and at the Ohio Pen, convicts had the freedom of the yard (ironic twist?) and received visitors. The state hospital for the "feeble-minded and insane" had a "platform dance"; the Barracks (Fort Hayes) had a band concert; and in the county jail, an ex-director of the city's service department, who was jailed along with his son and a former city council member and a city clerk on charges of bribery, had his dinner sent by a nearby restaurant.

It wasn't a Fourth of July celebration, but it certainly prompted great cheering: in 1967, a Boeing 707 passenger jet landed at Ohio State University's Don Scott Field, the pilot mistaking it for the Port Columbus airport.

July 5

Finding reasonable accommodations in Columbus was a challenge for legislators. Some drove home every night, even if it was one hundred miles or more; others shared spaces with other legislators at hotels, boardinghouses and in trailers, but one legislator took housing a step further. In 1971, Representative Tom Kindness, of the 109th General Assembly, lived in his motor home, which he parked in the statehouse lot.

July 6

The Ideal Theater, at 1571 Parsons Avenue, selected its second Ra-Lite Neon Sign in 1942. The modern little theater that opened a year before with a diminutive neon marquee, now went for the whole banana—the full-story vertical sign above the marquee. Ray-Lite at 1932 South High had an excellent reputation as a neon fabricator and was responsible for many of the now highly collectible commercial signs. After World War II, neon schools were established in the city with special scholarships and bonuses for returning veterans.

July 7

The year was 1953. Former president Harry Truman and his wife, Bess, were driving their own car back to Missouri after visiting their daughter. About noon, their car rolled up to the front door of the Deshler-Hilton Hotel at Broad and High Streets. They did not have a reservation, nor were they noticed at first. However, when Truman said he would like a room, everyone in the lobby looked. A dozen squealing teenage girls from a Future Homemakers of America convention ran to greet them. Writer Matthew Algeo described the finer details: "The unexpected appearance of the former president and the first lady at their [hotel]… practically sent the girls into delirium. They nearly tore the hotel drug store apart in their rush to purchase film for their…cameras." The Trumans were assigned room 1663, ordering room service for lunch. Algeo continued, in his book *Harry Truman's Excellent Adventure*, "After lunch, Harry took a nap while America's future homemakers stalked the corridors of the Deshler in search of him." Bess went to the hotel beauty shop and (as reported by the *Columbus Dispatch*, which also apparently stalked them), she emerged "looking rested and stylish with small curls covering her head and fluffy bangs topped her forehead." That night, the Trumans had dinner ordered in. They checked out the next morning at 9:00 a.m., waived their good-byes, got into their New Yorker car, and headed for home.

July 8

A postcard of Port Columbus in the late 1940s. *CML.*

Henry Ford and Edsel Ford, Amelia Earhart and Harvey Firestone were in attendance in 1929 at the dedication of Columbus's Port Columbus Airport on July 8. They had arrived by way of an Airway Limited train, disembarking on a specially constructed siding near the control tower. They left again to arrive in Los Angles by tri-motor planes and other trains, crossing the country in under forty-eight hours. Eddie Rickenbacker also attended, and that same day, aviator Charles Lindbergh selected Port Columbus as the vital eastern transfer point for the first transcontinental air-rail system. But the true age of air started when the coast-to-coast air and railroad service began that day. American Airlines, Trans World Airlines and Lake Central Airlines sent out sixty-eight flights a day. In World War II, the United States government stressed the importance of Port Columbus when it improved runways and taxiways for the building of a $4 million naval air station that was used as an aircraft manufacturing plant.

Mayor James Thomas laying the cornerstone at Port Columbus on April 18, 1929. The dedication celebration was held on July 8, 1929. *CML.*

July 9

A break in a downtown sewer line in 1986 in front of the LeVeque Tower on West Broad Street caused the infamous sinkhole that swallowed a car. (Not as thrilling as the "Killer Tomatoes," which can be terrifying since Columbus is close to the Reynoldsburg Tomato Festival.) A lawyer was waiting in traffic. Suddenly the street opened, and his new Mercedes fell straight down. Some wondered why it did not end up in the basement of the LeVeque Tower that stretches under Broad Street; others wondered why not on Spring Street where an actual "spring" still flowed in centuries-old brick vaults.

July 10

The city passed an ordinance forbidding the employment of "waiter girls" in saloons in Columbus in 1876. However, it was repealed the next month.

July 11

Where Columbus Commons has sprouted up and new condos will be built at South High and Town Streets, there should be a little remembrance corner—perhaps not for the loss of the colorful terra-cotta Knickerbocker Theater, the walk-up brownstone apartments worthy of Boston, the rambling Midtown used bookstore or even the doomed City Center Mall with its great legacy (underground parking) but for the Greek children who once lived there. In 1902 in Columbus, there was human trafficking of young Greek boys, working as bootblacks. Recruited by bootblack "bosses" to work in America and then required to pay back their sponsors, the highest-earning child had made only eighty dollars in one year and would work for three more years to pay off the debt. The boys were kept in squalor in rooms at the northeast corner of Town and High Streets. The passage into the building was barricaded by a piece of wood that a person had to climb to gain admission to a narrow corridor. The hallway had an inch of standing water. Ten boys slept in one room with one mattress on the floor and cooked for themselves in another small room. Infested with fleas and bedbugs, the rooms were guarded by a "lieutenant" under the direction of a boss. Except for working long hours on the street, the boys could not leave their quarters. City records from 1902 make no mention of any investigation.

July 12

The *Ohio State Journal* dropped ten thousand newspapers over the city in the area's first aerial edition in 1919. Hopefully they were not in one bundle.

July 13

The Franklin County Court House, the magnificent Victorian structure on South High Streets designed by George Bellows Sr., was dedicated in 1887. An old photo clearly shows another building in the background—a house and tavern at 22 East Mound—that was more than fifty years old in 1887 and today may be the oldest standing building in downtown: the Jury Room.

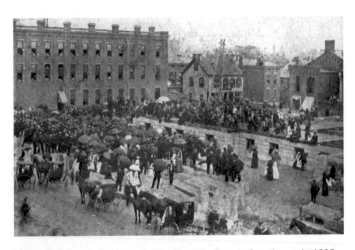

The laying of the cornerstone of the Franklin County Courthouse in 1885. The Jury Room Restaurant is pictured in the background (second building from left). *CML.*

July 14

Dr. Lincoln Goodale offered to donate forty acres of pristine land at the northern edge of the city for the city's first public park (now known as Goodale Park in his honor) in 1851. Goodale had come to the city in 1805 to the settlement of Franklinton, and he had invested his money in large pieces of property on the east side of the river. After the War of 1812 and the settlement of Ohio's capital on the east side, he used his profits in land to make the gift possible. (See April 22.)

July 15

In the nineteenth and early twentieth centuries, in any town or city in the Midwest, the term "gypsy" was applied to travelers who appeared suddenly and in their own conveyances, appeared to be setting up a camp or simply looked different (usually darker). Columbus did not have many Roma families who resided here with two exceptions: Roma families associated with the Sells Brothers Circus, generally as workers, and an association of combined families who traveled each year from Pennsylvania to Columbus to hold summer reunions near Kenny Road and Third Avenues (the site of Kingswood school). These families were already established when President James Buchanan was in office, and they continued to come into Columbus well into the twentieth century. However, on occasion, others passing through—and the arrival of "gypsies"—was almost always reported by newspapers because trouble was expected and/or provoked. In 1907, the Sam Reynolds and Jack Broadway families camped on Fifth Avenue near Nelson Road in Shepard, and a fight broke out over a card game. The Broadway family supposedly wired to Toledo (known as the home of the "king of the gypsies") for help on July 12. When the Toledo help arrived on the July 15, so did a wagon of police. A "small riot" broke out—men, women and officers alternately swinging and fleeing. Dr. Kidd of Shepard took care of the many broken arms and noses, busted teeth and bruises.

July 16

The Casto organization in 1946 announced plans to build a mile of stores, the nation's first regional shopping center, Town and Country, along East Broad Street, signaling a shift that would begin suburbanization in the area. Another spectacular shopping center opened in 1953, when the Casto and Skilken developers created nine wonders of the world in a parking lot in Great Western Shopping Center. "The Walk of Wonders" was not small-scaled but consisted of amazingly large and complex re-creations. Sure, it would be easy to create an almost-twenty-foot model of the Eiffel Tower (still rumored to be in a backyard in Westerville), but it is another thing to create Niagara Falls with running water and the Grand Canyon without making it look like a giant pothole. In addition to these wonders were the Carlsbad Caverns, the Taj Mahal, the Leaning Tower of Pisa, the Fountain at Trevi, the Parthenon at Athens and the Sphinx and Great Pyramids of Egypt. Of course, they also drew shoppers. However, they were not—like the real ones—destined for the ages. When a maintenance man found that part of the Niagara Falls suffered an erosion problem that carried off some of Buffalo downstream in the parking lot (imagine, little floating houses heading out to Broad Street), it was time to evaluate the creation. Sadly, it now exists only in postcards and memory.

July 17

The fear of fire in hotels and theaters was real. The Lyric Theater, a moving picture house at 22 North High, was the scene of panic in 1910. Two hundred people were intensely watching *The Egret Hunter*, a film about the hunting of birds highly prized for their feathers. At the moment in the film where a game warden was to shoot a hunter, a man in the front row yelled, "Fire!" and the audience, interpreting his cry to mean there was a fire in the theater, not a cry to the actor to "shoot" his gun, began to stampede. Two young women fainted. Several women were "so weakened from fear" that they could not move. Attendants in the theater, who understood the context of the man's exclamation, blocked the exits and further exacerbated the situation. A few people, including the man who had sounded the alarm, rushed past the attendants to the statehouse grounds, followed by the manager of the Lyric. He caught the man and called for a policeman. When the policeman did not arrive, the manager let the man go on his word that he had not meant there was a fire in the theater. The two women who had fainted were revived by theater attendants, and the majority of the crowd returned to their seats to see the rest of the picture show.

July 18

The directors of the Columbus Brewing Company awarded a contract for making all the designs of the exteriors of the brewery buildings to Mueller and Milner, Detroit architects, in 1899.

In 1910, the city seriously considered creating a "red light district" in the vicinity of Grant Avenue (then Seventh Street) between Mound and Main Streets to better control rampant vice.

July 19

Beautiful Mul-Bur Heights offered homes for war workers in advertisement flyers. A "big new 6-room Colonial" was available for only $200 down and convenient monthly payments in 1942. Homes had three bedrooms and up, a beautiful bath and shower, a large living room with brick fireplace, a full-sized dining room, and a kitchen described as "the housewife's dream." A full basement, coal furnace, screens, shades and Walltex (a washable plastic-like wallpaper made in Columbus) in the bathroom was included. Mul-Bur Heights was east on Hudson Street and bordered Cleveland Avenue. Schools, shopping centers and defense plants were nearby. Model homes were on Bancroft Street and Traymore Place.

July 20

In 1898, the Italian community held its annual picnic at Andrews Grove. Other ethnic groups and families used Catalpa Park, Black Lick Woods, Buckeye Lake or Hempy's Grove for their outings.

July 21

In 1927, Charles Inscho and other well-known local architects announced they were working on plans for an "English-type homes proposal" on East Broad Street. English Village was considered a unique subdivision development of the Kessler-Patterson Company. English Village was planned with parks, landscaping and curved streets. Kessler-Patterson was also developing many tracts in Linden and Berwick at the same time. However, its big development was in the north end near Indian Springs along North High Street. Here the company laid out what it called "Magic High Street."

July 22

The Great Railroad Strike reached Columbus in 1877 and for three days, Goodale Park "seemed to be literally covered with people." On July 22, brakemen and firemen from the Pittsburgh, Cincinnati and St. Louis Railroad met in the park to discuss a strike over a pending wage reduction. By the following day, a crowd of three hundred had turned into a mob of two thousand and marched through Columbus, forcing workers from factories, rolling mills and clay works. Supposedly, the mob was made up of a great many questionable characters with no connection to the railroads; nevertheless, the mayor discharged over three hundred policemen to restore order. The railroaders disassociated themselves from the mob and volunteered to restore order. Four days after it started, the strike had failed and the railroaders went back to work.

July 23

Beer kegs littered the streets at West Gay and Front Streets after a streetcar hit a Born Brewery wagon loaded with beer in 1898. Pedestrians scattered as beer kegs rolled down Gay Street toward the river. White foam covered the sidewalks and streets where hot and thirsty horses had a refreshing drink of one of Columbus's best beers.

July 24

In 1929, Columbus's most famous murder case was starting. A respected and quiet married professor of veterinary medicine murdered a twenty-five-year-old-medical student. Theora was the only child of a retired principal and his wife, who raised their daughter in a moral home. As the testimony unfolded throughout the next eight months, Mr. and Mrs. Hix were faced with the difficult possibility they had raised a sexual predator, a young woman thrilled with sex exacerbated with drugs and stimulants and who initiated an arrangement with a married man for sex and power and not love or marriage. Dr. Snook eventually confessed to the murder, but details of their affair and the testimony of a former boyfriend of Theora's indicated her own psychological makeup and demands may have contributed to her demise.

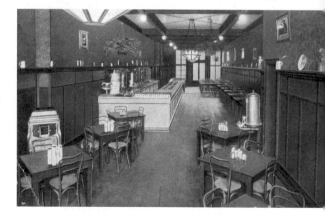

The Varsity Inn on North High Street, across from the Ohio State University, was once a grocery store and was one of the last places Dr. Snook and Theora Hix were seen before the murder. *CML*.

July 25

More than one thousand men were employed as quarrymen at the limestone Marble Cliff quarries by the Scioto River on this date in 1902. Evenly divided between African Americans and Italians, the quarrymen worked at the Casparis Stone Company, the Columbus Stone Company and Keifers. The African Americans came mostly as migrant workers for the summer months from South Carolina. The Italians were often single men and lived in boxcars below the Casparis "castle," from which Mr. Casparis could supervise. From April until cold weather arrived, the blasting of the quarry walls continued.

July 26

A new downtown plan turned Third Street and North Fourth Street into one-way paired arterial streets north of downtown in 1950. However, this change was not to build I-71 North or even to accommodate a rerouting of Route 23. Though President Eisenhower signed the National Highway Act in 1954, the Interstate Highway plans had not fully emerged. When they did, their purpose was to facilitate the rapid escape of city dwellers in case of atomic war during the Cold War. The changes to Third and North Fourth Streets were also motivated by war—not the Cold War but World War II. During the war, Columbus, like other cities, neglected its own infrastructure in favor of supporting the war effort and the need for materials to make guns, tanks and ships. The production of traffic lights, signs, barriers and other products associated with the safe movement of traffic was abandoned. In 1946, the city faced almost $2 million dollars in deferred maintenance, and at the same time, the automobile was first on the list of new purchases. From 1946 to 1950, an average of ten Columbus children were injured by automobiles each month. With mounting debts, no traffic lights and safety concerns, Columbus was turned into a city of one-way streets that proved to be a safe, low-budget alternative plan to solve the problem.

July 27

The fight continued in a U.S. Federal court in 1955 over alleged racial segregation in the Columbus Metropolitan Housing Authority projects. The original charges against CMHA were brought by a woman who said she was denied eligibility to public housing. The NAACP backed the plaintiff, saying, "Negro families are admitted only to Poindexter Village while only whites live in the other three housing projects—Lincoln Park, Riverside Homes and Sullivant Gardens."

Poindexter Village was dedicated by President Franklin Roosevelt in 1940 and named after Reverend James Poindexter. *CLF.*

July 28

The cornerstone for one of downtown's oldest churches, Trinity Lutheran Church, was placed at Fulton and Third Streets in 1851. A gathering place for young men returning from the Mexican American War in the 1840s and a place where their sons discussed joining the Union in the 1860s, the landmark in the German community became "orphaned" with construction of I-70 East.

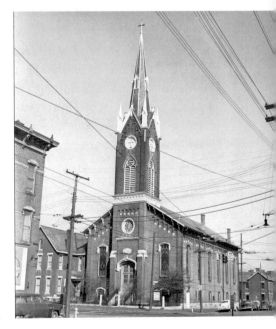

Trinity Lutheran Church is part of the history of the German community. *CML.*

July 29

William Dean Howells, "the Dean of American Letters" and publisher of *Harper's Magazine*, in 1916 wrote *Years of My Youth*, recalling his coming of age in Columbus. His memoirs described a pre–Civil War Columbus. He knew the statehouse and the state institutions, and he "drank it all in." He noted that the statehouse was really brick, just faced with limestone, and would not have cost anywhere near the amount the contractors were charging in construction. He remembered walking through the tree-lined streets and the parks, which would have included the present-day Victorian Village, Town-Franklin, East Broad Street and Goodale Park. In his day, Columbus showed its more Southern roots—where a young man might be invited into a party without a formal introduction and the music of an evening event spilled out into the streets and parks on a warm July night.

July 30

Troops were called into downtown in 1910 as violence escalated during the streetcar strikes. By August 10, as the labor strike continued, twenty-four streetcars were dynamited in Columbus, and Governor Judson Harmon mobilized 3,800 National Guard troops to maintain order. The streetcar strike was the most violent civil disorder in the city's history and caused former president Theodore Roosevelt to travel to Columbus to plead for law and order.

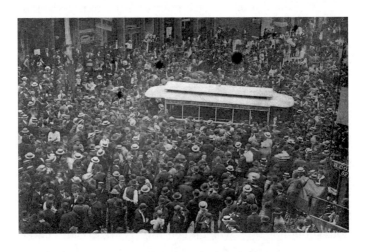

Before the 1912 streetcar strike, there were other streetcar protests, as seen in this 1890 photo. *CML.*

July 31

On this date in 1934, a customer could go to West Broad Street and Central Avenue, North High Street at Eighteenth Avenue, North High Street on Arcadia Avenue, 110 North Fourth Street, 1104 Cleveland Avenue, Main Street at College Avenue or 298 West Broad Street and know at that every spot, the White Castle employees had read the same sixteen-page employee manual. There were thirty-one points about how to dress, nineteen points on how to treat a hamburger, twelve points on the bun and more on floors, onions, coffee, pickles and even salt and pepper. Columbus has been home to White Castles for almost nine decades, and the company was one of the first "fast food" pioneers, priding itself on quality, affordability and, especially, cleanliness (that's why the Ingram family chose those white enamel panels for the buildings). The standards were high, but the points also imply that the Depression-era workforce might have needed coaching. Mandates included daily bathing, use of a hairbrush and "girdles… when necessary." Under emergencies, it read, "Your Castle will be provided with fly spray during the summer months. This should be used when no customers are present. Close all doors and turn off fans before spraying and then sweep up all flies." Extra credit for those who can match the 1934 White Castle locations with those of 2013.

August 1

On August 1, 1817, newlyweds from Easton, Pennsylvania, came into Columbus to settle, choosing "the most central and most public part" of the new city, as recorded by Betsy Green Deshler in a letter back home. Her husband, David, a cabinetmaker, bought his first lot for $1,000—187½ feet by 62½ feet—and built a two-room, one-story frame house while landing his first job making bookcases for the new library in the statehouse. In time, he acquired a full block, buying the High Street corner for $5,000 and the Wall Street corner for $12,000. When David died in 1869, he was a wealthy landowner, banker and self-confessed dreamer of owning a hotel on the corner. David's son William and his grandson John were born in the house, and William established a trust to provide funds for a hotel and instructions that the property should remain in the hands of the Deshler heirs for "as long as the law allows." Grandson John Deshler announced in 1912 that the old buildings would be razed, and a four-hundred-room hotel was built, opening twenty-three days and ninety-nine years after David and Betsy Deshler rolled into town.

August 2

The "Flying Squadron" was organized by Mrs. William McPherson, of 198 East Sixteenth Avenue, a campaign leader in 1918. Women advocated for suffrage for Columbus women at the polls on August 18. McPherson and Mrs. Harriet Taylor Upton, president of the State Suffrage association, joined with three hundred women who went door-to-door in the Sixteenth Ward urging "friends of the cause" (men) to get out and vote. Cards for streetcars read "service abroad in the trenches" for the young men and "service at home through the ballot box" for young women. On Fourteenth Avenue, "The Flying Squadron" approached a woman who said she had never been for woman suffrage, but she had just sent three sons to war and said if she didn't get the vote there would be no one to represent her.

August 3

Just who do you call if you have the first telephone? In 1879, the Central Telephone Office's first connections were made (often directly to a police station). On a related communications note, it seems there is still a telegraph operating somewhere from inside the building on the southeast corner of East Long and North High Streets. From that spot, the first telegraph office transmitted communications. Though the building had been long gone, telegraph signals emanating from that spot were reported in 1927 and thought to be the work of a diligent but not corporal telegraph operator who had died several decades before.

August 4

The life of a Columbus fireman was lost in 1870. Mark Newman was the first city fireman to die in the line of duty at the Columbus Woolen Mill fire. The Columbus Woolen Mill, located at Mound and Conrad Streets, was later destroyed by a fire on April 26, 1903.

August 5

The will of the late Ralph Lazarus, co-owner of the Lazarus Department store, was made public in 1913. His estate was worth $250,000, and Lazarus's attorney, Nathan Gumble, disclosed the contents. In addition to reconciling any debts and the continued maintenance of the Lazarus plot at Green Lawn Cemetery, he left his half of the East Town Street residence to his sister, Rosalie Cohen, and amounts of money to nieces and nephews (Ralph never married) along with sentimental but personalized remembrances. He left money to the Hebrew Orphan Asylum and a home for the aged and infirmed in Cleveland, the Children's Hospital in Columbus, the Columbus Lodge of the Benevolent and Protective Order of the Elks (to build a library or establish a plot in Green Lawn Cemetery for the burial of indigent Elk members). The majority of the estate was willed to Fred Lazarus. The will provided that should any beneficiary be dissatisfied with the provisions of the testament and seek to have them changed, "he shall receive absolutely nothing." Ok, then, moving right along.

August 6

In 1932, on this day, the Valley Dale Ballroom on Sunbury Road hosted Duke Ellington and his band. Valley Dale is on the National Register of Historic Places and an icon of the big band era, and it continues to operate. Valley Dale started as a stagecoach stop on Sunbury Road, but in the early decades of the twentieth century, it became a hot musical stomping ground. A strong radio signal could be picked up by radio listeners across the country. The music of the 1930s and 1940s came to be associated with a place in Columbus as famous as any swanky hotel ballroom in New York.

In 1955, the people of Genoa, Italy, presented a proclamation to the people of Columbus and the Sons of Italy in honor of the coming dedication of the Christopher Columbus statue at City Hall—affirming the Italian American friendship between the two cities. The bronze statue was created by artist Edordo Alfierti, who was known for both his traditional and avant-garde sculpture. The base of the statue was concrete made from the sand of San Juan Island where Columbus first set foot in 1492—and set foot he did. Given the height of the statue, his feet are estimated to be size twenty-two shoes.

August 7

In 1942, one of the bleakest years of World War II, when the outcome of the war was most uncertain and the conflict in the Pacific was particularly dire, the United States stepped up efforts to encourage more scrap and salvage drives. Cities on the East Coast, like Washington, D.C., lost vintage iron fences, gaslights, park benches and other decorative architectural embellishments. Few people realize that Columbus also surrendered Civil War cannons, cannon balls and other old war relics from the statehouse grounds and Fort Hayes to meet its quota of 2,175,000 tons of scrap iron and steel called for by the War Production Board in Washington. In addition, many citizens gave the wrought-iron fences from some of Columbus's oldest homes. There was no consideration of the historical or architectural consequences of the losses compared to the alternatives, and wrought-iron fences were "extremely desirable" by steel manufacturers because the cause was so important and the need so great.

Vice President Dan Quayle opened the Ohio State Fair in 1992 near a display of prize-winning potatoes (no, we made the "potato" part up). A surprise fireworks display went off to mark the opening and impress the vice president; however, unannounced fireworks on a bright, sunny day made the Secret Service protecting the vice president very nervous.

August 8

In 1903, a lot of little boys were happy. Over three hundred newsboys of the *Columbus Citizen Journal* were treated to a large carnival held for them on the west side at the grounds of the stadium. Everything was free for the boys—"Ice cream, ginger ale, lemonade, pop, Citizen, Citizen, always on top!" Lest you think how generous and charitable newspapers could be for the "newsies," the expense was actually an investment. The cost was offset by the 1,500 people who paid admission, but more importantly, the newsie was the vital link between the production of the newspaper and the customer. Without newsies, there was no circulation, and it was, after all, child labor. Newspapers could not afford to hire adults. In other cities, newsies sometimes went on strike for higher wages. Ice cream, in comparison, was cheap.

August 9

Married students in the Ohio State Student Trailer Cooperative near the state fairgrounds won the first round in a Common Pleas Court in their fight to move their homes to the Braemer Addition on Olentangy River Road, but in 1950, Judge Cecil Randall upheld an injunction filed by residents of the Braemer Addition, stopping student trailers from relocating. Students wanted to relocate because of the coming state fair. At a hearing two weeks before, the property owners said the location of a trailer camp in the addition on Olentangy River Road would violate deed restrictions. Fred Postle, attorney for the property owners, expressed sympathy for the students but said it was the responsibility of university officials to provide space for the married students to locate their trailer homes. The trailers were still on Seventeenth Avenue in the 1980s.

August 10

Cigars were big business in Columbus, and the Gallagher brothers' factory sprawled across 569, 571 and 573 North Fourth Street in 1900. It made 100,000 cigars a day. A traveling salesman whose route took him from New York to San Francisco commented, "Ah, stogies, just the good, old three-for-five, make Columbus, Ohio, the most democratic town in the country…One man told me that the people [of Columbus] were born that way [democratic]; another said that it was [because] Columbus was made up from little towns all over the state; and was merely a big village; but finally one of my wisest customers hit it on the head when he said, 'Stogies, that's the reason; no one here is either too rich or too poor to smoke them…I found the fireman down in the cellar, the janitor up in the loft, and the carpenter who was doing an odd job of repairing, all pulling away on the same kind of stogie as the boss…A fishing boat loaded with Columbus men looks like a steam tug under way, and the baseball bleachers are almost hidden in the cloud of smoke.'" (No wonder Columbus homes had sleeping porches and were concerned about consumption.)

August 11

President Rutherford B. Hayes finished speaking at the State Fair Grounds (now Franklin Park) at the encampment of the Grand Army of the Republic in 1880 when General William Tecumseh Sherman stood up. His impromptu speech must have shocked some ladies in the audience but pleased his former comrades. He said, "There is many a boy here today who looks on war as all glory, but boys, it is all hell." Within a few months of his remarks, his words "war is hell" became famous.

Fifty years later in another park, prizes were given away by the Red Bird Knot Hole Gang to holders of the lucky tickets at the stadium on West Mound in 1934. New bicycles and baseball equipment were in short supply during the Depression, and children competed in athletic events for the chance to win prizes. The Knot Hole Gang was officially created six years earlier by adults who remembered what it was like to love baseball but be too poor to buy a ticket. They would peek through the holes of the wooden fence at the old Neil Park (Cleveland Avenue across from Fort Hayes). In 1932, the president of the Red Birds, wanting to promote baseball, signed children up to be members of the Knot Hole Gang, receive membership cards and be eligible for filling the stands on certain days to cheer the players. By 1938, former Ohio governor James Rhodes, then a Columbus Board of Education member, expanded the idea to form leagues and a musical band. At its peak, the band numbered five hundred, and there were an estimated twenty-five thousand cards issued, lovingly taped to dresser mirrors or wadded up in children's pockets. (See June 3.)

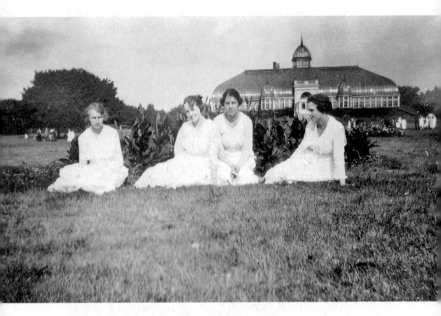

An early twentieth-century photo of ladies lounging on the grounds of the Franklin Park Conservatory, once the site of the state fairgrounds. *CLF.*

August 12

In response to the opening of the new Lazarus Department Store at West Town and South High Streets in 1909, the Union Department Store began to add two new floors to the store at Long and High Streets. Though there was always rivalry among the Columbus department stores—Lazarus, the Union, the Fashion, Morehouse-Martins and others—there was also the savvy of understanding shopper psychology. When a large department store across from downtown Lazarus closed, Lazarus paid to have the Union move into the empty space, knowing that they both would benefit from more shoppers. However, when Lazarus later added its famous air-curtain door, an executive across the street mused that he did not mind seeing the long lines of customers lined up along the streets waiting for Lazarus to open for its famous remnant sale days, but he did resent Lazarus having a door that could suck them in.

August 13

It turned night into day, and it was permanent. The High Street arches would stay, *and* the City would pick up the bill. The arches were so popular that four hundred lights were being planned to illuminate the viaduct (across from the present Convention Center). Columbus declared itself to be "the most brilliantly lighted city in the United States" in 1903 (never mind about Times Square). The City promised that the entire city would receive its share, and already the west side and the east side (from the Scioto River to Alum Creek) had over one thousand lamps. There would be arches in some spots and electric street lamps in other places. The superintendent of the municipal light plant said he would have preferred a double arc lamp system like the one used on Euclid Avenue (Millionaires Row) in Cleveland (again, the Cleveland envy thing). The City had already decided to abandon sharing poles with the Citizens' Telephone Company, preferring to erect its own poles and provide electricity from its own plant.

August 14

Excited residents poured into Columbus's most famous downtown intersection, Broad and High, in 1945 to celebrate the end of World War II. This was in contrast to the celebration that marked the end of World War I, when thousands crowded downtown but arrived days early because of rumors of peace and had to return three days later when the war officially ended. On August 14, 1945, they arrived en masse on the right day.

August 15

After thirteen years of construction, the last link of I-270 was opened, making it possible to skirt Columbus completely in 1975. Many Columbus residents who lived within the heart of the city, with no thought as to how much gas would be used to travel the more than forty miles around I-270, got into their cars to drive this entirely new experience and see what the suburbs and the exit ramps looked like.

August 16

Columbus was one day away from receiving potable water in 1908. The new Scioto River water treatment plant and pump station began pumping potable water to the Columbus public, and general water softening began five days later on August 22.

August 17

The cornerstone of St. Dominic's School, on Twentieth Street, was laid with impressive ceremonies that started at 2:00 p.m. on August 17, 1890. Marchers began from St. Joseph's Cathedral on East Broad and Fifth Streets, with an intricate parade route certain to confuse all who wished to march along. The church, originally built by Italians and located in a historic African American neighborhood, has survived over one hundred years with a diversity of congregants, some of whose great-grandparents worshipped there.

August 18

In 1917, a cartoonist with the *Columbus Citizen* mused about the necessity of sending the soldiers south to train for the Great War—why not train soldiers on Third Street? They could pretend they were engaged in trench warfare in the giant potholes that were large enough to hold a regiment.

August 19

Mayor Karb suddenly returned to the city in 1917 from his summer home in Michigan to issue the following statement: "Reports are being persistently made that gambling is being carried on and that someone is being paid for the privilege. Reports are also being made that speakeasies are being allowed to operate and that immoral rooming houses are being operated all over the city and that street-walkers ply their trade in every street. Every officer in the division of policy will use every effort and every means that he can command to stamp out these reputed evils." Then the mayor returned to Michigan. (Well, that was easy.)

August 20

Making a campaign stop in Columbus with former Ohio governor James Cox in 1932, New York governor Franklin D. Roosevelt visited the Red Bird Stadium, speaking just seven weeks after announcing his candidacy for president. His speech was broadcast across the country.

August 21

Robert Frost's connection to the city starts with a walk from East Rich Street to East Broad Street. Isabella (Belle) Moodie, Frost's mother, walked this path almost every day from the time she arrived in Columbus on August 21, 1855, to live with her uncle until she left in 1872 to take a teaching job in Pennsylvania. In between those years, she was a student and then a math teacher at Central High School on East Broad Street. Isabella was born in Scotland, and her early life often is still sanitized by biographers because she was most likely illegitimate. Belle was raised by strict Presbyterian grandparents and packed off to live with Edward Moodie, a well-to-do uncle in Columbus. She had a whirlwind marriage to a colleague in Pennsylvania and left for San Francisco with her husband, Will. When Tolstoy said, "Happy families are all alike; every unhappy family is unhappy in its own way," this applied to the Will Frost family. Belle hated housekeeping, and when the house became dirty and cluttered, Will moved her into a hotel where she could enjoy lively conversations. When she felt guilty about the arrangement, she moved into another house. In eleven years of marriage, there were eight different addresses within a few blocks. Will drank heavily, became enraged, consorted with other women and thought everything was irrelevant, except religion, to which he was indifferent. Frost said, "Some people can't resist tragedy. My mother couldn't. Nothing could have saved her but my father's death." If only she had married a nice local boy from Central High.

August 22

Governor James Rhodes presided over the groundbreaking ceremonies for the new building that would become the Ohio Historical Center in 1966. The new building opened exactly four years and one day later on Sunday, August 23, 1970, and was dedicated to "the people of Ohio whose illustrious deeds are herein enshrined and proclaimed for the inspiration of all." The American Institute of Architects applauded the Ohio Historical Center as a "bold, imaginative, almost startling structure." Architectural Record called it "the most architecturally significant public structure in Ohio since the State Capitol Building." W. Byron Ireland & Associates, a Columbus architectural firm, designed the building, an example of Brutalism, a rational, structural, monumental style exported in the early 1950s by French and British architects, and departed from the-so-called "bourgeois style" of stone and marble in favor of concrete (or beton brut, a technique for concrete employed by French architect LeCorbusier).

August 23

In 1877, the first patient was admitted to the new Columbus State Hospital on West Broad Street in the Hilltop neighborhood, which replaced the Columbus Lunatic Asylum on East Broad after it burned. Governor Rutherford B. Hayes presided over the groundbreaking for the building in 1870. The massive hospital was built according to the Kirkbride plan, which gave it a distinctive bat-wing shape when viewed from overhead. It was the largest brick building ever constructed in the United States until the building of the Pentagon in Washington, D.C. The hospital was designed to hold 850 people. It closed in the late 1980s as ideas about residential buildings for the mentally ill were being reconsidered. The building was demolished in 1997, and there were efforts to consider adaptive reuse. However, it was argued that each wall was a load-bearing wall, and adaptation of such a massive building seemed daunting. A cheer went up from those who wished to save the building when the first swing of the wrecking ball merely bounced off the brick wall. Artifacts of the building were saved and are part of the Hilltop Library at Hague and Sullivant Avenues.

August 24

The wrecking ball cracked away at the Broad Street Bridge in 1947, removing the debris caused by a lightning strike. The Broad Street Bridge had opened as "The Gateway to the West" in October 1921, after years of construction as part of the new Civic Center, following the devastating 1913 flood. At 5:30 p.m. on August 22, with the heavy rain and intense thunder, lightning hit the bridge with such an explosion that it caused a red flash and a huge dark cloud. Witnesses in the Huntington Bank thought the Neil House had been hit. Fire trucks arrived quickly. Four people had been blown off the bridge and were in the river. Two of them went under water twice when a large piece of concrete created a wave that engulfed them.

August 25

A $20,000 gift from the estate of the late F.O. Schoedinger was announced in 1965 to build an auditorium in the old Memorial Hall, at 280 East Broad, to house the $18,000 "Talking Glass Lady," a gift of the Columbus Junior League. In 1963, the life-sized Glass Lady, who talked about her body functions without referencing her lady parts, was an attempt to turn the 1906 Memorial Hall into a health museum. Planned to honor Franklin County Civil War soldiers and sailors, Memorial Hall was so long in coming that by 1906, it also honored Spanish American War veterans. (See October 29.)

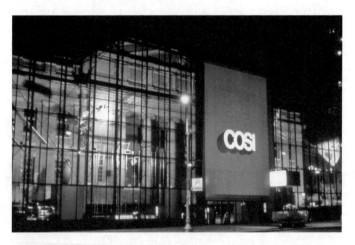

From 1964 until 1999, COSI's glass shell encased the old Memorial Hall. After COSI relocated to its present location, the county removed the glass shell and restored the building for county offices. *CML.*

August 26

In the 1920s, Gay Street was Columbus's "Wall Street," and over twenty vaults still remain though the banks disappeared (Buckeye Savings vault is now a breakfast bar in the hotel on site). But two streets over and twenty years later, Long Street had banking rights, of sorts. In 1947, there were eighteen "poor man's banks," or pawn shops. Fifteen of them were in the area around East Long and Third Streets, and three were on Mount Vernon Avenue. They were governed by the law, their own association and a sergeant who had been on pawnshop detail for eighteen years. In 1947, hours of operation were set at 8:30 a.m. to 6:00 p.m., but in the Depression, most opened at 4:30 a.m. and closed about midnight. By the 1940s, "pullers" were no longer used (men who literally pulled in customers off the street), and the shops, well regulated and cooperative with the police, appealed to people from all walks of life. Articles were kept for sixty days. In 1946, the shops loaned $100,000 to customers and $21,000 in stolen property was recovered because all shops were required to keep accurate accounts of customers and articles.

August 27

In 1972, *Columbus Dispatch* reporter James Breiner offered a critical perspective on rapid changes downtown, noting that much had been lost, like the Pe-Ru-Na building, Union Station and the August Wagner brewery. However, he noted that between 1960 and 1972, the following had been completed: the State Office Tower (30 East Broad); the Ohio National Plaza (155 East Broad); the Borden Building (180 East Broad); the Nationwide Plaza (Spring and High Streets); the Ohio Bell Headquarters (150 East Gay); and Motorists Mutual Insurance (471 East Broad). By 1972, Columbus had achieved an ironic record of proposed and hotly contested never-built buildings, including a sports arena next to Vets (1966), a sports arena next to the Ohio Center (1972), an eight-story convention center with interurban railroad depot at Rich and Front (1919) and a shopping center over the Glen Echo Park (1964) to hide a dump. In 1972, two historic properties were of special note: the boyhood home of World War I famous flying ace Eddie Rickenbacker on Livingstone Avenue that was home to Goff and Sons Roofing and Siding Company and Franklin County's first post office and oldest building on its original site, the Gift Street log cabin, owned by Harry Sells, who felt that the United States government should kick in $5,000 to save the building from being torn down. Happily, both buildings survived 1972.

August 28

An advertisement for L. Lesquereux & Sons advertised a new assortment of watches, jewelry, silverware, perfumery, clocks, canes and fancy goods at lowest cash prices in 1858. He offered wholesalers the chance to buy watches, tools and materials imported directly to him from manufacturers in England and Switzerland. His shop was located on South High, directly across from the statehouse, between the Neil and the American House Hotels. But as fine as his goods were, Lesquereux's story was finer. A jeweler from Switzerland, he was also a paleontologist, naturalist and botanist, corresponding with the men of his day, including Columbus botantist William Sullivant and Harvard University scientist Louis Agassiz. Lesquereux was one of America's most well-known scientists, but he lived his life as a jeweler. His wife acted as his interpreter because he was deaf. She had been his pupil in Switzerland, where he tutored her. She was also a countess.

August 29

The city celebrated its centennial in 1912 with much festivity in the oldest settlement in Franklinton where a Centennial Rock was dedicated—and then accidentally lost for much of the twentieth century.

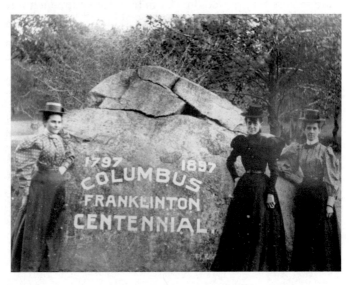

Ladies pose for a photograph in front of Centennial Rock in 1897. *IG.*

August 30

Having been president of the United States for only twenty-one days, Gerald Ford made history in 1974 by giving the first commencement address by a United States president at the Ohio State University. Speaking at St. John's Arena to the 2,500 members of the summer commencement class, he called himself the nation's "first instant vice president

President Ford makes a stop in Columbus during the 1976 campaign for president. *CML*.

and, now, America's first instant president." The president's arrival was greeted by the OSU Summer Wind Ensemble, which performed "Ruffles and Flourishes" and "Hail to the Chief." Ford joked with the crowd about his alma mater, the University of Michigan, and he remembered how it stung to lose 34–0 to the Buckeyes in his senior year in 1934.

August 31

In an effort to get a handle on how many students were not attending school under the new "compulsory school laws," J. E. Jones, the Columbus school truant officer, gave a report to Dr. J.A. Shawan, superintendent of public instruction, in 1900 before the new school year began. Ohio laws in the 1920s were effective enough that Columbus schools swelled in size, and new high schools—Central, West, North and South—were built in a relatively short period of time. However, though his report was a significant improvement over previous years, Jones reported that he made 1,750 home visits. Among his findings: 128 students were working in factories or stores; 149 students were kept home because of poverty; and 245 students were found to be truant and returned to school. In 1904, it was reported that over 200 girls under the age of fourteen worked as prostitutes, mostly in the area of the Barracks on Cleveland Avenue.

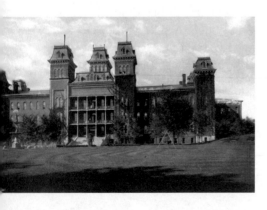

The Deaf and Dumb Institution on East Town Street opened on August 31, 1868. The presence of state institutions attracted fashionable residences on the surrounding streets. *CLF.*

September 1

The setting: a good address on a good street; 47 East Town, Columbus, Ohio; September 1, 1894; 9:00 a.m.

The characters: Mr. and Mrs. Harry Anderson, recent arrivals from Lexington, Kentucky, where Mrs. Anderson was said to be the daughter of a Baptist minister and from one of the best families of the bluegrass country.

The situation: Mrs. Anderson, described as "a woman of striking appearance…handsome, winning in manner and carried with her a smile seductive to a degree," was also known as Erdo, claiming that the mystic mantle of the departed (and supposedly famous) Gertrude Erdo, the Gypsy Queen, had fallen on her. As Erdo, Mrs. Anderson had peculiar power to help wives and husbands whose spouses' affections had been alienated or whose passion cooled. Left with jewelry or a valuable article of clothing, Mrs. Anderson (oops, sorry, Erdo) could meditate over the artifacts and win back the straying spouse.

The problem: Mr. and Mrs. Anderson did not appear for breakfast, nor were they to be found at 9:00 a.m., when victims "from some of the best families in the city" and clients of the Gypsy Queen began to appear for consultations. The Andersons' large trunk had also disappeared, along with diamond rings, necklaces, a gold watch and an expensive cape.

The lesson: Columbus citizens in the 1880s and 1890s were known by swindlers, con men, charlatans and pea-under-the-cup artists to be gullible victims, easily fleeced.

September 2

With imposing ceremonies, the cornerstone of the new Masonic Temple at North Fourth and Lynn Streets was dedicated in 1898 by the Grand Lodge of Ohio. For years, the Masons looked forward to a time when they would have a magnificent temple, and the dedication spared no expense of parades and parties. In the cornerstone was a copper box with a list of the names of the trustees and the building committee, a brief history of the city, the membership of the different lodges, copies of four newspapers, a city directory and some old coins. Presumably, they are still there. The Masonic Temple would expand, more than doubling in size, but it came perilously close to being lost until it was saved by the Ohio Preservation Alliance and became the Columbus Athenaeum in 1996.

September 3

In 1931, voters approved the removal of the trees from East Broad Street, the first step to removing the nineteenth-century carriage lanes and the widening of an already "broad street." The look that was inspired by Havana, Cuba, would be gone, though over the years, there were proposals to restore the idea.

For decades, East Broad Street was considered the most beautiful in Columbus. *CLF.*

September 4

From the viaduct in front of Union Station, President Woodrow Wilson made his first speech in favor of the ratification of the Treaty of Versailles and the formation of the League of Nations to Columbus citizens in 1919.

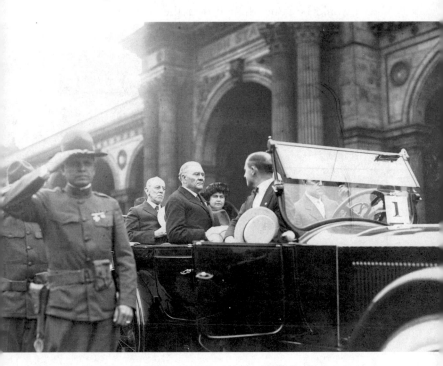

President Woodrow Wilson is pictured in front of Union Station on September 4, 1919. *CML.*

September 5

President Lyndon Johnson visited Columbus to celebrate Labor Day in 1966. Accompanying the president on his stop of three Ohio cities was Republican governor James Rhodes, who managed to talk his way into using Air Force One to go to Battle Creek, Michigan, while Johnson was in Lancaster, Ohio.

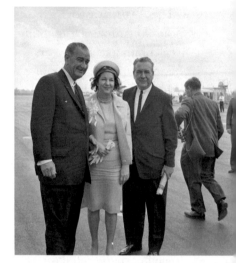

President Lyndon Johnson is pictured with Governor and Mrs. Rhodes at Port Columbus in 1966. *CML.*

September 6

The 1940s was the age of the drugstore—especially for the Mykrantz Drug Stores, operating since 1902 and celebrating its forty years with new store openings in 1942. Each store had a signature soda fountain, which was often the first item to be sold off when the drugstore converted to another business. In 1942, Mykrantz was located at 2418 East Main Street, 1945 Parsons Avenue, Parsons and Oak, 1208 West Broad Street, 2403 West Broad Street, 1 North High, 21 North Nelson Road, 2479 Cleveland Avenue, 1571 North Fourth Street, 1260 West Fifth Street, 247 King Avenue, 2520 Summit Street and 2599 North High Street (once the original site of Benchworks, an artists' cooperative, now Jack and Benny's restaurant). Does your neighborhood still have its Mykrantz?

September 7

School bells rang after Labor Day in 1953. In the *Jeffrey Service* magazine, published by and for employees of the Jeffrey Manufacturing Company in Columbus, along with stories on expert welders, employees who played in a melodrama at the sesquicentennial in the Ohio State Fair and a report that Jeffrey won the Industrial Softball championship of 1953, was a full-page feature article on "Back to School…with the Wilson Family." The Olden Wilsons, of 679 South Dexter Avenue, in Burnside Heights, were featured. Burnside was/is a west side African American neighborhood, the roots of which were in settlements from the Underground Railroad. Olden Wilson was a molder in the Gray Iron Foundry, Dept. 23, and at home were his wife, Bertha, and five children: Jean, Rita, Brenda, Mickey and the oldest and a senior at West High School, Nancy—Nancy Wilson. Ring a bell? THE Nancy Wilson who, the article noted, "was already making a real name for herself as a singer." Wilson was talented enough to win a local WTVN contest that gave her (at age fifteen) a radio show to host, and in addition to having a musical family where all types of music was listened to, she credited the jukebox at the local store as a factor in learning the popular arrangements of the day. What started in a little corner store in a modest neighborhood (that is still there) ended with a career of more than seventy albums and three Grammy awards.

September 8

It was official—why? Because a practicing physician said it was so in 1910. On this day, Columbus men and women learned that modern architecture was the curse of families. Gambling, extravagance and drinking were due to the fact that housekeeping was no longer a task. The good doctor said mechanical cleaning apparatus created indolence. Modern architecture designed apartments with everything planned to minimize housework, and that led to high living in restaurants, alcoholic stimulants, lack of rest and improper breakfasts. Oh, could it happen here? Columbus women hoped so.

September 9

Bill Moose was born on this date in 1837 and lived within two months of turning one hundred in 1937. In his long life, his people's history, the city's history and Ohio history were interwoven. He was said to have been the last link, the last of the Wyandot Indians. When the Wyandots left Ohio, twelve families, including the Moose family, remained at their old campground. He managed to get a "common school education" and even attended a trade school in Philadelphia. For nine years, Bill Moose traveled with the Columbus-based Sells Brothers Circus. He never married and was a Republican who cast his last vote for Abraham Lincoln. By 1918, Bill Moose settled in Columbus and lived for years on Morse Road near the Pennsylvania railroad tracks in a cabin he built for himself. Here it was said that he probably saved many lives because he reported broken rails to the company, and it in turn gave him money for each one he found and allowed him to live on company land. For the last fifteen years of his life, he was taken care of in a Franklin County home, and when he died, a special committee was named to handle arrangements because so many mourners were anticipated. The funeral was held at P.E. Rutherford Funeral Home at North High and Blake Avenues. Bill Rutherford, son of the owner, still remembers being put on the front step to count all those who came to pay respects, but he realized later that his important task was really just to keep him out of the way.

September 10

On this day in 2012, Resch's Bakery celebrated its 100th anniversary. Frank Resch and his nephew William opened their bakery at 1029 East Livingston Avenue, at the corner of Champion Avenue. According to family history, the family came from the Black Forest region of Germany in 1906 and moved to Columbus when they heard there was a large Germany community there. Uncle and nephew worked in a bakery, and having learned the trade and art of baking, they discussed opening their own. The owner, overhearing them, ended their careers with his operation, calling them "ungrateful immigrants." The present bakery at 4061 East Livingston is still operated by fifth-generation Resch family members.

September 11

The headline of the *Columbus Dispatch* read "The Day of Terror" in 2001, and the next day, local reaction to the attacks on the World Trade Center, the Pentagon and Shanksville, Pennsylvania, was of utter horror and total shock. In the chaos of the first media reports and over the next few days, Columbus police and Ohio highway patrol units were dispatched to Port Columbus and OSU Don Scott Airports in a defensive mode. Downtown Columbus office buildings were evacuated on the day of the attack. Workers were sent home, and parents picked up distraught children. Air traffic was suspended for three days. Columbus residents recalled seeing Air Force One, escorted by fighter jets, flying overhead as President George W. Bush flew back to Washington, D.C. Plans were made to send firefighters and medical assistance to the East Coast. People rushed to give blood at special sites set up in anticipation of what would be needed in New York. Sadly, little blood was needed as the death toll mounted.

September 12

Jarvis Pike, at age twenty-one in 1816, became the first mayor of Columbus. One of his first jobs as mayor was to dig out the tree stumps on High Street and the statehouse grounds where citizens grazed their animals.

September 13

Lyne Starling wrote to his sister in Kentucky in 1812 that there is "nothing here but the sound of war." Starling was one of the four founders of Columbus, and his sister, Sarah Starling, was married to Franklinton founder Lucas Sullivant. During the War of 1812, Franklinton became a center of military activity with troops stationed there. One of the more notable incidents that occurred in wartime Franklinton was the explosion of a church in the Franklinton Pioneer Cemetery. The church was commandeered for grain storage to feed the troops, but when a heavy rain leaked through the roof, the grain inside swelled to the point that it burst open the walls of the building.

September 14

In 1906, there was no one like her. Alice Roosevelt Longworth arrived in Columbus to dedicate the memorial to martyred President McKinley in front of the statehouse. "Princess" Alice was the oldest daughter of former president Teddy Roosevelt and married to Nicholas Longworth, an Ohio congressman from Cincinnati. In 1906 at age twenty-two, she was as pretty as her cousin Eleanor was plain. Her whereabouts were kept secret when she arrived in Columbus, but still the crowd was estimated to be fifty thousand. People mobbed her, and some crawled under the speakers' platform to avoid being crushed. Alice took refuge in the governor's office and then escaped to the Outlook Building at 44 East Broad. Eventually, she and her party holed up at the Hartman Hotel before they left for Cincinnati. She remarked many years later, "Crowds, crowds... Yes, I've seen them all over the world, but I never saw anything that could compare with this." Poor Ida, McKinley's widow, was eclipsed by the spectacle. The McKinley monument had been placed facing the Neil House, where he and Ida had once resided when McKinley was governor of Ohio. Ida, an invalid, had a red carnation delivered each morning for his coat, and each morning when he went to the statehouse, he turned to wave to her on the spot where the monument was later placed. If he was in his office at 3:00 p.m. each day, he lowered the window shade as a secret sign of love that she could see from her window. His dying words were, "Be careful how you tell Ida."

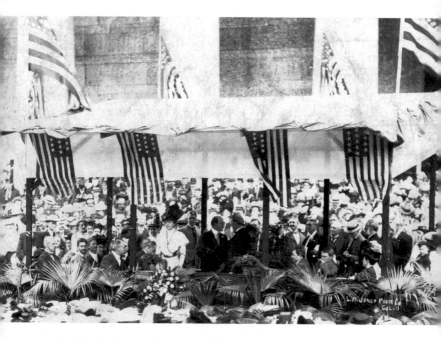

President Teddy Roosevelt's daughter, Alice Roosevelt Longworth, dedicates the McKinley monument at the statehouse in 1906. *CML.*

September 15

At the place where the Scioto River is closest to the Watermark condominiums is the spot where Columbus rejoiced in 1831 when the feeder canal connected Lockbourne and Columbus and the world. Two days earlier, the first water of the canal met the water of the river. On this day, the first canal boat, the *Governor Brown*, arrived from Circleville. People and cargo could travel by boat from the Great Lakes to the Ohio River and, once there, could sail the world. With this new improvement, Columbus went from looking like a primitive frontier town into a provincial capital. Of course, at the entrance to the canal, the area quickly filled with warehouses, taverns and docks. The first Catholic Mass was celebrated in a canal tavern.

September 16

Abraham Lincoln made his first address in Ohio at the statehouse on the East Terrace in 1859. He stayed at the Neil House hotel.

In 1870, the B'nai Israel Temple was completed, and the congregation marched from its old home on Town Street to the new temple. The new building was brick with limestone trim in a popular "villa" style, including a mansard roof and twin towers trimmed with minaret corners. The cornerstone had been laid with great ceremony and included presentations by the Masons, the Maennerchor, the Odd Fellows and B'nai B'rith.

September 17

They came on foot, by carriage and by horse almost three miles from downtown and the Union Railway Station in 1873. They brought food, clothing, pencils, some books, paper and a good attitude (though no beer was reported). Travelling up the Worthington Pike and past the old North Graveyard, they passed a few farmhouses but generally saw only trees and fields. Their destination was a farm—the Neil farm— and the two dozen young men assembled to begin their studies at the new Ohio Agricultural and Mechanical College. Within a year, they would be joined by another three dozen students and seven faculty members, all living and taking classes in the unfinished University Hall, where the sounds of hammering were still heard.

Two years before, with the death of William Neil, the areas around the university were poised for change. On January 4, 1871, a small ad appeared in the *Ohio State Journal*, "Desirable Building Lots for Sale. I have subdivided into lots of different sizes from one to six acres each to suit buyers the forty acre tract of land lying between the City and the Agricultural and Mechanical College grounds. The land is beautifully situated and will be sold on time to purchasers. For terms of sale, refer to Collins and Atkinson, my attorneys. Mrs. E.J. McMillian." Mrs. McMillian was the late William Neil's daughter. In 1878, the college was renamed The Ohio State University. No word as to when the first pizza establishment opened.

September 18

Columbus was experiencing a building boom in 1926. In August 1926, Columbus had been fourteenth in the country in building permits (despite being only twenty-seventh in population), outranking Cincinnati and coming in second to Cleveland (again with the envy). The city was spreading—especially westward, with over a dozen new storefronts on Sullivant Avenue. With the recent laying out of new subdivisions on the west side and Hilltop areas and new improvements on the streets, it did not seem to matter than Sullivant Avenue did not touch High Street. In one month, 34 new homes had been built with 128 planned in Barnett's subdivision.

September 19

In 1987, Mrs. Margaret Evans Lyons sat down in her living room to talk about her remembrances of the south side. She had an intimate childhood connection to the Bonney-Floyd Company since her parents were caretakers of what amounted to a rural estate surrounding a factory on Parsons Avenue. As an only child growing up in a relatively isolated and adult world, Uncle Walter (Mr. Floyd) made her a nine- by twelve-foot playhouse complete with a porch, picket fence, electric lights and a gas stove. Mr. Floyd's male secretary was sometimes sent all the way to Livingston Avenue and South High to Erlenbush's for ice cream. Only the best for "Baby." Her parents maintained three acres of lawn, flowerbeds, livestock, vegetable gardens, pasture land and a farmhouse. Although she had a sandbox half the size of an average living room, filled with new sand each spring, she preferred playing in the forbidden old barn where the wooden steel patterns were kept.

September 20

A full page advertisement in the *Columbus Dispatch* read, "Central Ohio's Best Known Steak House Now More Spacious-Beautiful." Frank Kondos, owner of the Clarmont Steak House, said in 1954, "This is the proudest week in my thirty-five years of restaurant operation…a week when I can at last throw open to the public the carefully planned and beautifully executed new lounge and dining room, modernized and enlarged kitchen and an artistically beautiful foyer where you may rest and relax in comfort. It is 'the Clarmont Appreciation week.'" The work of Kellam & Foley architects, the Clarmont's charm never tarnished. The politics of the many breakfast meetings made it the place to be seen. The waitstaff never wrote down an order but always had it right, and the steaks remained the specialty even as it closed suddenly in 2012.

John J. Lentz dedicates the AIU Citadel in 1927. *CML.*

Two days of celebration were in store for Columbusites in 1927 with the dedication of the American Insurance Union Citadel (AIU) at North Front and West Broad. The building was the fifth-tallest in the world at the time of its dedication—555 feet and 5 inches—designed by C. Howard Crane, a theater architect from Detroit, and purposely 5 inches taller than the Washington Monument. An art deco marvel with heavy ornamentation inside and out that acknowledged a variety of world cultures and mythologies on its white shag terra-cotta exterior, the AIU was the brainchild of John Lentz, a self-promoting businessman and politician. Lentz advocated for laws to protect children in the workplace and other progressive agendas, but he was best known for advocating affordable insurance for families. The building became the LeVeque-Lincoln Tower and later, the LeVeque Tower in 1977.

September 22

In 1934, Charles Makley and Harry Pierpont, two members of the Dillinger bank robbery gang, tried to escape from the Ohio Penitentiary. Both men were on death row for the killing of Sheriff James Sarber in Lima, Ohio. Inspired by a successful jailbreak in Indiana by John Dillinger, they carved fake guns out of soap and coated them with shoe polish to bluff their way free. Makley's and Pierpont's plans went awry, however. Makley was killed in the attempt. Pierpont, a soft-spoken man said to be the brains behind the Dillinger gang, suffered severe injuries. Pierpont was kept alive long enough to be executed in the electric chair a few weeks later on October 17, 1934. Sheriff Sarber's descendants live in Columbus.

September 23

Fresh from his historic role in the Arab-Israel settlement, President Jimmy Carter traveled to Columbus in 1978 to dedicate the Mount Vernon Plaza, an African American–owned commercial and residential development on the Near East Side. The dedication highlighted the federally insured project of townhouses, an apartment building, a shopping center and an existing fire station turned daycare. Mount Vernon Avenue had once been a lively street on the Near East Side, documented by local scholar the late Dr. Anna Bishop as the "Blackberry Patch" of her childhood and by the murals and books of Aminah Robinson. It was also known as Bronzeville in the late 1930s, having been one of only a few cities to use that term to indicate it was a strong and proud community capable of representing its interests to the city. Marvin Bonowitz, historian and member of the Jewish Historical Society, also wrote a book based on oral histories when the street was filled with Jewish and African American commerce, a theme also captured by writer Wil Haygood in the *Haygoods of Columbus*.

September 24

Considering there was a war on—not just World War I but also a war over temperance, immigration and values—the Columbus distributors of Anheuser-Busch beer products tried a new approach in 1914 to link their product with the "right side" (whatever side that was). They proclaimed, "Of all Human Blessing, Personal Liberty is Prized the Highest—Every American would sacrifice his fortune and his life to perpetuate the freedom guaranteed by the Constitution of the United States. Americans holding such ideals have built the name and established the fame of Budweiser."

September 25

St. Patrick's parish was established 1852 and the church opened in 1853, with a school in 1854 at Grant (then Seventh Street) and Naghten Street to serve the needs of the non-German speaking Catholics—meaning the mostly English-speaking Irish. The Flat Iron (Higgens Building) and St. Patrick's Church are reminders of when Naghten was known as Irish Broadway (Naghten was the first Irish Catholic president of city council), and it was said that there were enough saloons and places of amusement on the edge of the Badlands that one could receive a paycheck on a Friday night from working in the buggy factories, take part in pleasures of the street and then finish with early Sunday Mass at St. Patrick's. One visitor to Columbus who departed Union Station in the early 1900s and turned east in search of a hotel commented that she had never seen—not even in Boston or New York—so many poor white people in one area. There were many ragged children who played in the streets, and over the years, a persistent story emerged of a crying ghost child who wanders the streets, carrying a pair of shoes that are far too large for her. Perhaps the visitor to Columbus didn't see her, but many others have over the years.

September 26

Yet another Deshler home would become part of the Catholic diocese in 1926 when Martha Deshler's property on East Broad, near Big Walnut Creek, was converted into a shrine dedicated to St. Therese of Lisieux, the "Little Flower" who had been canonized in 1925 and had strong followers among World War I veterans. The parlors of the home were converted into a chapel where daily mass was said.

St. Therese of Lisieux was built on the former Deshler family property. *CML.*

September 27

In 1934, Forester's Restaurant, a popular downtown lunch and dinner spot with a new soda fountain, served lunch specials ranging from fifteen cents to twenty-five cents—the low end was a frankfurter and potato salad and the high end was scalloped potatoes and ham with cream slaw. Open seven days a week from 11:00 a.m. to 11:00 p.m. at 201 South High Street, Forester's magnificent exterior "restaurant" sign remains though the interior has greatly changed to become Novo's.

September 28

In 1865, the *Daily Ohio Statesman* announced that the Tripler Hospital had been chosen for use as a soldiers' home. The hospital, located in Franklinton, had been built to treat Union soldiers, and it contained twelve wards with forty beds each. The soldiers staying there lauded it as "a pleasant home for weary ones." Though it opened in 1864, its life as a hospital was short-lived because the Civil War soon ended. Following a whirlwind of remodeling, a soldiers' home opened in the hospital in October 1865. However, this too closed after a few years when the National Soldiers' and Sailors' Home in Dayton opened.

September 29

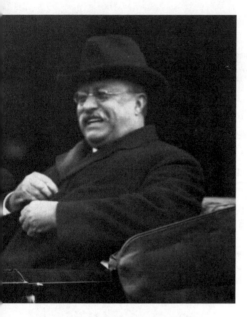

Former president Theodore Roosevelt returned to Columbus on September 29, 1918, to dedicate the Franklin County Soldiers Memorial. *CML.*

In 2011, the Athletic Club of Columbus was placed on the National Register of Historic Places. The six-story brick clubhouse at 136 East Broad Street was built in 1915 and designed by Richards, McCarty & Bulford. Frank Packard served as advisory architect. In 1912, the Athletic Club of Columbus was founded by a group of business professionals interested in promoting both social and athletic endeavors. The façade has changed very little since its dedication in 1915, and the choice of brick seems to have been made in a most democratic way (for a private club)—skids of brick were set up on the street and passersby could choose their favorite. The site, purchased by Samuel Hartman for the club, was the former site of the Esther Institute, a girls' school before the Civil War and a makeshift hospital during the war.

September 30

The Germans were bombing Antwerp. The French were routing the German line. In Columbus, the superintendent of the parks was suspending the caretaker of Goodale Park in 1914 on the grounds of incompetency, gross neglect of duty, failure to carry out orders given by proper authority (sounds very military, doesn't it?) and discharging a firearm unlawfully. He was fined fifteen dollars and costs for having discharged the gun in city limits, firing three shots to frighten three boys he had arrested but who escaped. The police noted that the caretaker had been in the habit of doing considerable "promiscuous shooting" about the park.

October 1

In 1914, the Jewish community of Columbus raised almost $700 in cash at a mass meeting at Agudas Achim synagogue, with expectations that the amount would swell to $3,000. The aid was to relieve the Jewish immigrants from Russia at the close of the European war. More than 250,000 Jewish immigrants had already arrived in the United States during the war. The meeting closed the Jewish Day of Atonement, Yom Kippur, with more than seven hundred in attendance.

October 2

The heart of Columbus, the corners of Broad and High Streets, has also been the conscience and the pulse of Columbus—hosting war bond drives, fortune seekers off for gold strikes, suffragettes and farmers, soldiers and students, abolitionists and presidents, strikers and reform movements, marches, rallies, Hungarian supporters and victory celebrations and even an occasional runaway steer—but in 1914, it seemed a little weird. Bales of cotton piled up and continued to pile up. The Columbus Chamber of Commerce started a "Buy a Bale of Cotton" movement. The Civil War had been over less than fifty years, and a campaign was launched to save Southern plantations from bankruptcy. The campaign had been started by Billow-Lupfer Company, of 231 West Mound Street, which brought bales of cotton at its own expense to sell in Columbus (the going rate was ten cents per pound). Upon buying the cotton, the purchaser agreed to hold it in storage for a year until cotton prices, disrupted by the Great War, went up. Women's clubs promoted the buying of cotton, reminding, "Try [to] make as many Christmas presents of cotton materials as possible…Dainty aprons and caps are always acceptable…if Cotton is King, Dame Fashion will make a splendid consort." (The power of buying American or buying local aside, saving the post-Reconstruction, tenant-farming South by making Dame Fashion a consort is just plain weird.)

October 3

On the other hand (yes, we are still in World War I), if the South was losing money, Columbus was making money in 1914 because of the war. Columbus was a town capable of delivering manufactured goods based on its excellent railroad system and industrialist connections. In many ways, World War I solidified the fortunes that would impact the city in urban planning, paternalistic politics and the arts and culture for generations. Early in the war, the Kilbourne-Jacobs Company, operating north of downtown near the Panhandle shops, shipped machinery for the manufacture of guns to Portugal and also worked on war orders for one thousand transport wagons. The Jeffrey Manufacturing Company manufactured parts of automobile trucks to be sent to France for assembly. At the height of the war, it was not unusual for deals to be made in the newly established Athletic Club as foreign buyers for European governments came looking for metal products, saws and equipment related to carriage and buggy manufacturers. Charles Allen was shipping cavalry horses for the English government. Charles Pavey, one of the largest suppliers of horses for the Belgian army, moved his operations from North High Street north of Ohio State to the fairgrounds. The prosperity of Columbus was in stark contrast to the towns east and south of Columbus and Franklin County from which many Columbus natives drew their roots. More than a dozen coal mining towns were facing a winter of starvation and illness.

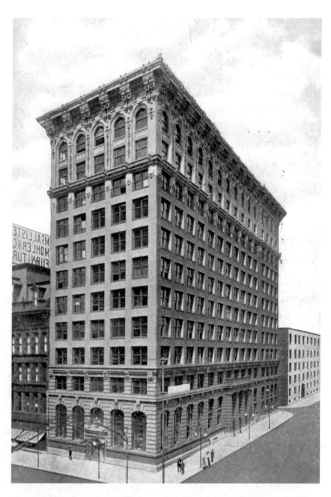

The Ohio Club, on the twelfth floor of the Ohio Savings and Trust Building (now known as the Atlas Building), would later merge with the newly formed Athletic Club of Columbus in 1912. By World War I, the Athletic Club was the site of many business deals involving the war. *CML*.

October 4

The most ambitious building to be built in Columbus was announced in 1953—the Temple of Good Will, designed to be taller than the LeVeque Tower and serve as headquarters for all the Protestant denominations of the United States. The purchased site covered two city blocks facing the Scioto River between West Long and West Spring Streets. Construction would start for a hotel, broadcast facilities, office space for five thousand workers and parking as soon as $330,000 could be raised. Dr. B.F. Lamb, president of the Ohio Council of Churches, convinced many that Columbus was the ideal location. However, by 1968, the Ohio Council of Churches voted against making Columbus its headquarters. The net worth of the property (that now included the Smith Shoe factory, lots east of the factory and the Chittenden Hotel) was valued at $3.5 million. The city donated 1.5 acres of streets and alleys, including Marconi Drive. The State of Ohio offered $1.75 million for the site in 1965 to build a new Ohio Historical Center, but it was considered "ridiculously low" by Dr. Lamb, who changed his mind in three weeks. However, the State had already decided to build a new museum near the fairgrounds. The site was sold to Nationwide Insurance for the low price of $1.75 million—later revealed to balance only part of debt held by Nationwide. Dr. Lamb continued to live in his Upper Arlington home, paid for by the Ohio Council of Churches.

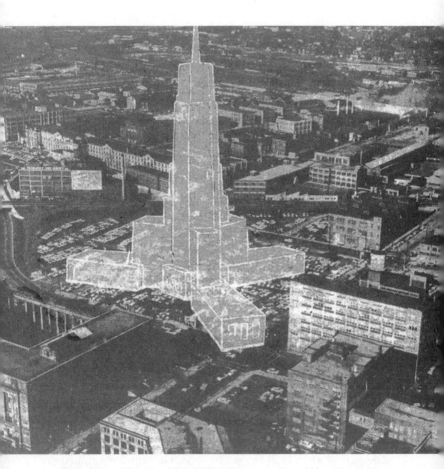

The proposed Temple of Good Will that never was would have been the tallest structure in Columbus in 1953. *CML*.

October 5

The Open Air School, at Neil and Hudson Avenues, opened as the first specialty school in Columbus in 1928. It drew its enrollment from the underweight and physically disabled children of all Columbus schools and offered courses in hygiene and wellness, targeting those children who might be most susceptible to T.B. and respiratory illnesses. It was thought that a location on the Olentangy River would be conducive to fresh air. Children's studies were planned around snacks and meals and naps—which were taken outside, even in winter, but with many layers of blankets.

October 6

In 1966, Schiller Park was the site of the German Village Society's first Octoberfest, actually held in October. It was actually not an Augustfest, a Septemberfest or a Novemberfest.

An early 1900s view of Schiller Park, renamed Washington Park during World War I. *CML.*

October 7

Two weeks before its official dedication, Ohio State University's new Ohio Stadium was the site of the first official OSU football game in 1922. OSU lost to Ohio Wesleyan, but the Ohio Stadium, designed by University architect Howard Dwight Smith, and his horseshoe design were winners. Smith won a gold medal for his design of the concrete structure.

An aerial view of Ohio Stadium at the Ohio State University shows the unique horseshoe design.

October 8

In 1969, a small herd of buffalo and deer were the first animals to arrive for an American Plains Animal Reserve to be built at the new Anheuser-Busch Brewery on Shrock Road.

October 9

Each side accused the other of land grabbing in 1953. Columbus and Upper Arlington had been engaged in such hostile conversations about annexations that a committee was set up to dig out the facts when certain townships were being considered for annexation or incorporation. The three-member committee reported that Mifflin Township was almost annexed to Columbus before a group to be formed to oppose the move; Columbus made overtures for the industrial sites in Marion Township but did not want the residential areas, with their meager tax base; and Upper Arlington worked through the Perry Township school board to annex a segment of the township north of McCoy Road. Perry Township, because of the number of groups supporting or opposing the annexation, was now being called "Petition Township."

October 10

In 1900, the Ohio Statehouse still kept a curious relic—a mad stone—a cure for those who faced hydrophobia after the bite of a rabid animal. Supposedly, rubbing the stone on the infected point of entry or wound would cure the victim. No word of whatever happened to the mad stone.

October 11

On Ohio Field, located on North High Street near Woodruff and where Ohio State football became popularized by player Chic Harley, a touching tribute was made to Cecil Fanning in 1918. He was classically trained, made his debut in England and sang before royalty. He directed the choir at Bryden Road Temple and First Methodist Church. Cecil Fanning was an American baritone who arranged a "community sing" at Ohio Field. A few weeks before the "sing," Fanning had sung at a special program to honor Booker T. Washington, prominent educator, singing songs by the African American composer H.T. Burleigh. During a lull in the "sing" at Ohio Field, Elliot B. Henderson, a poet and "artistic and patriotic" leader in the African American community, approached and presented a proclamation to Fanning "as a token of appreciation by the colored citizens of Columbus." Fanning's tombstone in Mount Calvary Cemetery is adorned with a staff containing a clef and two notes.

October 12

Flags flew from all the buildings and residences and schools. All city offices (with the exception of the public services) closed, and all local Italians paraded and held speeches in celebration of Columbus Day in 1914. They formed the parade at Rich and High Streets at 1:00 p.m., led by Nick Albanese and Salvatore Bova as marshals and Cincione's band for marching music, parading to Third Street to Broad, Broad to High and north on High to Goodale Park. (Cincione's band was not just a band but rather an entire army of musicians, starting with brothers Alphonese and Phillip, who taught nephews Ray and Henry. Musically trained in Italy, Phillip also played with John Philip Sousa, and both brothers later played at a variety of theaters. The nephews played at the Gloria Nightclub and for Hollywood stars in the 1940s. Fireworks in the shape of Columbus's ship *Santa Maria* concluded the event.

October 13

Rumors swirled for weeks, and then in 1901 there was a letter to the editor of the *Columbus Dispatch*, stating that though it had been twenty years since Robert Wolfe, the president of the Wolfe Bros. Shoe Company, was sentenced to an Indiana Penitentiary for intent to kill, he was being blackmailed for his past. The letter was written by Wolfe's lawyer for the newspaper Wolfe owned.

Columbus learned Wolfe was a poor kid who struggled to help his family. Visiting relatives in Indiana, he defended his sixteen-year-old cousin, who was slandered by a resident of the village. Wolfe, revolver in hand, confronted the man and was accused of assault to kill. In jail, fearing mob justice, he escaped, was captured and pled guilty for a lessened sentence. He knew shoemaking and was placed in that prison department where he invented mechanical improvements to improve the production. Released from prison, Wolfe began repairing shoes and was joined by his younger brother at the H.C. Godman Shoe Company. In their spare time, Harry made shoes, and Robert sold them on the road. In 1894, they launched the Wolfe Bros. Shoe Company. Their first diversified investment was the purchase of the *Ohio State Journal* in 1903 and the *Columbus Evening Dispatch* in 1905. More investments and wealth would come later, but in 1901, Robert Wolfe was only facing full disclosure about a youthful misdeed.

October 14

Following the successful and widely covered "round the world" flight of the dirigible airship *Graf Zeppelin*, the *Columbus Dispatch* reported that the world-famous airship would likely visit Columbus with the "assurance of flight over Dayton [that] practically makes certain the view of the dirigible by Columbus and Central Ohio" in 1928. Although never making a stop, the famous airship would indeed fly low over Columbus many times, most notably on its way to the 1932 Chicago World's Fair. Noted Columbus developer Don Casto flew aboard the famous and luxurious zeppelin as a passenger in 1928 on a voyage from Germany to Lakehurst, New Jersey. Convinced that aviation would play a huge role in the future of Columbus, Casto used the trip to attract attention and generate publicity for a city bond issue to construct an airport (it had failed the previous year). With the publicity Casto generated from his trip, Columbus voters approved the bond issue on a second vote. The AIU citadel, also known as the LeVeque Tower, was constructed on top to accommodate a mooring dock for zeppelins. Imagine that.

October 15

Based on the many speeches, marches and lobby groups that descended on the Ohio Statehouse, the *Columbus Citizen Journal* newspaper in 1914 took a bold step by endorsing women's suffrage. There was no rhetoric or flowery language. The paper's arguments were well reasoned: "It is outrage to deny them [women] equal rights with men while we make them carry men's burdens... When their husbands are dead, or are drunkards, or are in jail, the women support the children and do it bravely and efficiently. They pay taxes for the support of a government in which they have no voice...There are 18 men in prison in the United States for every woman who is behind bars...Look over the graduating class in the nearest high school and see if there are not two girls there for every boy. In Ohio there are 12,000 more men who can neither read nor write than women...If physical ability to go to war is a necessary qualification for a voter, then three-fourths of men over 30 years of age should be disenfranchised...Seven thousand gentlewomen marched through the streets of Cleveland a week or so ago, as a plea for suffrage. Similar parades have been held in the past in Columbus. It is only simple justice that they should be recognized as the legal equal of men, as they are at least men's equal in all the elements of good citizenship." The men yawned. The issue went down to defeat.

October 16

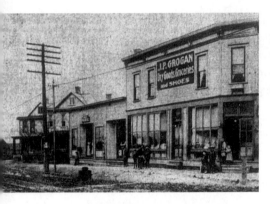

A rare photo from the 1900s of J.P. Grogan Store. The predominantly Irish neighborhood became known as Milo-Grogan. *CML.*

After more than a year of wrangling, heated debate and quiet under-the-table offers, it was official in 1908. The community of Milo decided to be annexed into the City of Columbus. While other villages and unincorporated areas often tried to dodge annexation, fearing that it might not be an advantage to have to heed Columbus's laws, Milo voted 270 "yes" to 68 "no" to join. It was the second time in a year that the issue had come up, but this time the annexation also included the Panhandle shops of the railroad. J.P. Grogan, a merchant who lived north of Milo in Grogan, also wanted the annexation. Happy with their own school system (today the Milo Arts Castle), residents wanted the better streets and sewage system promised by the city, and they were willing to pay higher taxes. That was fine with the city; it was already eyeing the new revenue for long-overdue sewer repairs on the south side.

October 17

Parsons Avenue merchants ended their four days of street celebration in 1926. Prizes had been awarded for the best decorated automobile or float entered into the street parade. Street dancing, rides, shows and athletic stunts were held. A beauty contest for any girl over the age of sixteen and living on Parsons Avenue was held.

October 18

The *Columbus Star*, a scandal sheet that heavily relied on a sort of Fred McMurray/Barbara Stanwick noir mentality (with pinups and detective stories thrown in), asked readers if their families were prepared in case of an atomic attack on Central Ohio in 1958. Six people responded—no names are given in case they still have relatives in town (mind you, this was in response to an ATOMIC BOMB attack):

"I haven't thought too much about it. We live fifteen miles from Broad and High. We don't have a basement, but I wish we did. I'm depending on the nation's defense system."

"No, but we've thought about it. We've no basement, but we think our hallway would give good protection. We do have food and medical supplies on hand."

"We've thought about it but we haven't been able to get to it yet."

"As for digging a shelter in the ground, I don't think it's necessary. I do know first aid."

"Being prepared is a good idea, but I just haven't gotten around to it just yet."

"We always have plenty of canned goods on hand. A bomb shelter is too expensive."

October 19

Monday was usually washday in the neighborhood of 164 East Russell Street (in Italian Village), but on this day in 1914, most women spent the day sitting by postholes in an alley next to their homes. They prevented workers from putting up a fence that would cut off an alley and also cut off the entrance to the rear of their houses. The alley in question was the first west of North Fourth Street, running north from Russell. The alley, according to a few women who had set up comfortable chairs in the street by the postholes, had never been dedicated and was technically owned by J.W. Davy of 59 King Avenue. They didn't object to the fence as much as to the house that was now being built in the alley. When workmen entered the alley with wire fencing and posts, they only finished two postholes before a neighborhood "war council" descended on them and ended with the women sitting over the postholes and the workmen in retreat. At lunchtime, three of the women—Mrs. Canfield, Mrs. Ijams and Mrs. Williams—were relieved of picket duty by other women in the neighborhood. The neighborhood sought an injunction to have the work stopped and the alley made official.

October 20

President Richard Nixon campaigned at the statehouse for Republicans Robert Taft Jr. for United States Senate and Roger Cloud for governor in 1970. Arriving at Port Columbus, Nixon was greeted with large crowds along his motorcade route to downtown. OSU coach Woody Hayes warmed up the crowd of thousands and noted that in addition to being happy to greet Nixon, he regarded the president as a good omen for the Ohio State football fortunes. Hayes noted that in 1957, then vice president Nixon came to watch the Buckeyes play Iowa, and OSU won the game and the national championship. Nixon may have been a good omen for OSU football in 1970. The team won every game (9–0) that year but lost the Rose Bowl on January 1, 1971.

October 21

Bob Hope and President Gerald Ford were among the luminaries who rededicated the Ohio Theater in 1977 after it was close to being demolished.

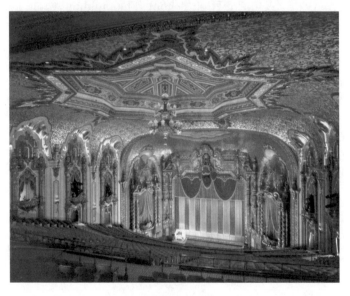

The Ohio Theater, opened in 1928, was designed by Thomas Lamb and is now home to the Columbus Symphony Orchestra. *CML.*

October 22

The American Architect in 1922 announced that the new high school to be built in Columbus, Ohio, as part of the Civic Center would be named Washington Gladden Technical High School. The building would be constructed as an extension of a new civic spirit. It would use the most prominent spot in downtown and on the river, constructing a Greek classical building of Indiana limestone—and a limestone (not brick) building was possible because taxpayers were willing to spend $50,000 more for a stone exterior. The building did, indeed, come to be built with every feature and amenity planned and only one exception—the name became Central High School, and Washington Gladden, founder of the Social Gospel movement that spread across the United States, was never honored by the naming of this school.

October 23

In 1914, the Glen Echo viaduct was formally opened with an automobile parade and fireworks and five candidates for mayor who strutted for attention. The Glen Echo quartet sang. So imagine how surprised the residents of Clintonville and Glen Echo South were to learn—exactly one year to the day later—a major hospital was planned for over the viaduct in 1915. Glen Echo was already owned by the board of trustees of the White Cross hospital that proposed building a campus of new facilities, including maternity, medical, contagious and laboratory facilities, as well as a power plant and nurses' home. The architects were already showing renderings. The board was convinced that it was operating on a business plan that could pay for itself even if a large number of its cases were charitable. The plan for that site was shelved, and the new facilities (Riverside Hospital today) would be built later.

October 24

Glick Furniture store started in 1907 in the first blocks of East Long Street by Robert Glick and his son, Frank. Though the business was only six years old at the time of the 1913 flood, the company forgave the debts of its customers who lost everything in the flood. Glick's left the Long Street store in 1974. The store was originally known as Arch City Furniture for the many arches that lined High Street. Eventually, Glick's would also open at Northern Lights Shopping Center, Town and Country Shopping Center and Great West Shopping Center and expand to Eastland Shopping Center.

October 25

Although he claimed to have made up the mnemonic device while spending a night in jail in 1920, a self-proclaimed "mayor" of Flytown was wrong. The saying was far older. The well-known children's saying for remembering the order of Columbus's downtown streets (starting south and going north) was "Mr. Livingston Fulton lived on Mound and Main; he got so Rich, he bought a Town within the State he lived. He went a'Broad and walked along and felt so Gay that he tried to Spring a Chestnut on Mr. Naghten." A "chestnut" also meant a "trick."

October 26

Welcomed at Union Station by OSU football coach Woody Hayes, Vice President Richard Nixon made a campaign stop in 1960, assailing his opponent, John Kennedy. Kennedy had said that the Soviets were stronger than Americans. Police Chief Sholer estimated the crowd at seventy-five thousand people on the grounds of the statehouse. Nixon boasted that he received a larger crowd than Senator Kennedy, who had given a speech at the statehouse ten days earlier.

October 27

"Civic pride demanded it," said Mayor Karb. The new city hall and the Civic Center Plan should never be built unless "those miserable looking, broken-windowed, soot-covered, disheveled, old rickety buildings disfiguring Front Street between Gay and Broad Streets were removed!" In 1926, Mayor Karb announced he would personally head an organization to fight for the passage of the $1.1 million bond to raze the eyesores. The Chamber of Commerce echoed its support, saying, "We feel satisfied that Columbus has gained one more point in her struggle for recognition as 'The One Best City in the Central States.'" (We were struggling for this actual title?) Mayor Karb, ever persuasive, probably won on the basis of using so many adjectives.

October 28

It was as if they couldn't wait to print the headline—"Butcher Chokes His Paramour to Death and then Surrenders." In 1914, "with the fury of a wild beast, prompted by jealousy, George Meier, 27, a Central Market meat dealer, of 616 West State Street, attacked Mrs. Josie Garner, 24, in her home, 624 West Chapel Street, about midnight Tuesday and choked her to death, biting and mutilating her body." At the same time, Mrs. Meier was at the city prison filing a complaint on her husband because he paid too much attention to Mrs. Garner. Meier turned himself in at Engine House No. 6, and trembling from the effects of drink, he claimed insanity. Meier later testified that when he arrived at Garner's house, another man was there but left to get beer. Alone with Garner, Meier became enraged at her seeing someone else. He said he "could not resist her wiles and that she had only to motion to him to compel him to go to her."

Arnold Schwarzenegger, Bruce Willis and the Oak Ridge Boys greeted President George H.W. Bush at a reelection campaign rally at Nationwide Plaza in 1992. An estimated five thousand were in attendance. Spotting a sign in the crowd that said, "Keep Millie in the White House," referring to Bush's dog, Bush said when he wanted foreign policy advice he would go to Millie before he would go to Clinton. The line was repeated on late-night comedy shows.

October 29

In 1909, $2,000 worth of tickets had to be refunded when famous dancer Isadora Duncan decided at 4:00 p.m. on the day of her performance that she would not dance on the Memorial Hall stage, saying the stage floor was too high, the ceiling was too low and the floor did not have a small slant, making it impossible for her feet to be seen by the audience. The performance was quickly shifted to the Southern Theater, which held only 1,600 seats. Mrs. Huntington, wife of a prominent banker (see January 2), was quoted as saying Duncan was "tempermental." (See August 25.)

October 30

The first free cancer clinic in the United States was established in Columbus at 499 Oak Street in 1921. The building had been purchased by the Rotary and given to the Columbus Society for the Prevention and Cure of Tuberculosis. The building was originally a double residence and proved to be large enough to house both the cancer clinic and the tuberculosis society. Mrs. Samuel, president of both organizations, proposed the combined use (she was both the mayor's wife and Dr. Carrie Nelson Black). Between the years of 1921 and 1926, over 1,200 people were screened for tuberculosis for no charge. Within the first months of 1926, 54 applicants had been screened, 38 reexamined and 8 found to have tuberculosis.

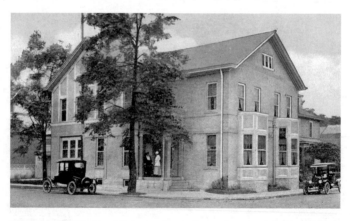

The Columbus Cancer Clinic was located near Grant and St. Francis Hospital. *CLF.*

October 31

Columbus was afraid in 1902, and it had every right to be. Hordes of children (mostly small boys) were preparing for their annual revenge as the sun went down. Asking for candy was not a Columbus Halloween custom, but mischief bordering on vandalism was. Halloween was a three-day mischief-athon. The first night was devoted to "tick tacks," small spools of string wound around a nail and fixed to windowpanes where the wind unraveled them. Occupants might be frightened it was a burglar. A quicker and more gratifying variation was to steal a handful of corn from the grocer's barrels to throw against a window. Grocers had started to put lids over the barrels a week before to thwart temptation, and some even kept a club next to the barrel. The second night was cabbage night where the hard cores of cabbages were jammed against doors to prevent inhabitants from getting out of their houses. The third night was gate night, and wrought-iron gates were removed from their hinges and tossed into trees or carried a distance from the original location. At the worst, they were placed on tracks in the hopes of derailing a streetcar. The annual council of war at the Columbus Board of Education met the day before, knowing that 17,500 or more school-age children might seek revenge against their most despised targets. Janitors were asked to stay the night in their buildings until dawn. Meanwhile, many farmers on the outskirts of Columbus planned to sit up all night in their fields with muskets loaded with rock salt.

November 1

It was no trick or treat—just pure tit-for-tat revenge on the part of Columbus brewers in 1914. Residents of Columbus had begun to receive a free newspaper on their doorsteps, gratuitously left by the Franklin County Dry Federation. The bulletin contained photographs of residences and properties owned in Columbus by the brewers—business blocks, the Chittenden Hotel—in contrast to hovels along the Scioto River and slums in the city. Their purpose was to draw a moral that those engaged in the manufacture and sale of malt liquors could afford to live in palatial residences while their alleged victims of drink were forced into hovels. The brewers pointed out that there were four hundred saloons in the city, but the total number of men in all the hovels could not support a single establishment. And so, in keeping with their "ba-zinga" moment, the brewers published full-paged pictures of the palatial homes where the officials of the Anti-Saloon League lived in the dry town of Westerville, north of Columbus, alongside pictures of shacks located within two hundred feet of the home of the most prominent official of the Anti-Saloon League. The brewers used the eye-catching attack to present arguments against the Anti-Saloon League's goals. Prohibition would be devastating to the tax base of communities, unfairly take away right to earn a living and, in a chain of dominoes, would hurt the grocers, the dry goods merchants, the wholesalers and the farmers, as well as the proprietors, bartenders, porters and manufacturers of all supplies needed by the industry.

November 2

Think of the impact of one night's work at City Council chambers in 1926. Council formally approved plans for the new riverfront city hall, officially calling it the Municipal Building (ok, that didn't work); approved building two stone comfort stations near the Griggs and O'Shaughnessy Dam; vacated lots on the west side of Naghten Street for the building of Aquinas College; changed zoning on the west side of Indianola Avenue from Hudson to Duncan Streets from apartment to business district; expanded the streetcar line from Camp Chase to Demorest Road; provided the night owl streetcar service; and agreed with forty-three west side residents to not encroach on their properties for sidewalks. The council members did postpone a decision to wipe out racetrack off-site bookmaking with higher fines and ninety days hard labor.

November 3

Barnes Sundries was the last business to vacate the buildings at 44 and 50 East Broad to begin demolition for the new State Office Building in 1970.

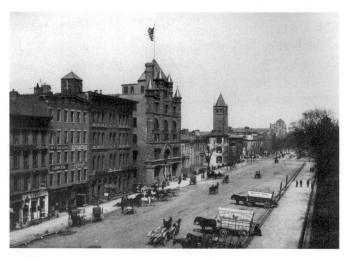

The north side of East Broad Street. The statehouse is located to the right but not visible in this photograph. *CLF.*

November 4

In 1871, exhausted and ill-clothed for Northern winters, nine young African Americans arrived in Columbus under the direction of George White, treasurer and musical director of Fisk University in Tennessee. Five years before, Fisk had been founded as the first liberal college to receive students regardless of color, but in 1871, Fisk was in debt and threatened with closing. White took nine teenaged students and set out on October 6 to raise money for the school through their concerts. They were rebuked and even harassed by most audiences, who were accustomed to minstrel singing. White churches turned them away. The fifty dollars they earned from concerts was given to victims of the Chicago fire. Cincinnati was particularly hostile, and when they arrived in Columbus the next day, they were ready to return home. But in Columbus, Ohio, they prayed for resolve and guidance and found both. Here they added the name "Jubilee" to their name in reference to the Year of the Jubilee in the Book of Leviticus, becoming the Fisk Jubilee Singers. They continued to tour (some of the original members took this as their mission for years, never returning to finish their formal educations). In time, they became so well known that they were invited to the White House by President Grant and to London by Queen Victoria, but it was here in Columbus they found their resolve in a name.

November 5

In 1932, all federal employees in Columbus (and throughout the United States) received a 30 percent wage cut for a period of twelve months to help raise federal funding and keep banks solvent. Relief funds in Columbus and other cities were coming to an end, and thousands were unemployed. The federal government put through plans for public works projects. Columbus's federal works projects included the city's still-emerging civic center; the extension of roads, such as the Olentangy River Road to Fifth Avenue; the building of an honor dormitory in the Ohio Stadium, the caretaker's house in Schiller Park and bridges over the Glen Echo Ravine; improvement of school grounds, such as the athletic field at West High School; and numerous and long-overdue sewer and street improvement projects.

November 6

In 1938, the North High Street façade of the Olentangy Village apartment complex was just completed, and thousands of Columbus citizens descended on the new development at Kelso and North High. Over one hundred families already lived in the apartments. Built by developers LeVeque and Lincoln, Olentangy Village was compared to the colonial House of Burgesses in historic Williamsburg, Virginia. The business and residential complex had replaced the popular turn-of-the-century Olentangy amusement park, originally built by the Dusenbury brothers in the 1890s, at the terminus of the Columbus Railway, Power and Light Company streetcar line. In 1938, crowds toured the model apartments that had been fully furnished by the F&R Lazarus Company to showcase modern apartment furnishings.

November 7

Columbus was not a hotbed of unionism, though the bricklayers, printers, bakers, tailors, brewers and others had organized into "union-like" benevolent societies (often ethnic or religious) to take care of their own. But on November 7, 1910, as a direct result of the streetcar strike, Columbus turned a little to the left and elected four members of the Socialist Party to city council and two members of the Social Party to the board of education. It was a brief Socialist dream by a minority, but just before they were voted out in 1913, the Industrial Workers of the World ("Wobblies") demanded equal rights to speak from street corners as the Salvation Army did. As two Salvation Army speakers finished their sermon at the corner of Broad and High, two Wobblies took the podium to speak. A "riot" followed, the police were called and the safety director took it into his own hands, prohibiting members of the IWW from speaking on downtown street corners. And Columbus has not seen a Wobblie since, not even at the DooDah parade on the Fourth of July—though the most celebrated anarchist in America, Emma Goldman, did come to Columbus on several occasions. Fresh from her return from an international congress of anarchists, she commented, "A desirable citizen is one who throws off traditions and the past and acts freely on the impulses of the present."

November 8

In 1985, city inspectors said crossing on any one of twelve heavily traveled bridges could be hazardous to one's health. The bridges needed immediate repair. If this book were a high school textbook on government and not an almanac, here would be the section on municipal responsibility. The following bridges have been repaired or replaced since 1985, and they are listed in the order of the greatest need at that time and the year they were built: Joyce Avenue over the railroad tracks (1907), Town Street over the Scioto River (1917), Parsons Avenue over the tracks near Buckeye Steel (1915), Stelzer Road over tracks south of Fifth Avenue (1943), Indianola Avenue over Iuka Avenue (1912), Buckeye Steel side road bridge over tracks (1915), Watkins Road over tracks east of Fairmont Avenue (1930), Front Street bridge over track's north of Nationwide Boulevard (1956), Calumet Street over Walhalla ravine (1934), Groveport Road over tracks north of Williams Road (1910), Main Street bridge over Scioto River (1935) and Mound Street over tracks west of Short Street (1910).

November 9

A steer belonging to a butcher was impaled on the fence of the statehouse at Broad and Third Streets about 11:30 a.m. in 1905 as it attempted to jump the fence. It had become separated from five others at the Union Stockyards as they were driven south on Third Street. Further enraged by the pain of a sizeable gap on its neck, the steer reached Fourth Street and turned north, narrowly missing a collision with a streetcar. When it reached Long Street, it turned west toward North High Street and then turned south. The street was crowded, and people rushed to get out of its way. In front of the Neil House, it ran on the sidewalk, and people took refuge in shops. Winded by this time, the steer was more easily subdued with a rope around his neck for two hours, then killed and carried to the slaughter house on the west side.

November 10

In 1880, East Rich Street was part of Columbus's Fourth Ward. On the first block (from South High eastward) were nine households, from 27 Rich Street to 67 Rich Street, that present an interesting view of a Columbus street. The residents of the street included a bank clerk, a retail salesman, two unemployed agents, a restaurateur, a baker and confectioner, a teamster, a dressmaker, two clerks, a grocery owner, a trunk maker, a buggy shop worker, a machinist, a dry goods clerk, a dentist, an attorney, a cigar store clerk, a domestic, ten children, two mothers-in-law, two married daughters with husbands and a total of five servants. And of all these residents, twelve were boarders; seventeen were unmarried adult children living at home and working; and four were widows and heads of households, including Mrs. Amelia Lazarus (whose two sons, Fred and Ralph, and daughters Rose and Sallie and Sallie's husband lived with her). It is not known how Rich Street acquired its name, but in the early twentieth century, people remarked that it was because "the rich" people lived there—not so.

November 11

Even before President Woodrow Wilson addressed a joint session of Congress, announcing the terms of Germany's surrender in 1919, thousands came downtown, "the greatest demonstration in history," marching in an impromptu parade to celebrate "the downfall of Hun militarism." They assembled before daybreak with bands, horns, sirens and other noisemaking devices to wake up the people of Columbus to the good news. The scene was described as a "mardi gras of patriotism" as more than twenty thousand people gathered on the streets and hundreds waved from windows and rooftops, causing the *Columbus Evening Dispatch* account to state, "Never before has Old Chris [Columbus] so given himself over to carousel. Revelry was the big idea." As marchers passed the temporarily erected memorial on the corner of Broad and High, gentlemen removed their hats, and the "spirit of revelry was briefly forgotten and a silent tribute was paid to those who had lost their lives for freedom three days earlier.

November 12

Where could one get oysters, fish, game, steaks, chops and confectionary delights in one stop? At the Ambos restaurant at 59–61 South High. In 1899, it proudly advertised its phone number—231 (yep, that's it, three numbers). The Ambos was *the* place for catered foods, but in 1899, it also advertised the "only exclusive café for ladies and gentlemen" and touted ice creams, meringues and other goodies. The building is long gone, but the business made Ambos wealthy enough to have an almost-life-sized statue of himself done for his resting place at Green Lawn Cemetery. In 1908 under the headline "Dead Man Pays for Big Feast," it was noted that "clad in hunting and fishing costumes, 25 friends and acquaintances of the late Emil Ambos, the philanthropist and naturalist, were banqueted Tuesday night at Schenck's hall in a novel manner, carrying out the provisions of the will of the late Mr. Ambos, which provided that dinners were to be given to friends when interest on $1,000, which he had set aside to be donated to the Children's home, was sufficient for the purpose. Two dinners have been given, and that of Tuesday night was the last, as the $1,000 has been turned over to the home…The banquet room was transformed into a hunting and fishing camp…There were pine trees placed about the hall, and a fishing tent in one end of the room. The Fourth Regiment band, which furnished the music, was also dressed in camp costume."

November 13

Former first lady Eleanor Roosevelt visited Ohio State as a lecturer in the Mershon celebrity lecture series in 1959. She toured the ROTC dormitories and visited with students on campus, sharing lunch with them. That night she received a standing ovation from the packed audience and "warned that individuals must give the very best they have to offer, not hoard their resources. These moments may not come back in history. Now is the time to act."

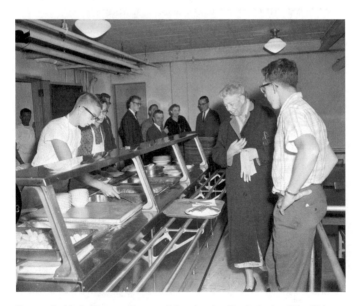

Former first lady Eleanor Roosevelt has lunch with students at the Ohio State University in 1959. *CML*.

November 14

A reader of the *Columbus Gazette* in 1858 felt compelled to share his architectural view of the new statehouse (and its controversial top that some later would call "a cheese box" because it was round and flat, though architect Frank Lloyd Wright liked it). The reader wrote, "The dome on the capitol is nearly completed. The spire on the top looks like a little 'something tapered off to the little end of nothing.' We should judge that in the finish of this work, that there must have either been a great lack of material or that the appropriation must have about 'gin eout.'" Safe to say, it "gin eout," whatever that meant.

November 15

The first Wendy's Old Fashioned Hamburgers restaurant opened at 257 East Broad Street (formerly a car lot) on this day in 1969, across the street from Memorial Hall. The interiors were outfitted by the Wasserstrom family, who also remember stringing all the beaded curtains up the night before the restaurant opened. A year later, Thomas opened a second restaurant in Columbus, ushering in a new era in fast food as it featured "the first modern-day, drive-through window." The original location closed in 2007 and was purchased by the Catholic Foundation, and the restaurant did a most amazing change—it became a small Gothic-like abbey.

The first Wendy's restaurant on its last day of operation on March 5, 2007. *CML.*

November 16

The lavish Hotel Hartman, owned by Dr. Samuel B. Hartman, opened to the public in 1901. The building designed by Kremer and Hart was built in 1898 as a luxurious private hospital retreat for wealthy patients from all over the world before becoming a grand hotel two years later. Before there was a state-owned governor's residence, Governor Andrew L. Harris chose the hotel as his official residence. It is probably a little ironic that Governor Harris's progressive agenda included supporting pure food and drug laws in Ohio in the early twentieth century, because that is exactly what brought down the Hartman empire of alcohol-infused patent medicine.

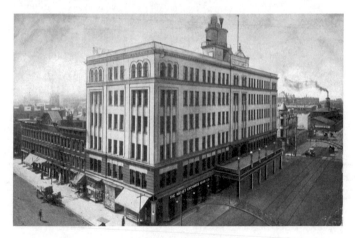

Hotel Hartman was a favorite place for private dinners. *CML*.

November 17

In 1963, the S.G. Lowendick firm changed the urban face of Columbus. Nearly two decades after the end of World War II, the city had pent-up energy to look modern. The company most often hired for demolition contracts had torn down over three hundred homes and a dozen commercial buildings in just a few years, and in November, the walls of the former Rowlands Building at the northeast corner of East Broad and Third Streets came down more rapidly than most by using a steel demolition ball. A new skyscraper would take its place. Lowendick had moved his business from Newark, Ohio, to Columbus in 1955, and with the changing times, he and his three sons found Columbus to be very profitable.

The Sheraton Hotel opened on November 17, 1987, on the site of the former Virginia Hotel, which was owned by Dr. Samuel B. Hartman. *CML*.

November 18

Booker T. Washington—author, lecturer, educator and proponent of the rights of African Americans—arrived in Columbus on the morning of November 18, 1902, to speak later in the evening at the First Congregational Church on East Broad Street. Washington stayed at the Neil House on this occasion where he was working on a new book, *Work with the Hands*. His first book, *Up from Slavery*, had already been published in four languages. On other occasions, Washington stayed at a boardinghouse on West Eleventh Avenue owned by a member of St. Paul's AME Church, where, according to the daughter in the family, he liked to write in the morning from bed. She, the young daughter in the house, brought him a breakfast tray and fled back downstairs to report to her mother that Mr. Washington had broken his glasses. She had never seen half-sized reading glasses that perched on the nose. Booker T. Washington made a return to Columbus the next year. (See April 14.)

November 19

In 1955, it was said that the greatest concentration of meat sellers in the United States was in Central Market, located down South Fourth Street between Rich and Town Streets. Sixty-five had stalls inside the market that was already 105 years old. The produce, egg and live chicken sellers were in stalls surrounding the market. The first market in Columbus, built in 1814, was a frame building on South High Street south of Rich Street. There were the North Market, the Eastside Market and the Westside Market, but Central Market was the most famous. In 1847, Thomas and Sarah Asbury sold land to the city to build the market. The Asburys were also proprietors of the oldest tavern in downtown Columbus, now the Jury Room. As part of the deed, if the market closed, the land was to revert to the Asbury heirs. Presumably, that did not happen.

November 20

(While reading the next section, softly hum, "Move 'em, move 'em, move 'em, keep those doggies move 'em... Rawhide..."—the theme song of traffic engineers). Arguments over the Olentangy Freeway route—which many had believed was settled in October 1963, when Ohio State had agreed to a compromise route between Kinnear Road and Lane Avenue through the "OSU of the Future"—turned worse. The director of the Ohio Department of Highways postponed hearings indefinitely after the Union Cemetery Association promised to "fight to the last ditch" to stop the freeway from taking nearly seven acres of land and Riverside Hospital insisted the freeway be routed past its back door instead of carrying heavy traffic through the scenic front lawn. The proposed $18.8 million project had been in the planning for ten years to eliminate traffic bottlenecks along Olentangy River Road. When it was over (thank goodness, that bottleneck was solved!), the boulevard of magnificent flowering trees of East North Broadway Avenue and across Olentangy River Road was lost. They were planted as a memorial to the fallen Columbus sons and daughters of World War II, in keeping with a concerted effort in all communities to not erect statues or stones but "living memorials" of trees, libraries, community centers, auditoriums, playgrounds and swimming pools after World War II.

November 21

In 1902, two hundred angry people converged at Northwood School (2231 North High) and adopted a resolution declaring, "In view of the many horrible accidents which have occurred on the decline from Northwood to Woodruff Avenues, due to the reckless speed at which cars are run on this down grade," the city council should take action reducing the speed limit from fourteen to ten miles per hour. They further maintained that the street railway company was responsible for the deaths as a result of the high speed it maintained at this point. North siders were upset over two recent deaths on High Street, including the killing of Colonel Hopkins, who was hit by a speeding streetcar.

November 22

"She's a Hit—As Usual. Texas 'Ayes' Jackie" read the headlines on November 22, 1963, in the local papers. They commented on President and Mrs. Kennedy's arrival at Houston International Airport. Of course, the paper had been printed before the unthinkable happened. The president had just concluded a speech at Fort Worth, and he and his wife were off to Dallas. The news was old. People stopped strangers on the street to tell them the news. The doorman at the Deshler-Hilton Hotel asked bitterly, "How in the hell could somebody get that close?"

November 23

Local reaction was heartbreaking on Saturday, November 23, 1963, one day after the assassination of President John Kennedy. Governor James Rhodes announced that all state offices and schools would be closed to observe the national day of mourning.

November 24

On November 24, 1898, Robert Day was the happy recipient of the annual Ohio Penitentiary Thanksgiving Pardon. He was convicted of shooting his aged father, though both men (including the father before he died) denied it. "Thanksgiving day is always a happy one to the inmates of Ohio's big prison. Today was no exception to the rule, for the men, one and all, enjoyed the holiday greatly...the program of the day consisted of the re-production of the pantomime, "From Fireside to Battlefield," as it was given at Olentangy Park last summer," reported the *Press-Post*. When the pantomime was over, the curtains closed and reopened to show the warden on stage with Robert Day, who received the pardon from a child vaudevillian with the governor's signature. He had received a life sentence for shooting his father thirteen times.

On the same day, during chapel services, Guard Gump was presented with a "handsome Colt revolver," a gift from his fellow guards in appreciation for an act of bravery a few weeks before, and Superintendent Laney, having miraculously recovered from a near-fatal illness the previous year, was presented with "a big turkey." (We could not make this up.)

November 25

The original Chittenden Hotel opened in 1892 on the northwest corner of West Spring and North High Streets in a renovated building, but on this date in 1893, the hotel burned in what was, at the time, the largest and most destructive fire in the city's history. The hotel and two theaters were destroyed, and one fireman lost his life; but the fire resulted in scrupulous attention to the use of noncombustible materials and modern egress. The new Chittenden Hotel, with Moorish towers and overhangs, opened in 1895. The hotel was razed in the 1970s after it went into receivership as part of the Temple of Goodwill scandal. The Southern Hotel was built in 1896 and advertised as a fireproof hotel to distance itself from the Chittenden's fire.

November 26

In 1938, Mr. Masters of West Oakland and Neil Avenues admitted he was out of control. A former contractor and now night janitor at city hall, his land on old Tuttle Field (now Tuttle Park) in 1913 had once been home to trotters and saddle horses. Now in 1938, he turned his attention to his Oakland Gardens, where he created elaborate and extensive cement and rock garden folk sculptures. And the sculptures kept coming and coming: stone cradles to honor the Dionne quintuplets; a twenty-five-foot-tall monument to the Eastern Star, Masonic Order, Order of Odd Fellows and Knights of Pythias; and walls, vases and arches on the 200- by 150-foot lot decorated with pieces of pulverized glass and dishes. In addition, fifty different flower varieties and twenty-five different shrubs were landscaped into the elaborate designs. He claimed he never had a plan—just a hammer, a trowel and stones—and he did it because he never smoke, drank or took a chew. Though Mr. Masters entertained famous visitors to his gardens, his wife, the granddaughter of the founder of the Hare Orphans Home, said she thought her husband was proudest of how he gave Columbus its first playground, later named for legendary local sportswriter Clyde Tuttle, who championed children's activities.

November 27

Mounds and earthworks in Columbus are the most tangible reminders of the ancient Native American cultures of the Adena and Hopewell people. When first viewed by European settlers and farmers, these works were a marvel and an annoyance. Some mounds, like the one that gave Mound Street its name, was large enough to have a house and a doctor's office on top and create an impediment to a straight trip down South High Street (meaning it would eventually have to go—Columbus likes its straight streets). Generally created for mortuary ceremonies and burial chambers, Adena mounds were "picked and plundered" for imagined treasures and artifacts, used as gravel pits for the making of brick (the early statehouse was made of the mound of Mound Street) or plowed under by farmers. Ephraim Squires and Edwin Davis, concerned that mounds and earthworks would continue to be lost to the plow, studied earlier records, cataloged and left a record of many of Ohio's over 100,000 mounds and earthworks in *Ancient Monuments of the Mississippi Valley* in 1848. The Shrum Mound is one of the few remaining Adena burial mounds in Columbus. The twenty-foot-high mound is about 100 feet in diameter and set in a small one-acre park about half a mile from the intersection of Trabue Road and McKinley Avenue.

November 28

It was not enough that the Lazarus family gave Columbus the most amazing department store emporium for over one hundred years—the "no hassle" one-price deals, singing canaries in every department (in 1909), a ladies' room and place to lay down with an attendant on duty (shopping is so tiring!), a return policy that included taking back things that had never been sold in Lazarus, wonderful celery dressing—but most astonishing is that the store fixed the floating date of Thanksgiving. Though Thanksgiving was a holiday since Lincoln's time, the last Thursday in November was sometimes the fourth Thursday and sometimes the fifth Thursday. If the date were fixed to the fourth Thursday, Fred Lazarus reasoned that customers would not be cheated out of shopping days before Christmas. Lobbying President Franklin D. Roosevelt, Lazarus single-handedly stabilized the Thanksgiving date in 1941. However, it was not without cost. The first year of the "new" national holiday was a nightmare on train timetables and football games (including the Ohio State/Michigan game).

November 29

Throughout the fall of 1914, various sports writers continued to report on Hank Gowdy, the baseball hero from Columbus. He had been honored by elaborate parades and dinners since coming home a month earlier. When Gowdy got off the train near North Columbus, an auto escort of several hundred cars met him to proceed down High Street to Broad and High for a formal reception at the statehouse. Five bands and more than twenty sporting organizations and civic groups turned out to welcome him. Ohio State and North High School were wild with excitement. He was the baseball catcher who had helped to bring the Boston Braves to a pennant, moving from last place to victory in just two months and earning them the title "the Miracle Boston Braves." He was respected because he volunteered in World War I, saw some of the heaviest trench fighting in France and went on a speaking tour about the war when he came home. He was honored in Columbus by having a field named for him. If it does not immediately come to mind, it may be because it was once a landfill—as evidenced by the Olentangy River Road south of Third Avenue, which rises and dips. Today, OSU hospital has two facilities there, and Time Warner has its offices on the former Gowdy Field, noted only by a little sign with no mention of his greatness. Many of Gowdy's stories were captured by another person who had a field named for him: sportswriter Clyde Tuttle. (See November 26.)

November 30

A massive ornamental window in the Central Methodist Episcopal Church on East Broad Street near North Fourth was removed and was being prepared to be reinstalled at Broad Street Methodist Church in 1935. Central, opened in 1885, was to be razed for a filling station and parking lot. At the dedication of Central, Bishop Foster said it was the finest window he had seen in either Europe or America. Four panels of the stained glass, set in stone and cement, represented faith, hope, charity and victory. Two employees of the Von Gerichten Studios were in charge, and the cost of removal was $1,000.

December 1

The American House Hotel opened in 1863 on the northwest corner of West State and South High Streets, putting it in a prime location across from the statehouse. The proprietors of the hotel, Colonel Eli Blount and his wife, Sara, lost their lively almost-six-year-old-son George in an accident 1873. George, in a hurry to accompany his mother for a carriage ride, dashed down the stairs to retrieve something he had forgotten in the office. The stairs seemed too slow for a small child, and he hopped on the banister rail. The clerk in the office and a porter in another room heard the crash and came running. The child had hit his head and was helpless and bleeding. Doctors Loving, Smith and Frankenberg came to administer whatever relief they could, but after eight days, George died. Having recently commissioned a portrait of their son, the parents used the likeness to commission an almost life-sized statue for his grave in Green Lawn Cemetery. Today, the statue is decorated by anonymous gifts and articles of clothing—in winter, OSU scarves; in summer, sunglasses—and small toys are left. Gifts are removed if there is a possibility the gifts could damage the sculpture. Eli died in 1900, and Sara followed in 1908. The American House Hotel may have lasted much longer. It is thought the back wall of it remained as part of the old Kresges store before buildings were razed for the Vern Riffe Center.

December 2

One of the most striking mansions in Columbus stands across from Goodale Park. Appropriately resembling a Victorian Gothic circus tent, the Sells mansion belonged to Peter Sells, of the Sells Brothers Circus. The Sells brothers—Allen, Lewis, Ephraim and Peter—formed a circus in 1872 that rivaled the Ringling Brothers, whom the Sells brothers mockingly called "the Ding-Dong brothers." Of course, they had to eat their mockery when they sold to them in 1905.

It was not a happy home for Peter Sells and his wife. There were intimations that Mrs. Sells cheated on her frequently traveling husband. She made sure her indignation reached a reading audience in 1899 when she was quoted in the newspaper saying, "It is simply a conspiracy against me…I am, of course, at the great disadvantage, being a woman…. They tell me I am accused of improprieties with two physicians, a 'Columbus boniface,' and a prominent railroad man…and I am speaking truthfully when I say…not one of them do I know personally." A best defense is a good offense, as they say, and perhaps that part was true. Mrs. Sells did not know a Columbus boniface (an old word for jovial innkeeper). However, she did know Mr. Bott, who was a prominent keeper of a billiard parlor and saloon. Mr. Sells had a detective trace the whereabouts of his wife, who entertained Mr. Bott in her home wearing little more than a "wrapper" as she answered the door, or so said the neighbors. He discovered evidence to sue for divorce and custody of their daughter. The detective, hiding behind the Fish Gate across the street, recovered Mr. Bott's bicycle from the Sellses' bushes.

December 3

As Columbus was on the eve of a new century in 1899, there was time to reflect on almost fifty years of changes, as evidenced by an 1852 City Directory. In 1852, more than twenty-two thousand people lived in the city in five wards. Mayor Lorenzo English was still remembered by the older residents in 1899. The city boasted two fire brigades, four temperance societies, four Odd Fellows lodges and many Masons. There were two German benevolent societies, a mechanics and engineers association and, of course, the Female Benevolent Society, of which Hannah Neil was president in 1852. Street names may have been the same but house numbers were not used—for instance, the 1852 city directory noted a man might live on High Street but "over Mr. Halm's store."

December 4

An Orthodox congregation was formed on December 4, 1901, by two saloon owners, a bartender, two traveling salesmen, a peddler and a furniture dealer. These seven Hungarians organized what was often called the First Hungarian Hebrew Church, later known as Tifereth Israel. The seven organizers did not necessarily live close to one another, but they were bound together by being Hungarian and sometimes by geography. The Wassterstroms and the Polsters knew each other from village life. The congregation first met at 392 Livingston Avenue and then moved to 330 South Parsons in 1909 and built a new building on the site in 1915. In 1924, it then moved to 1354 East Broad Street.

It was announced in 1960 that hunters and marksmen would be prosecuted under a new law if they were caught shooting at Franklin County's new flasher signals at railroad crossings. Thirty-eight signals had been shot in two weeks.

December 5

Columbus has many 1920s small commercial buildings. Their histories and those who built them are often forgotten. One featured here represents the many that go unrecorded. On this date in 1997, the transfer of ownership was completed for 231 East Livingstone Avenue, and the Margulis family no longer owned the property they had built from a peddler operation into a department store. Columbus had successful retail establishments, many from the first wave of Jewish (mostly German) immigrants. The second wave of Jewish immigrants came from the Pale Settlement (Poland, Latvia, Lithuania, Ukraine and Belorussia). In the Pale, it was common for women to work both in and outside the home, raising and selling produce or making and selling textile goods. In Columbus, women worked as seamstresses, fishmongers, chicken and egg sellers or operators of small stores while their husbands did other jobs. According to Julius Margulis, who was interviewed by another prominent member of the Jewish community, Marvin Bonowitz, in 1998 for the Columbus Jewish Historical Society, the Margulis Department Store began when Lena (Furman) Margulis, a seamstress from Poland, married Harry Margulis, a peddler from Hungary, in 1912. She began making extra merchandise in her living room. Her work was sold from Harry's horse and cart and then sold in her living room turned tiny store at 247 East Livingston Avenue for twenty years. Her stock of aprons, dresses and other articles of clothing grew to where a store was needed—the one that stands today with its handsome glass window treatment. Probably it is best remembered as a video store to German Village residents.

December 6

The Christmas Nativity scene once in front of the statehouse was erected in front of 666 North Hague Avenue by its creator and owner and well-known Columbus decorator Gordon Keith in 1967 (usually choosing the night before St. Nicholas Day, still celebrated by some in the German community). He lit it nightly during the season in a natural setting in front of his factory. Keith also maintained a Decorator Showcase Barn in a former stable on Wall Street, south of West Town Street, and later he moved his business to Hague Avenue.

December 7

In 1967, the walls of the old Fourth Street School, one of Columbus's German schools, started to crumble under a wrecking ball. The school, 114 years old at the time, had been built in 1853 after the city purchased the property two years earlier for $490. The school cost $32,000 to build in 1853, and 100 years later, when it sold to the Heer Printing Company, the cost was $50,000. (It is now the site of the Downtown High School.) Wreckers found old school seats and some books dating back to 1903. Several people stopped by to take a piece of history for remembrance. The school had many famous alumni—including General Curtis LeMay, head of the Strategic Air Command. On the same date in the same year that his old school was being torn down, LeMay, retired United States Air Force, was at the Neil House on the anniversary of the bombing of Pearl Harbor, speaking before a packed audience of members and guests of the Capital Club Young Republicans. LeMay—who is always cited as having originated the phrase "Bomb them back to the Stone Age"—was strident in his approach to the Vietnam War. "We should fight with our strength…switching from men to material resources." No word as to whether he stopped by for a brick from one more "bombed"-out building.

December 8

Samuel Gompers arrived in Columbus to chair the convention of the Federation of Organized Trades and Labor Unions in the United States and Canada in 1886. An important event was brewing at Druid's Hall on North Fourth Street (also called Hassenauer Hall after the saloon on the first floor owned by Charles Hassenauer). The Federation of Organized Trades suddenly disbanded. On the second floor of Druid's Hall, several disgruntled labor groups, including four assemblies of the Columbus Knights of Labor, the German Butchers' Association and the Chainmakers' Association, merged to become the American Federation of Labor.

December 9

Just over two weeks before Christmas in 1865, Columbus citizens were crime victims. The *Daily Ohio Statesman* reported that "notorious thief and pickpocket" Elizabeth McCarty was arrested for creating her own crime wave on the downtown streets and around Central Market, then located near North High and Town Streets, where she had pickpocketed several women. A pocketbook, stolen from a woman in Fay's store, was also found in her possession. Her stay in Columbus was extended by a thirty-day sentence in jail, and she was fined sixty dollars.

December 10

Fans of all ages mobbed Ohio State's Archie Griffin at
Port Columbus in 1975 upon his return from New York
City, where it had been announced that he was the first
ever repeat Heisman Trophy winner. In one game short
of four campaigns, Griffin led Ohio State to four Rose
Bowl games and a record of forty wins, four losses and a
tie in forty-five matches. Before he left the airport, he had
kissed his mother, babies, his fiancée and aunts; he had
signed autographs for kids, grandmothers, policemen and
waitresses—and remained, as he always had been, humble.

December 11

Columbus Chamber of Commerce changed its name to the Columbus Area Chamber of Commerce in 1956. Despite the new name, its building on East Broad Street would not last another decade. This was not the first time the name changed—it once was the Columbus Board of Trade, but this was considered an old-fashioned term by World War I. The Franklinton Board of Trade has proudly kept its original name since 1904.

December 12

In 1886, the Columbus Club, located on the southeast corner of East Broad and North Fourth Streets in the former Benjamin Smith mansion, was incorporated and opened to all "gentlemen of lawful age."

December 13

In 1983, popular neighborhood newspaper (with subscriptions even overseas!) the *Neighborhood Busybody* reported on a building and a sign that puzzled many who passed by—the Ohio Gloria Society at 1353 North High Street. The Ohio Gloria Society was the brainchild of Archie Henry, former mayor of Henderson, West Virginia, and a longtime civic activist who believed that many people came to Columbus to find work but ended up in the welfare system. His motto was "combating apathy through self-esteem." The name of the society was taken from a song he wrote, "Ohio Gloria," performed at the Conservatory of Music in Cincinnati. *Busybody* editors Jean Hansford and Pete McWane lived in Dennison Place neighborhood and produced the *Busybody* for years, including short stories, meeting notices, ads, commentaries and even crossword puzzles on occasion.

December 14

In 1858, the incomparable Professor Fowler appeared in Columbus. A well-known and distinguished phrenologist, he drew large audiences, explaining how the bumps on one's head could reveal much about personality, tastes, health and even future. He was at the Neil House for nine evening lectures, willing to delineate people's characters with his very own hands. Every lecture ended with his examinations, which, he believed, should be done before one contemplated marriage, children, new jobs, money transactions, changes for health reasons and the like. He would, of course, see private patients who would gladly pay more than the twenty-five-cent ticket to have their heads felt. His visit was his one and only stop in Columbus before he was off to Europe. Though he made his money in phrenology, his enduring gift was the design of the octagon house. Virtually all octagon houses emerged in the decades after the 1840s. Dr. Fowler believed that everything was better in an eight-sided house—fruit would not spoil, knives would not dull, and even sex was better. Dr. Fowler liked to talk a lot about sex, though at the time, all lecturers used the word "marriage" (wink, wink, nod, nod). Columbus has an octagon house on East Broad Street dating from this period, and over the years, it grew "wings," or additions—seems as though everything in an octagon house might be better except for finding closet space and arranging furniture in pie-shaped rooms.

December 15

In 1926, Columbus drew high praise from Chicago art and architecture critics for its contributions to American arts. Dudley Crafts Watson, Chicago Arts Institute director, made the pronouncement at the Rotary Club. Columbus had five outstanding examples of its achievement. He said Alice Schille, George Bellows, James Hopkins and Charles Rosen were currently among the best of the living American painters and the American Insurance Union Citadel (LeVeque Tower) was the "most original and American of skyscrapers." The AIU drew more praise as "the most beautiful and consistent American skyscraper ever built…It doesn't mean much that it is the fifth-tallest building in the world. It is the fact that you have a building that is not an imitation of a Gothic tower, a Roman bath or a Greek Temple…You feel in its exterior design it is an honest building and no camouflage or veneering. It is just an honest piece of magnificent construction." Schille and Bellows were Columbus natives. Charles Rosen was a Pennsylvania impressionist, but he taught painting in Columbus. James Hopkins was from Irwin, Ohio, and studied at Ohio State University and Columbus Art School. Though he traveled widely, by 1920 he had returned to Ohio State to head the Fine Arts Department, a position he held until 1948. OSU Hopkins Hall is named for him. (See January 31 and January 6.)

December 16

In 1901, ice dealers harvested their supply of ice from streams around the city when the ice was four to five inches thick. Ice cutting in the city generally did not start until January, but the very cold weather made it possible to employ the 350 to 400 men necessary to gather the ice earlier. Ice came from Alum Creek and from the Licking Reservoir, where it was stored in icehouses and shipped to Columbus.

December 17

On this date in 1958, two events occurred that reflected how Columbus was changing in the "modern" era. Mrs. Eleanor Roosevelt, recently returned from a trip to Russia, felt Columbus was important enough to warrant her making a speech at the Southern Hotel to address the American Association for the United Nations on the U.S., the USSR and the UN. Also, the City of Columbus took thirty-eight owners to court to achieve slum clearance in the Goodale area. The chair of the Slum Clearance and Rehabilitation Commission said that the city was moving against the owner-occupied property cases, despite the fact that many were older people on fixed incomes who could not buy new homes on the appraised values ($6,500–$7,000). The project was ahead of schedule in razing the entire area to be resold for private development, and 180 of the 473 properties had been acquired. Three years earlier, after the public defeated a bond issue, the agency wrestled with what to call itself because clearly the public didn't understand it was charged with "cleaning up slums in rotting parts of the city," according to the agency hired to do the job. Was it Slum Clearance and Neighborhood Improvement? Slum Clearance and Redevelopment? Urban Redevelopment Authority? On the other side of downtown, the Market-Mohawk project would be completed by May 1959. The term "urban renewal" was still new to the lexicon of urban planning and acquiring a less-than-pleasant connotation.

December 18

In 1921, the *New York Times* reported the children of Princess Amelia zu Lynar, who had died fourteen months before in Germany, had filed suit in the United States Supreme Court against Secretary Andrew Mellon of the Treasury and the Allen Property Custodians to win back their mother's fortune, worth $1.5 million, on the grounds that the money was of American origin. The property had been seized by the United States during World War I. The adult children—Prince Ernest zu Lynar, Count Georg Felix Mortiz William Alexander zu Lynar and the Countess Jane Georgiana Zople Margarita Isabella zu Lynar—claimed that the money was of Columbus origin since their mother (the former May Parsons) inherited her father's and grandfather's wealth. Though she had married into German royalty in 1853 (see May 16), May brought to the marriage substantial resources from the Parsons estate. May's father, George Parsons, had expanded the family fortune, and his mansion at the northeast corner of Parsons Avenue and Bryden Road later became the first home for the Columbus School for Girls. The family land was extensive and reached to Monroe Avenue. Gustavus Lane was named for Gustavus Swan Parsons, May's brother. The suit was not successfully resolved for the children, all of whom continued to live in Europe.

December 19

"Port Columbus Naval Base to Close Down by June 30" screamed the *Ohio State Journal* headline in 1958. The news was received as a blow to Senator John Bricker and Airport Superintendent Francis "Jack" Bolton. The navy estimated its land and plant facilities at Port Columbus to be worth almost $3 million. Lost to Columbus was a large payroll from the Naval Air Station and its Marine Air Detachment. Over five hundred enlisted men and officers were affected. But the postwar adjustments to higher wages, rising prices and increased costs made the cuts necessary.

December 20

In his offices of the Frankenberg Brothers Paper Box Company at 479 South Ludlow Street (now part of the Wasserstrom Company complex), Mr. Louis Frankenberg talked in 1953 about his father, Alexander, who obtained a patent on December 20, 1853, for an improved soda fountain and water cooler. Alex Frankenberg was a dealer in confections, drugs and baked goods and had an establishment at the corner of Mound and South High Streets. The patent described the invention as healthful since it contained filters, no lead or copper pipes and treated water that was excellent in the use of soda water and lemonade.

December 21

One would have thought it was 1908 and not fifty years later. On December 21, 1958, a Sunday, four squads of special assignment police officers, accompanied by a lawyer from the Columbus prosecutor's office, raided businesses that had the audacity to violate Columbus's blue laws. Attorneys for the businesses called the blue laws "antiquated," but the laws carried a fine of $25 for a first offense and a $50 to $100 fine and five to thirty days in jail for a second offense. Over a dozen stores were cited, including Shoppers Fair, Smith Hardware, Pick Way Shoe Store, Lee's Department Store, Luckoff's, Sun Television and Appliance, J.D. Clark, Inc., Simplex Auto Parts, Bargain Surplus Sales and Culters. Columbus can be a mean town when it has to be.

December 22

The first ordinance aimed at the control of dance halls continued and continued and continued. It was as much a control issue for the city as it was an honest concern over the morals of the city. Although Mayor Hinkle (who had only ever spent twenty dollars for his election campaign but was clearly gung-ho in his approach) once ripped aside the flap of a tent at the Ohio State Fair and yelled, "I'm Mayor Hinkle and we'll have no hootchy-kootchy dancing here!" Still, on this date in 1913, two controversial dance hall ordinances went to the voters, even though a second one passed by city council negated the first one by the council. Ordinances and counter-ordinances flew back and forth from December 22, 1913, to December 31, 1913, and again from March 23, 1914, to May 1, 1914. Confused? Everybody was in on the act: women's clubs; Carl Hoster, the brewer; Mayor Karb, Hinkle's successor, who vetoed the proposals; and councilmen who voted over the mayor's veto. The ordinances were almost identical except for a nuance of wording. In essence, the ordinance(s) regulated public dance halls to prevent the sale of liquor. Without the ordinance being resolved, the city was forced to prohibit public dancing in the city parks because there was no way to regulate these dances.

December 23

In 1934, the State Automobile Mutual Insurance association at East Broad Street and Washington Avenue created its most elaborate and unusual Christmas display. Known today for its life-sized nativity scenes, eight decades ago State Automobile created "The Little Church in the Air." The largest such display ever created in Columbus, it contained over eight hundred electric lights with eighteen different circuits. The church atop the building was more than sixteen feet high, illuminated both directly and indirectly; the lights emphasized the cutout figures approaching the church from two different directions. In addition to old-fashioned figures, a high-wheel bicycle in motion and a stagecoach drawn by galloping horses, thirty-seven windows of the building had natural pine roping with flashing stars, a Christmas tree was at the corner of the building and each evening a quartet appeared at intervals behind a window to sing carols to the accompaniment of an organ. The display was erected by the J.W. Thompson Company and was said to be the most elaborate ever created in the United States.

December 24

It is all on the flat stone in Green Lawn Cemetery—a man's entire and extraordinary life—near Brown Road. "Washington Townsend was the slave of Andrew Johnson, President of the United States, escaped to freedom in Columbus, Ohio—30 years with Ohio State University, died in December 24, 1904. Not all the debasing influences of his early life as a furnace man, field hand, deck hand, jockey, fighter, and slave could undermine those of honesty, courtesy, faithfulness, dignity and sweetness of disposition. He was essentially nature's nobleman. His example was an inspiration to his race and a rebuke to those whose fortunes were greater and achievements lesser." Only a few other facts are known. He was listed as a farmer in North Columbus, living somewhere off North High Street in the vicinity of East Patterson (which had not yet been platted), and he worked in University Hall, where a list of university employees and their compensations in 1878 reported him as a janitor who earned $480 a year, the same as the night watchman and a fireman, but more than Olive Jones, the assistant librarian, who earned $300. President Scott made $3,000.

December 25

For the Christmas season in 2003, Helen Bierberg Walsh wrote *The Bierberg Story: Four Generations*. They were and still are involved in the tradition of Christmas baking. Her grandmother Theresa Hoehl started the family business in 1913 at 427 South Eighteenth Street at Engler Alley. She was a trained cook, and all her life she was proud to say she "made a cake for Kaiser." She met and married Ferdinand Bierberg, also from Germany, in Columbus in 1910. Ferdinand was a tailor and made cassocks for the clergy in the area. When Ferdinand became ill, Theresa returned to her craft and began baking for well-to-do Columbus families. Although she was Catholic, she kept a kosher kitchen and was appreciative of the Jewish community that supported her. The Bierbergs had two sons, Gustav and Rudolph. Gus ran the bakery, and Rudy became a priest. Gus married Emma Gremm, who was a tremendous asset in the bakery. When Theresa died, her son moved the bakery into German Village at 729 South Fifth Street, making wedding cakes, bar mitzvah cakes and twenty-five different kinds of cookies. Helen and her husband, Harold, and son James, along with Emma, took over baking when Gus died in 1976. Harold passed away in 1998 and James in 2002, but Emma and Helen continued baking through 2003. All four children, plus two in-laws, continued as the fourth generation of cookies made traditionally for the public only at Christmas.

December 26

In 1934, two railroad men were killed and at least twelve passengers were injured when a Pennsylvania passenger train from Cleveland went through an open switch in Linden and crashed into an entire string of freight cars. Sabotage was suspected. The switch leading from the main line to a track had been locked "open," but more telling was that the semaphore arm of the switch, which would have warned the trainer engineer that the track was not clear, had been torn off. Witnesses who lived on East Twenty-fifth and East Twenty-sixth Streets near the tracks said the damage was extensive, as the train was going over forty miles per hour. Linden was a farming community located along Cleveland Avenue before its annexation into Columbus.

December 27

The First Congregational Church opened in 1857, with the roots of Congregationalism coming from far more modest origins in a small house. It was from this site on East Broad Street near Third Street that Reverend Washington Gladden, pastor of the church, launched the nationally known Social Gospel movement (which in essence said if one were a Christian, one should act accordingly). Gladden's presence in the city made Columbus a destination for presidents and religious leaders, Progressive thinkers and municipal do-ers. He thought nothing of taking on the Badlands and the saloon keepers. He launched an actual children's crusade against Sunday saloon sales with thousands of little children signing petitions to close the evil places. He served until his death in 1918, when the congregation moved to a site farther east. The original church was razed in 1932.

December 28

It was rumored in 1951, and in two weeks, it was reality. Two huge assembly plants would be built on a 130-acre tract at Innis Road and Cleveland Avenue, but first the area had to be re-zoned from agricultural to light industrial. North Linden residents were not happy, saying their land would be devalued if the re-zoning occurred. No names for the plants were revealed by the landowner and attorney seeking the revision, Frank Amos (and you wondered how the Amos Center got its name), but it still leaked out. One was the Shoe Corporation of America. Shoes had always been big business in Columbus, and the Shoe Corporation of America also made more "burial slippers" than any other company in the world. Schiff Shoes was one of the largest local outfitters, but the American Shoe Corporation had outlets in thirty-two states.

December 29

In 1934, Mrs. Mary Case, of 866 West Mound Street, lived not far from where she earned the distinction of being the sole female worker on the Scioto division of the former Ohio Canal, driving a three-horse hitch and her father's canal boat. She was interviewed about her life as well as about her father, Captain John "Peg" Hayes, who operated three boats. Born on a canal boat in 1884 somewhere between Groveport and Canal Winchester, Mrs. Case started working as a driver when she was nine years old. Her father hauled corn, wheat, lumber, grain, groceries, dry goods, chickens and butter. She continued working on the canal until she married in 1905, and she estimated that she had attended more schools than most—eighteen different schools up and down the Scioto River.

December 30

By this date in 1911, art collector and Pe-Ru-Na business partner of Dr. Hartman, Frederick Schumacher, was headed home to Columbus by way of Toronto from Ottawa, Canada. In the early part of the twentieth century, he went to a small town in Ottawa to prospect for silver, finding gold instead, but what he really found were children. More than 280 of them, mostly of Croatian families, they lived hardscrabble camp lives. He vowed to make life a little easier for them and bought each one a Christmas present—not just any Christmas present but the very one thing that each child really wanted and their parents could not afford. Years later, these children—now grown into adults—remembered getting a chemistry set or building blocks. Schumacher made lists of all the children's names and ages and after leaving Columbus by train would stop in Toronto and personally select the gifts. All children under the age of twelve received a gift—and they still do. The town is now a combination of old immigrant groups and native tribes, but through a trust he established at Huntington Bank, the tradition continues. He was honored by the town, which was named Schumacher, Ottawa. Once asked by a little girl on the train to Ottawa what his name was, he replied, "Mr. Schumacher." "No, it's not," she said, recognizing him, "You're Santa Claus."

December 31

The 1985 headline read, "The End," with a subheading, "How Did Columbus Become a One-Paper Town?" The death of the *Citizen-Journal* (the *C-J*), a Scripps-Howard newspaper, was "like a mystery with no shortage of suspects." For twenty-six years, under an agreement with its largest competitor, the *C-J* had been published by the *Columbus Dispatch*, which ended the agreement. The two companies each blamed the other, and newspaper trends showed that the morning paper was more attractive. The *Columbus Dispatch* became the new morning paper. The last issue was filled with nostalgia: art critic Gene Gerrard's description of a musical performance ("The violin was as flat as a ballerina's chest"); Betty Garrett's description of seven young men from Bealsville who died in Vietnam; the outrage when "Doonesbury" was dropped for a week because it dealt with homosexuality (copies were made available at the desk, and "Doonesbury" moved to the editorial page); and City Editor Sam Perdue's twelve-hour effort to talk a man out of committing suicide. More than one eatery in Columbus has a framed copy of the last *C-J* newspaper still on its wall.

AN INDEX (OF SORTS)

Because we are convinced that Columbus remains a small town and everyone in it is related to a dozen original families, stories tend to fold back onto themselves. Therefore, while not the most exhaustive guide to specific places, the following is meant to help find stories about places or people associated with places. Please remember, we never claimed to be infallible.

Places and Families

Goodale Park, Dr. Goodale: March 7, April 22, July 14, July 22, July 29 and September 30

Hartman Hotel or Hartman family: January 31, September 14, November 16 and December 30

Huntington Bank: January 2 and July 2

Lazarus family and Lazarus Department Store: March 1, June 1, June 19, August 5, November 6, November 10 and November 28

Memorial Hall: January 4, May 27, August 25 and October 29

Neil House Hotel: January 10, February 5, March 22, June 2, September 16 and December 7

Ohio Statehouse: January 5, February 1, February 13, February 14, February 21, May 20, June 23 and July 15

Ohio State University: February 2, February 8, March 12, March 26, April 6, May 4, May 11, May 28, June 10, December 10 and December 24

Port Columbus: March 14, May 8, July 8, October 14 and December 19

Southern Hotel (Westin) and/or Southern Theater: January 10, March 17 and May 20

Union Station: March 27, June 29 and September 4

Three Very Different Jameses and a Howard

James Poindexter: January 19 and February 6
James Snook: February 28, June 14 and July 24
James Thurber: January 12, March 25 and May 5
Howard Thurston: March 1 and April 13

ABOUT THE AUTHORS

Tom Betti serves on the board of Columbus Landmarks Foundation and is also chair of the Education Committee charged with leading the organization's educational tours and extensive programming. He is dedicated to bringing history to life through entertaining storytelling. He co-leads the Historic Tavern Tours with Doreen, bringing dry humor and wit. Tom also founded and leads the Historic Preservation Committee of the Athletic Club of Columbus, celebrating, organizing and documenting the club's one-hundred-year history. A native of the Cleveland, Ohio area, it is fitting that his condo resides in the historic 1898

Hartman Hotel Building in Columbus, Ohio, where he lives with his Boston terrier, Hugo.

Doreen Uhas Sauer is the immediate past president for Columbus Landmarks Foundation and serves on a number of boards in the University District, where she is active in urban issues and local history. A longtime Columbus educator with Columbus City Schools, she currently directs a federal Teaching American History grant and has worked extensively in international civic education. She has received statewide recognition for her work in preservation education, developed more than thirty local history/ architecture programs and was named Ohio Teacher of the Year in 2003. She has coauthored books on local Columbus history and on the University District, where she resides with her husband, John, whose roots are extensive in the German South Side.